Film Actresses

Volume 4

Greta Garbo

Documentary study

Part 1

ISBN-13 : 978-1503258457
ISBN-10 : 1503258459

Copyright©2012-2014 Iacob Adrian
All Rights Reserved.

Dtp and graphic design

Iacob Adrian

Copyright©2012-2014 Iacob Adrian
All Rights Reserved.

Author statement

The actors and actresses are the the bricks .

The cast and crew are the plaster .

They stand on the foundation created by producers and writers and directors .

All these people creates the great palace of the art of film .

Iacob Adrian - 2013

Copyright©2012-2014 Iacob Adrian
All Rights Reserved.

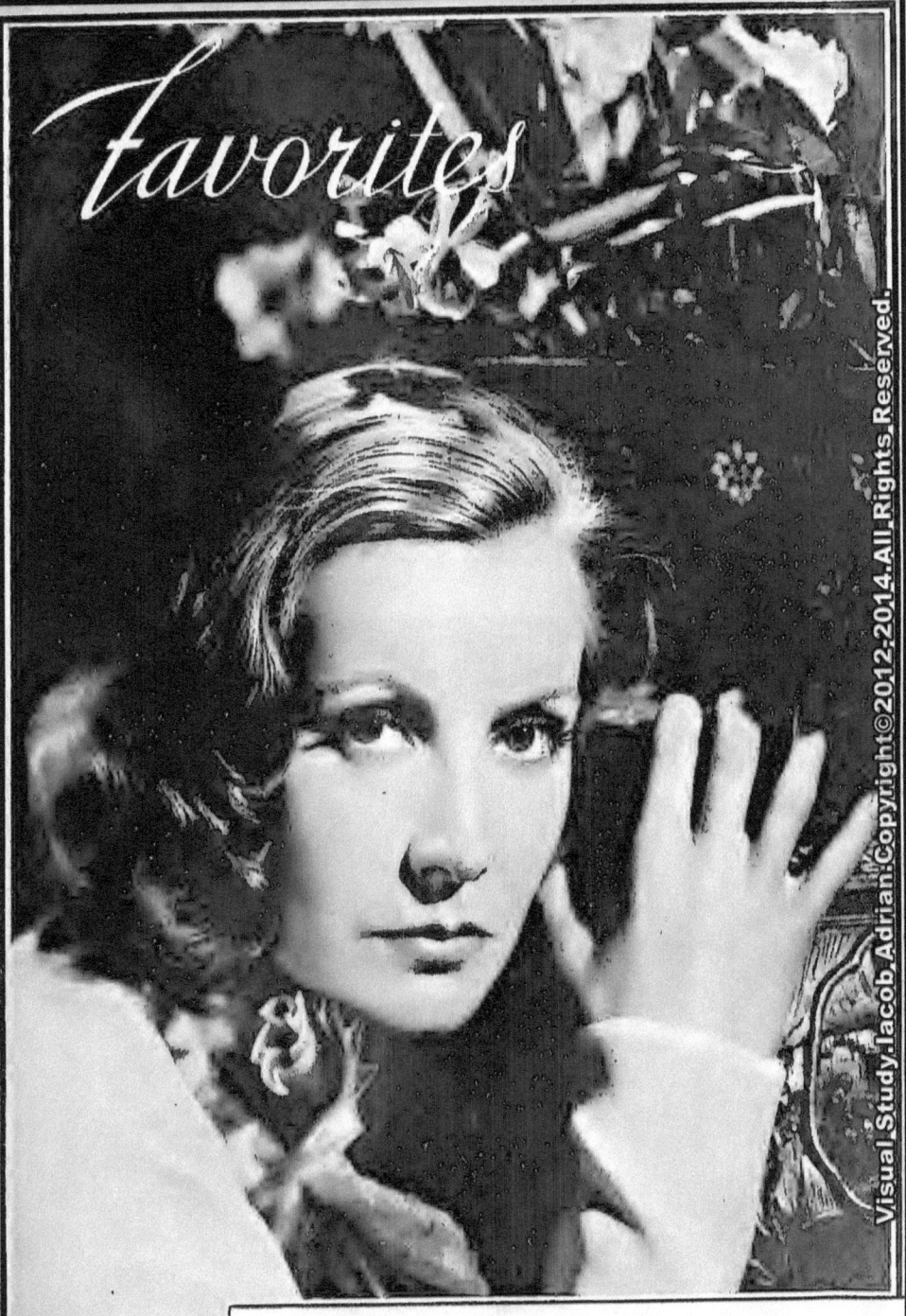

Greta Garbo — Greta Garbo assured her millions of fans that she would remain with them for at least two more years when she signed her recent contract with Metro. Her salary was raised from $8,500 to $9,000 per week

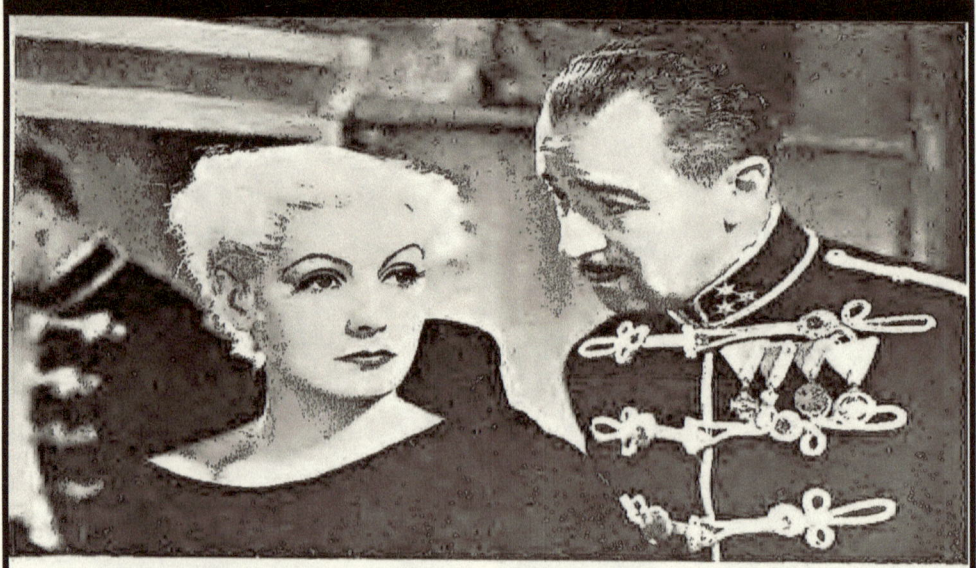

When sued for $3500 for a portrait of himself, Tom Mix maintained he wouldn't pay that much for one of Rembrandt's.

Garbo appears even more beautiful when she dons this blonde wig for her latest picture, "As You Desire Me." Albert Conti is the lucky fellow.

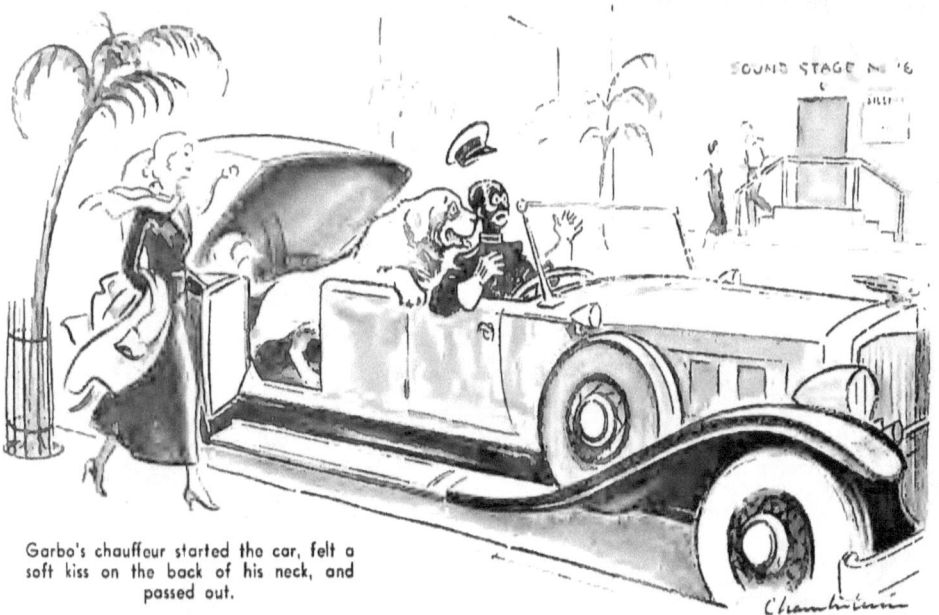

Garbo's chauffeur started the car, felt a soft kiss on the back of his neck, and passed out.

Our Hollywood Boulevardier becomes a gallant knight—

In Defense of GARBO

**Indignantly yours,
HERB HOWE**

Hollywood:

BY the time this appears all will be over. Greta says she is going home to Sveeden this month.

So you'll have to pardon the incoherence. The typewriter is choked up, and the wails issuing from the boulevardier's tower have my hound Cellini in a yelping paroxysm downstairs. He thinks the master has gone off the nut or the wagon again. The master really should be in bed. But no, the show must go on! Wish I could sing *Pagliacci*.

OF course Greta may have changed her mind. She's a goddess. Personally, I'd rather see her go Sweden than Hollywood. And she is a lot more likely to.

There is this consolation: I can assure you that Greta will not retire. Her work is the only thing that means much to her. She wants to be free to play the parts she chooses on screen and stage. Max Reinhardt made her an offer some time ago, to appear on the stage in Germany. And, of course, she can have her own picture company in Europe if she wants it.

Greta is tired. She works with exhausting intensity. On the set between her scenes she paces up and down, her lower lip protruded, her breath issuing in quick sibilant gasps between clenched teeth. She appears to be suffering from stage fright.

HER aloofness is due entirely to shyness. She's so self-conscious before people that she could not descend the stairs in a scene of "Mata Hari" until the extras were dismissed from the set. For such requests she is misjudged high-hat.

I recall meeting Greta for the first time. She had been practicing a tango with Tony Moreno for "The Torrent." Tall, blue eyes, pleasantly gauche, she gave a firm hand-clasp. "Did you see me dance?" she asked breathlessly.

"No," I said.

"Tanks God," she said and took flight.

WHILE Hollywood is partying, Greta is home taking bottles of sedative. She suffers agony from insomnia. She wakes up every morning at four and goes tramping for miles. When recognized she breaks into a run. Unlike her colleagues, she cannot endure the pursuit of her screen shadow. She's a humble person.

HER avoidance of the press is due entirely to fear. She was scared to death by interviewers. When she first arrived in Hollywood she was asked questions about her romance with Mr. Stiller. She thought she was being given a third degree. She didn't know it was an old American custom to ask impertinent questions. Later when she met one of the inquisitors at a party, she grabbed her hat and ran out of the house with the alacrity of a rabbit beholding a bird dog.

Greta says she wants to work in Europe. In Europe they do not ask about the love life, and privacy is possible.

A great actress, Greta has no desire or ability for acting off screen, no liking for the ballyhoo that is considered the commercial asset of an actress in this land of Barnum.

GRETA has not liked the stories assigned her. She quickly realized the futility of struggle, however, and has bided her time. When told that Ramon Novarro had been assigned a football picture called "Huddle," she exclaimed: "You are joking. It is true? Oh, will they never learn?"

SHE quits the set every afternoon exactly at five. She does not consider herself an artist, but a workman, and she wants the hours of a workman. Never has she claimed the prerogatives of an artiste. Marion Davies, John Gilbert and others have their palatial "bungalows" resembling palaces on the lot. Greta has two rooms in the dressing barracks exactly like any contract player.

She does not carry a watch, but she knows when it is five o'clock. Out of the corner of an eye she sees her colored maid, Alma, hoist a mirror several times. It is the signal. Greta stops abruptly, smiles sweetly, and murmurs "Adieu" to the company. "Adieu," and she hurries from the set, bounds into the closed car that waits all day next the stage on which she is working. Without a word from her, the colored chauffeur starts the car as he hears her step in.

Once a supervisor smartly declared that he could get her to work overtime. He explained that there was a large crowd of extras costing the company money, and would Miss Garbo consent to remain. Miss Garbo bowed assent and remained. But she did not appear the next day or the next. "Sick," said Alma. Smart supervisors have not asked her to work overtime since then.

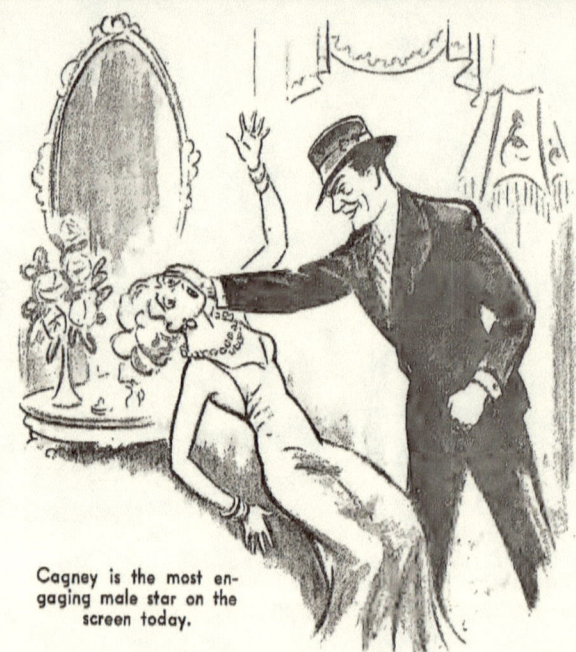

Cagney is the most engaging male star on the screen today.

SIMPLE, direct, natural, Greta is described as a child by those who know her best. She likes to laugh. Her humor is child-like. One of her favorite jokes, now, is a story about Mr. Jones, inebriated, asking a waiter if Mr. Smith had been at the restaurant that evening.

"He has," said the waiter.

"Well, what I came to ask is," hiccupped Jones, "was I with him?"

GRETA is an enigma to Hollywood. An atheist, you might say. She's indifferent to the local gods. She abhors notoriety and cares little about money. With the possible exception of Alice Terry, I do not think there has been an individual in Hollywood with such indifference to personal position. Greta, without striving, is an observer of that Hindu proverb which says: "Work for results but leave the results with God."

Hollywood, the artificial, suspects Greta of posing. Actually she is being herself while they have lost themselves long ago.

WHAT would you think if you were Greta's colored chauffeur and felt a warm nose cuddling your neck from the rear, just as you started the car for her ladyship? You'd probably collapse, as the chauffeur did. When he revived and rolled his eyes round, he beheld Buster Keaton's dog in the back seat. The door of the car had been left open to receive Garbo. Buster's St. Bernard likes to ride in nice cars, so bounded in. Being always on the alert for a soft step as a wordless signal, the chauffeur started the car, felt the kiss on the back of his neck, and passed out.

"Pardon me while I go knock myself out with a powder puff," said Bob Montgomery.

KIDNAPERS do not confine themselves to children. Buster Keaton's beautiful St. Bernard is always being stolen. Buster offers a reward, and the dog is brought home. Now there is an engraved collar on the dog's neck. It reads: "Leave this dog alone, and he'll come home."

MY desk is stacked with letters asking me to do something for my old friend Ramon Novarro. So I did. I lunched with him yesterday in his dressing-room.

Fans think Ramon has been getting a dirty deal. I agree with them. I've stuck a lot of feathers in the bonnet of Chief Thalberg, and so feel I have the right to pull a few out. Irving has not done right by Ramon. But, if you knew what Irving, a young, gifted and charming boy, has to endure, you would be more lenient.

Ramon himself is partly to blame. He agrees to stories for which he is not suited. Ernst Lubitsch once said to me: "An actor only judges a story by how many times he can go 'eeeee' and 'aaaaa'—do his pet stuff."

Ramon wanted to do that sap part with Greta in "Mata Hari." So don't blame Thalberg.

I admire Ramon. I know he could be second to none if he did the things for which he is gifted. But Ramon does not know himself.

For one thing, he wants to be operatic, when his genius is for folk songs. He can sing the ballads of Mexico as no one can sing them. He can lift trifles into art. But he wants to bellow like Tibbett. He wants to be the clown with the breaking heart, whereas he was born to be a gay troubadour —like Francis of Assisi.

FRANKLY, Ramon has irritated me. If I didn't like him so much as a person, admire him so much as an artist, he wouldn't.

Ramon, when I first knew him was unique. A poetic, sensitive, monastic person. They wanted to make him a successor to Valentino. The two fellows were poles apart.

In Defense of Garbo

I liked Valentino, admired him. He radiated an earthly warmth and heartiness. Ramon in his way was just as lovable. Devoutly religious, a Galahad of ideals, he reminded one of that gay Boulevardier, saintly troubadour of Assisi.

But Hollywood did not approve of Ramon's type. What he needed, they said, was sex, worldliness and experience in necking. In their egotism they supposed he had never had these educational opportunities. I read in one column that Ramon had just been educated to his first cocktail. I happen to know that Ramon knew more about wine and cocktails than the hosts who were educating him.

Ramon is plastic. He is easily influenced. He hasn't the stubborn integrity of Garbo. Well, Hollywood has succeeded in bringing Ramon out, as they call it. And they have succeeded in making him miserable.

Ramon loves his family with a pious devotion. That family has culture, tradition, idealism beyond the comprehension of Hollywood. Ramon never leaves the house without kissing his father's hand, his mother's brow. The life of the Samaniego family is a beautiful ceremonial. Having had the privilege of knowing it, I esteem it above the cheap worldliness of this wretched, corrosive Hollywood.

Ramon's mother is a woman of spiritual beauty and gifts. Three of his sisters are nuns serving the poor and the sick. Ramon's father is a don whose hand is worthy of being kissed.

How could Hollywood educate or "bring out" a son of such a family? How could they do anything but spoil him with their cheap gods?

I talked the other night on the telephone with his sister, Carmen, a beautiful, shyly lovely girl. She said, "We are worried about Ramon. He is so nervous. He works too hard."

So I went out to the studio to see Ramon and told him he had better get out of Hollywood, as Greta is getting, since the art of living is more important than the art of being a star.

RAMON has been bitterly hurt the last two years. Friends he trusted implicitly have turned on him. But Ramon does not grieve. That's the charming thing about him. Like *Scaramouche*, he can say, "I was born with the gift of laughter and a sense that the world is mad."

In fact, he did say, "You know our saving grace, Herb, is that no matter what happens we can always laugh."

Perhaps the Hollywood experience has been good for him. The superficiality may make him appreciate the wisdom and beauty into which he was born.

Ramon Samaniego is so much more important than Ramon Novarro, the movie star, that I know he will return to himself. I have never known a finer character.

JAMES CAGNEY, my favorite star, is at odds with Warners over his salary. Or is as I write this. He gets $1,400 a week. Ruth Chatterton gets $7,000. William Powell gets something like that.

Can you blame Jimmy? On the other hand, can you blame Warners? They are probably losing on Chatterton. Miss Chatterton may be a great technician. I've read that she is. But try to get me to see her pictures. I have no appreciation of technique and English accent—when spoken by Americans—and never could see anything but artificiality in the vaunted Chatterton.

Why contracts, anyhow? The rest of us don't have them. I wouldn't want one. If I don't earn my money, I want to quit. If I'm not getting what I'm worth, I want to quit too. The same should go with actors.

Cagney is the most engaging male star on the screen today. He should get more. And he'll get it. He's a great gangster.

I'M glad Doug Fairbanks, Jr., has got over his adolescent regard for the Barrymore manner. He's great in "It's Tough to Be Famous." Mary Brian, too, is a surprise. Now if Joan Crawford would forget her eyebrows and diction, if Norma Shearer would overcome her giggle, if Novarro would only sing, if Marlene Dietrich would get another director, if Beryl Mercer appeared in more pictures, if Pola Negri got a real part, if Jeanette MacDonald and Ramon Novarro did "The Merry Widow," if Loretta Young would learn to act, if Clara Bow would come back, if Marie Dressler would hurry along with the "Tish" story, if Universal would make a great picture of that great story, "The Road Back" by Remarque, if Garbo got a really great part, if Lupe would only come back to mamma and me, what a gay old world the screen would be!

ON the set with Bob Montgomery: Bob said, "We actors must toil and suffer and give up our private lives. And what do we get out of it?—a fortune!"

With a loud laugh, Bob adds: "Pardon me now while I go knock myself out with a powder puff."

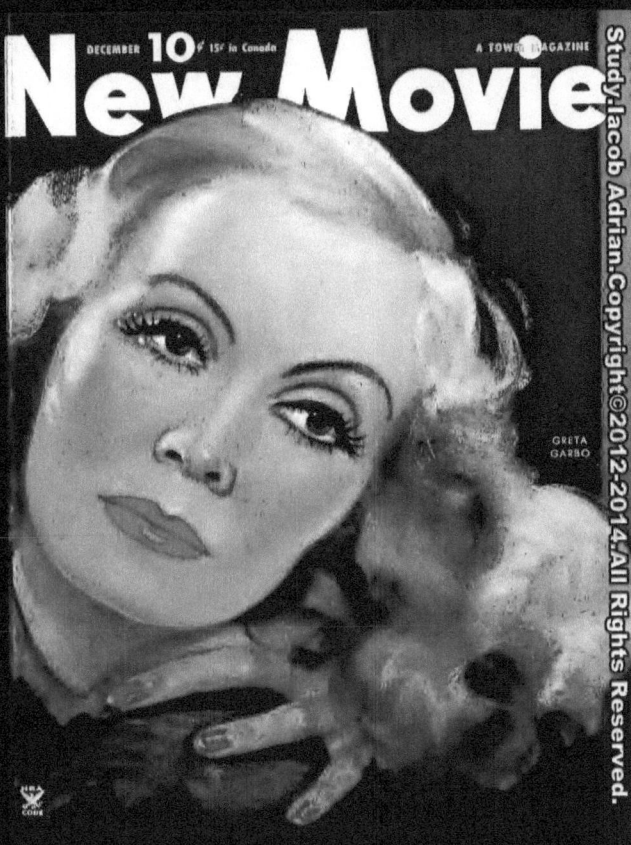

HOLLYWOOD'S BATTLE OF THE AGES

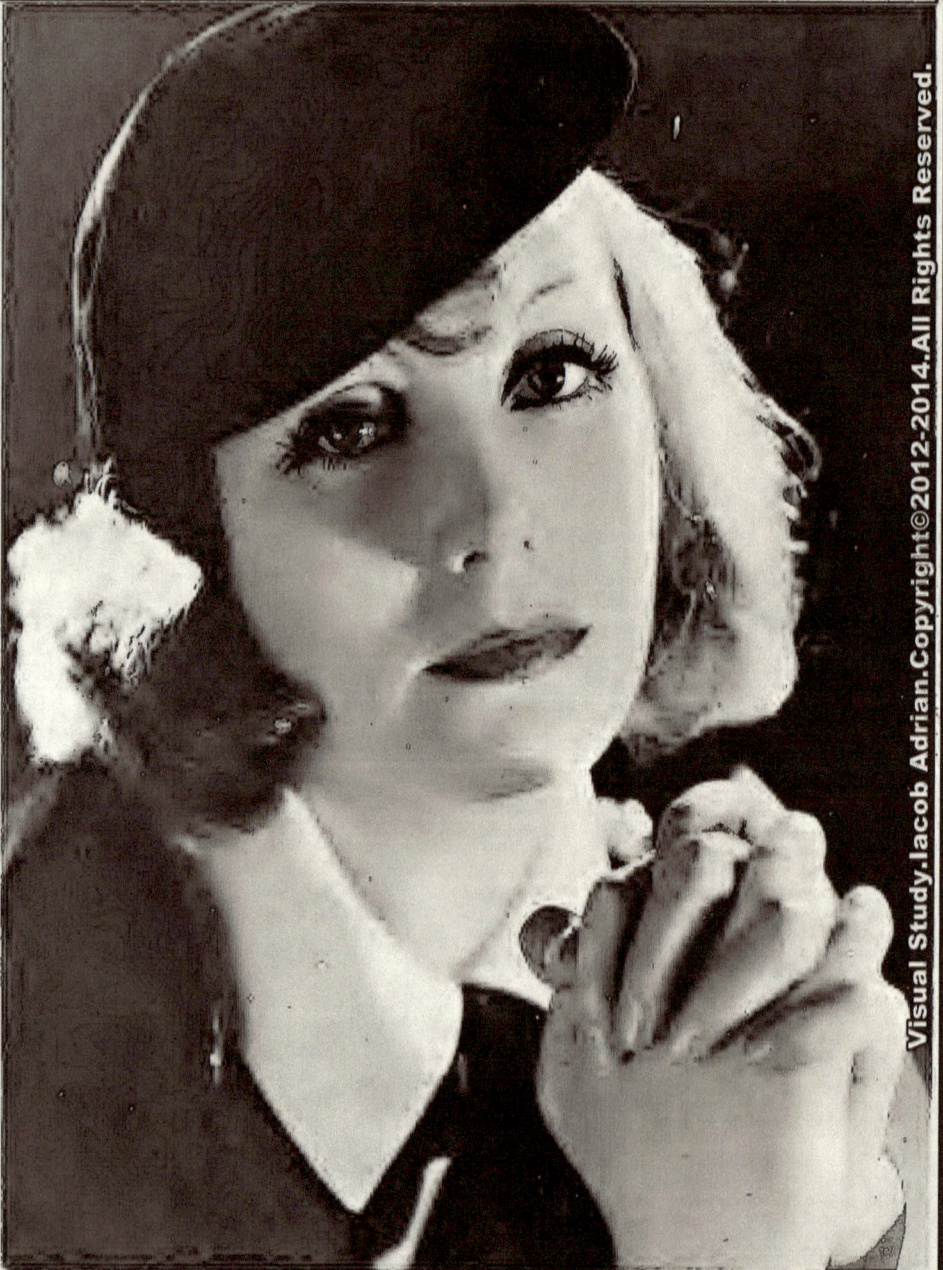

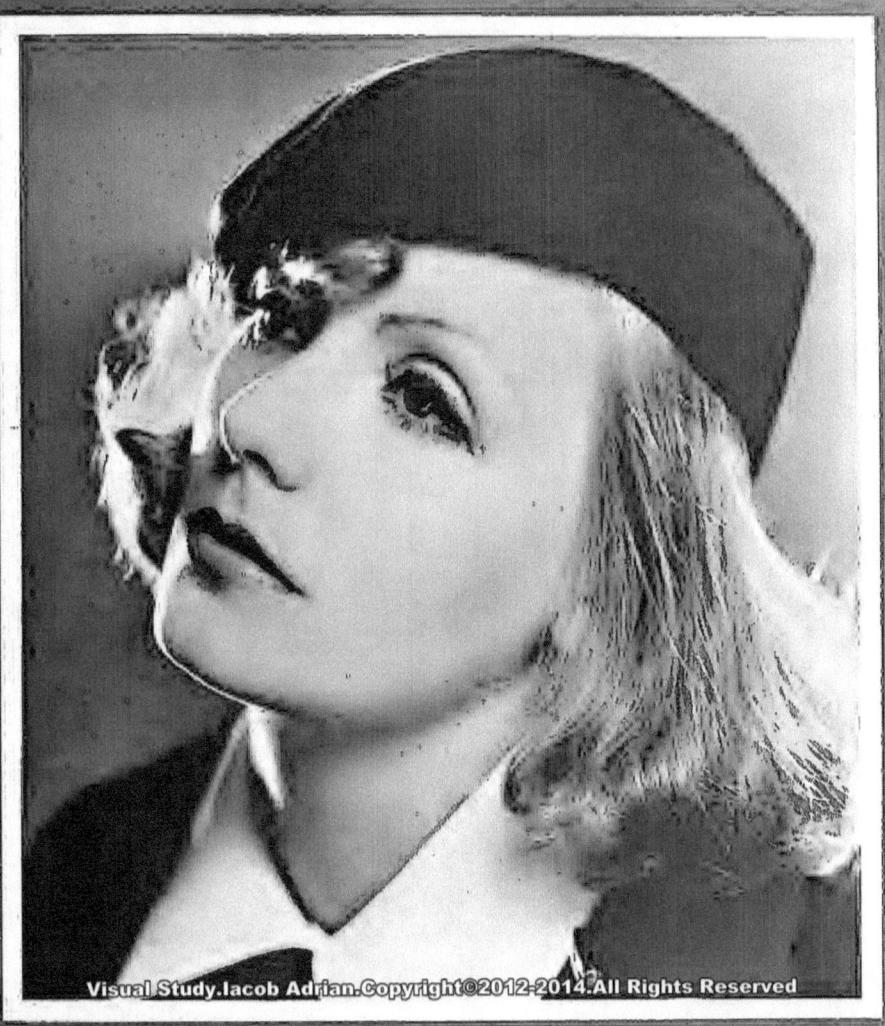

Do frantic directors fuss, fidget and foam?
Our Greta says calmly, "Ay tank ay go home!"

Do contracts displease? With a shake of her dome
She alters the terms with "Ay tank ay go home!"

Do suitors propose in the glimmering gloam?
She gives them the gate with "Ay tank ay go home!"

It's rumored she'll stay, and it's whispered she'll roam,
Well, what does she mean by "Ay tank ay go home!"

Is "home" built on Swedish or Hollywood loam?
All Greta replies is "Ay tank ay go home!"

Should Greta quit—millions, from Capetown to Nome,
Will say "Nix on movies! We tank we go home!"

By
BERTON
BRALEY

Is GARBO

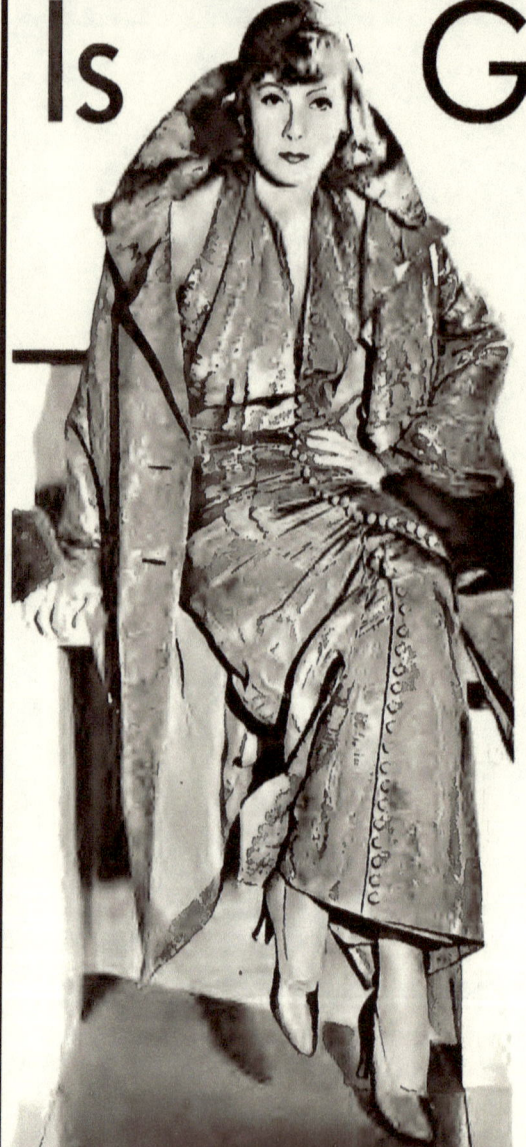

MARY MARGARET McBRIDE

discloses for the first time the real facts about how much money the world's highest salaried film star has earned and saved

AN unknown girl from Sweden went to work on the M-G-M lot in Hollywood seven years ago at a salary of one hundred dollars a week. This year her salary from the same company was six thousand dollars a week—one thousand dollars for every working day. And she has just accepted a new M-G-M contract under which this salary will be more than doubled.

In other words, when Greta Garbo, the girl who started in Hollywood at one hundred dollars a week, goes back to work, she will be making twelve thousand, five hundred dollars each week.

Is Garbo broke?

There have been various rumors alleging that in spite of her tremendous income, she had lost so heavily in unfortunate financial ventures and speculations that much of the sum she had made was swept away. Because of these rumors THE NEW MOVIE MAGAZINE undertook the mission of obtaining from the most authoritative sources possible the exact facts as to Greta Garbo's financial position today—and is able to present for the first time the truth about the actual money earned by the world's highest-salaried film star—and how much of that money she should now have.

Broke? Not Greta Garbo!

A thrifty Swedish girl is Greta, who learned long ago in the hard school of poverty that when you earn a dollar (or its equivalent in any language), the canny thing to do is anchor half, or even more of it, in some good safe place. That is what Greta, bolstered by the sage advice of Harry Eddington, her manager and agent, considered by many the shrewdest business man in Hollywood, has done during the seven years since she came to America in search of fame and fortune.

And so today, in spite of panics and bank failures, and contrary to busy rumor, Greta Garbo is a rich woman by the standards of any country.

The glamorous Garbo went on the Metro-Goldwyn payroll as a green, naïve unknown at a salary of one hundred dollars a week. This was on September 10, 1925. As motion picture pay went, one hundred dollars was not much, but they didn't know much about Greta in Hollywood then. Or, rather, only one man among them knew about her—Mauritz Stiller, the director. It was he who really gave Garbo to America, for when he had an offer from Samuel Goldwyn to come to this country, he refused to cross the ocean until his protégée was included in the contract.

One hundred dollars looked big to the Swedish girl then, for she knew no more about Hollywood and its huge pay checks than it knew about her. She learned rapidly, however, so rapidly that after "The Torrent," her first picture, was completed on December 23, 1925, she demanded and received a raise to two hundred and fifty dollars a week. She obtained another small increase after she did "The Temptress," and at the end of "Flesh and the Devil," her first picture with John Gilbert, she was getting five hundred dollars a week and earning every cent of it as a box-office draw.

By that time she had realized her own value, and before anybody knew what was happening, she had staged a strike—terms: more pay or no work. The

BROKE?

strike went on, too, until early in 1927, when the studio tore up her old contract and made a new one calling for twenty-five hundred dollars every week in the year. In the meantime, Eddington, whom she met through Gilbert, had become her manager.

That contract expired this spring, and according to the best authorities, the star has been paid six thousand dollars a week for some time. Most of this money went into Government bonds and savings banks. The beautiful Garbo is remarkably sagacious about money—she has *had* to be—and there is no danger of her risking all her eggs in one basket. She was not partial to large checking accounts, for she wanted to see her money working for her and, anyway, in contrast with most motion picture actresses, she needs no very large cash amounts, for she is not a prolific spender.

Her losses in the Kreuger stock we have heard so much about were small—not large—and made no perceptible dent in the fortune, estimated at more than half a million dollars, she has piled up in this country.

And now, at last, Garbo has carried out the threat she has made so often and has gone home. She is coming back in a few months, however, to a new contract with Metro-Goldwyn-Mayer, which I am reliably informed calls for the sizable salary of twelve thousand, five hundred a week.

And so the star's jaunt, in spite of the conclusions jumped at by sensation-seekers, was not caused by a disagreement about money.

Ivar Kreuger, the Match King, who many people thought cost Garbo a fortune in his disastrous speculations, and his summer estate, "Anxholmen," near Stockholm, which it was reported Garbo had bought.

Is Garbo Broke?

She went home to rest, just a working girl on vacation, and when her holiday ends, she will come back to her job.

Though it was the most natural thing in the world for Miss Garbo to go home in the interim between winding up the obligations of an old agreement with her studio and taking on the duties of a new one, there was an additional and weightier reason for her journey at this time.

For some months, although letters from across the water were cautiously worded for fear of alarming her unduly, Greta has been worried about her mother's health. That worry alone was enough to send this devoted daughter hurrying across the ocean as fast as a high-powered liner could carry her. You see, she has known two heartbreaking bereavements in the death of her father and her sister.

Originally there were five Gustaffsons (Greta became Garbo merely for the sake of brevity and euphony)—father, mother, two daughters and a son. The father died before Greta finished primary school. There was no money so the older girl, Alva, and the boy, Sven, got jobs at once.

Their little sister, eager to do her part to lighten the family burdens, insisted upon leaving school and finding work, too, though they begged her not

thing to aid her in getting the training she needed to realize her lifetime ambition to act. The sensitive, seriousminded girl appreciated their desire to help but was determined to look out for herself.

Alva was Greta's idol. "My little sister," Greta called her, though Alva was nearly four years older.

The big brother Sven, although only two years Greta's senior, bravely tried to take his father's place. Anna Gustaffson, the mother, cheerfully made a home for them all, trained them to be content with what they had and above all, was the perfect companion to her children.

She made their interests hers, walked with them, listened to their confidences, even fished with them in the clear Stockholm streams—or at least sat on the bank and applauded while they to for they were ready to sacrifice anyproudly drew in their catches. Evenings, Greta or Alva generally read aloud to the others, while the busy mother sewed or mended.

There was great rejoicing in the household when the younger girl got a chance to attend the Royal Dramatic Academy and the four Gustaffsons celebrated every small success of the girl in her early stage work.

When finally there came an offer,

The NEW MOVIE MAGAZINE

10¢

GRETA GARBO by

The FASHION REVOLUTION in HOLLYWOOD

ADELA ROGERS ST. JOHNS · HERB HOWE · HUGH WEIR · HOMER CROY
THYRA SAMTER WINSLOW · WALTER WINCHELL · DICK HYLAND

Is Garbo Broke?

through Mauritz Stiller, for Greta to go to America, they were sad, yet thrilled. America seemed very far away but that must not be allowed to stand in the way. They sorrowed because they must give her up but they felt it was her great chance.

They were right, as the whole world now knows, for Greta Garbo has had not one failure in all her American career. The shy, plainly-dressed Swedish girl came, saw and conquered, learning the English language and the technique of the screen with a rapidity that amazed veterans. More important, audiences took her to their hearts—she became a box office draw overnight.

Then just as she was beginning to taste the triumphs of which she had dreamed, sorrow invaded her life for the second time. She was in the midst of making "The Temptress" when word came that her sister had died of anemia.

It was all the greater blow because Greta had planned and hoped that some day the adored Alva might join her in America and perhaps act with her in an American-made picture as she had once done in a Swedish film.

Greta was denied even the small consolation at this time of instantly rushing home to her mother and brother. There was work ahead that she was contracted to do and she must stay. She felt the separation from her loved ones even more keenly after Alva's death and they missed her doubly now. Besides, the mother was constantly uneasy about her younger daughter. She expressed more than once a fear that Greta would diet and break down her health.

When new pictures of her daughter arrived, she scanned them anxiously and felt worried, because to her motherly eye, the girl looked too thin. It was true that at sixteen, Greta had the sturdy, solid outlines of the typical Swedish girl, and that in America, she had grown almost ethereal.

Three years passed before the star found it possible to go home. She sailed then, to be met in Sweden by a welcome so tumultuous that the police had to be called to protect her from the enthusiasm of her well-wishers to many of whom she was already a legendary figure.

That homecoming was a happy one, but it lacked some of the elements that made the more recent one so momentous. The Swedish people have always loved and been proud of their ambitious countrywoman but the intelligentsia at first were cautious, even a little suspicious. They had an idea that the furore about Garbo was the result of wild American advertising.

Satirical poems and cartoons expressing this doubt appeared from time to time in the more aristocratic and conservative papers.

To them she was still the little girl from the south side whose head would undoubtedly be turned by all the fuss and nonsense.

This time, though, it was very different. When the Swedish S. S. *Gripsholm* drifted into the dock at Gothenburg with Greta standing, starry-eyed on the top-most deck, cameramen and reporters from all over Europe were waiting, and prominent in the expectant group were journalists representing Stockholm's most staid and highbrow press.

Moreover, such sheets opened their

Is Garbo Broke?

front pages to her and welcomed her with warm words of appreciation and approval. The little girl from Stockholm's south side, they acknowledged, had won out. They acclaimed her as a great lady and a great artist.

The Socialist paper which gave only a stick or two of type on an inside page to the marriage of the king's grandson, ran a lay-out of pictures and a two-column story about Greta on the front page.

One of the most dignified sheets said her fame could only be compared to that of Cleopatra, Queen Elizabeth of England and Madame Pompadour!

When she was ready to land, the actress was still in such a joyous mood that after she had kissed her brother and inquired about her mother and nephew—"is he handsome, the little rascal?"—she broke her invariable rule and granted an interview to the press. Sitting in the grand salon of the *Gripsholm*, a gray beret topping her long, blond bob and a gray cape thrown about her shoulders, she faced the palpitating reporters, her blue eyes half-amused, half-frightened.

"This is terrible," were her first words as she glanced expressively at the array of cameras. That broke the spell and she was deluged with questions in several languages. Why had she come to Sweden? Was she going back to America? Would she play in Germany? In London? Was she going to buy the beautiful summer estate of Ivar Kreuger which includes four islands in the Stockholm archipelago?

"I have come home to rest," Miss Garbo answered firmly to the first question, adding, "that is, if there *is* rest for a restless soul." To most of the other queries, she vouchsafed only a cryptic "perhaps" or "I don't know."

She waxed really eloquent, however, when one reporter asked if she did not dislike publicity, impertinent cameras and persistent reporters.

"I should think so," she said emphatically. Then she went on to relate that the dark glasses and the cape over her head in which she was reported to have arrived in New York were inventions of the same gentlemen who "have made me make misstatements about the essence of love, analyzing Goethe and my early life. The truth is that I have never written a word for any publication, although many words have appeared under my name."

Later, she motored away from Gothenburg in a sports roadster driven by her brother, and her vacation was declared officially begun. And, such is the understanding and sympathy of the Swedish people for one who comes to their country seeking privacy that having greeted her, they turned to other things and let her enjoy her holiday in peace.

It was well-known that she was staying in the Province of Warmland, home of the writer, Selma Lagerlof, with her friend, Mimi Pollack, a Swedish actress who was a fellow student at the Royal Academy in Stockholm, but the sightseers kept away. Meantime, Mimi's husky husband constituted himself Greta's bodyguard to make sure that her seclusion should not be invaded.

This brings us by a simple and natural route to an explanation of Greta Louvisa Gustaffson that apparently has never occurred to any except the Swedish mind. Americans somehow find the desire of a star for privacy entirely unique. They can never quite believe in it—suspect her of posing, of trying a new publicity stunt.

The Swedish attitude toward Miss Garbo and her career is well illustrated by the story of Einar Widbeck, the Stockholm barber for whom the star worked in her first little-girl job.

When the Garbo picture, "The Rise and Fall of Susan Lennox," opened at the Metropole Cinema in London, officials of the theater took a leaf from the book of their American cousins and decided upon what they thought would be a wonderful publicity stunt. They cabled Einar and invited him to fly over at their expense to be present at the opening. The barber got the cable, read it thoughtfully and—declined to go. He feared it wouldn't be respectful to Miss Garbo and her art!

Probably the star wouldn't have minded if he had gone. She is not in the least ashamed of the early poverty which caused her to take a perfectly respectable job in a perfectly respectable barber shop.

And whatever else it is, the source of her desire for privacy is *not* highhattedness. Garbo is friendliness itself to those she likes and she likes many people of all classes and kinds—but usually only when she has made their acquaintance of her own volition.

Not long ago, while riding in the park—this was in California—she encountered a group of visiting Swedish cavalrymen, hailed them and rode along for a while talking amiably.

Returning from that other visit to Sweden, she struck up a boat friendship with the wife of the Swedish aviator, Einar Lundborg. The last of the voyage she said to Mrs. Lundborg, a simple, kindly Swedish woman, "Tonight I shall be sitting alone in my hotel room, for I don't know a soul in New York. I think I shall feel like throwing myself from the window!"

She knew she would be lonely but apparently it never occurred to her that anyone of hundreds or even thousands would have been proud to have her as a guest that night. Or perhaps it did occur to her but failed to change her feeling since all these hundreds would have been "strangers" in her sense of the word.

I knew a woman who was once the star's next door neighbor in California.

"Although I have seen Miss Garbo run and hide behind a tree when a group of strangers approached, in our infrequent encounters I found her to be friendly and charming," this woman told me. "As a matter of fact, once or twice we leaned on the back fence and discussed rose bugs and fertilizer. I think she realized that I had no desire either to pry or spy and so she was willing to come more than half-way in neighborliness. She is not in the least unfriendly—she just feels strange in crowds."

In her own country, I imagine, Greta does not feel strange, even in a crowd. Her people understand her as we perhaps never shall. But we feel a sense of part ownership, for, in return for the pleasure she has given us, we have made her what she is today—a rich and successful woman.

THE NEW MOVIE MAGAZINE'S

GALLERY
OF
STARS

Garbo, as the Swedish queen who was crowned "King," who abdicated her throne to marry the man she loved—Garbo, the Magnificent. This is her latest portrait, the first one made of her in more than a year.

CHRISTINA

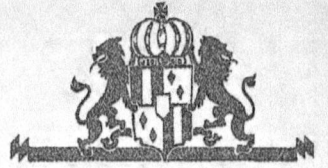

I Loved Garbo

BY HUBERT VOIGHT AS TOLD TO GURDI HAWORTH

HE sat behind his desk. On his wall hung a study of Greta Garbo, autographed by her. On his desk, a photograph of himself with her.

"You want the story of Greta Garbo as I knew her" said Hubert Voight, veteran publicity man—the first man to welcome Garbo to America. "I don't know that people want to know her as she really was—and as she is. They prefer keeping her the world-weary Grusinskaya . . . but the Garbo that I knew is not so."

I could not conceal my interest. . . . Here was someone who had been with her every day of the first six weeks that she had spent in America . . . who had eaten with her, taken her to theaters, laughed with her, joked her out of her famous moods. Here was one whose opinion of the "terror of all journalists" was worth while.

"In August of 1925," stated Hubert Voight in a low voice, "I had just been given a job by the Metro-Goldwyn-Mayer Company as their news service man in New York. You know the sort of person who meets people coming in from the European countries and extends them welcome.

"I was sitting in my office one day when there came a telegram which read:

'STILLER ARRIVING GRIPSHOLM ACCOMPANIED BY GRETA GUSTAFSSON MEET THEM AND EXTEND COURTESY.'

"No more than that. I, only, knew about it. No one else cared. No one paid any attention when I suggested a welcoming party . . . there was no fuss . . . no flurry. This girl was unknown here and certainly not well known abroad . . . had I not been so young, so enthusiastic I would never have called the newspapers as I did, nor would I have hired a cameraman to go to the dock with me . . . it was only to make an impression, that last, as I all too well recall . . . I just wanted ten dollars worth of pictures. No more, no less. I had a young girl named Gympt go to the boat with me to act as interpreter. So Gympt, the ten-dollar cameraman and myself went down to the dock.

"AS the boat came parallel with us, they started to play the Swedish anthem. Something stirred within me. I had a sense of a thing inexplicable. I looked up at the top deck—I don't know why . . . but I looked up there and I saw the loveliest young girl dressed in a suit of huge black and white checks. . . . I was thrilled. Beside her stood someone massive and portentous in a heavy cap and heavy coat.

"I turned to my cameraman and said, 'I don't give a damn whether that girl is Greta Gustafsson or not. . . . I am going to find out who she is.'

"I ran as fast as I could up the gangplank with Gympt and my poor little man at my heels. . . . When I got up to the top deck, I stopped short. The girl in the check suit was gazing, enraptured at the skyline. And the Statue of Liberty. She was tearful with emotion. I spoke to the man. It was indeed the great Stiller. And this was his little protegee. Garbo turned to me. We were introduced. She smiled and said something in acknowledgment in Swedish. She had a lovely smile."

Here my narrator became dreamy and quiet. After a moment he said:

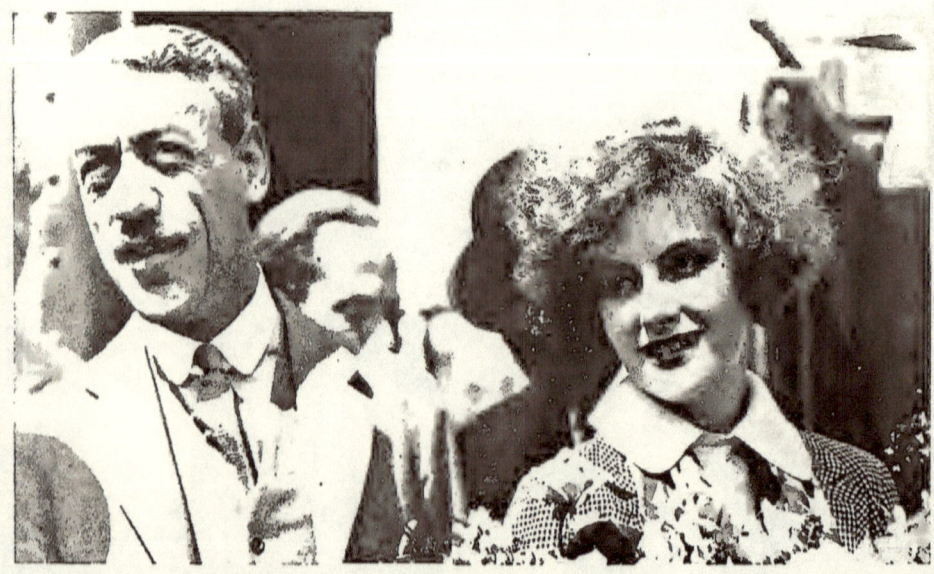

Garbo and Mauritz Stiller as they were greeted on their first day in Hollywood.

The dramatic story of the young man who first welcomed Garbo to America and his experiences with the woman who was destined to make a world worship at her feet

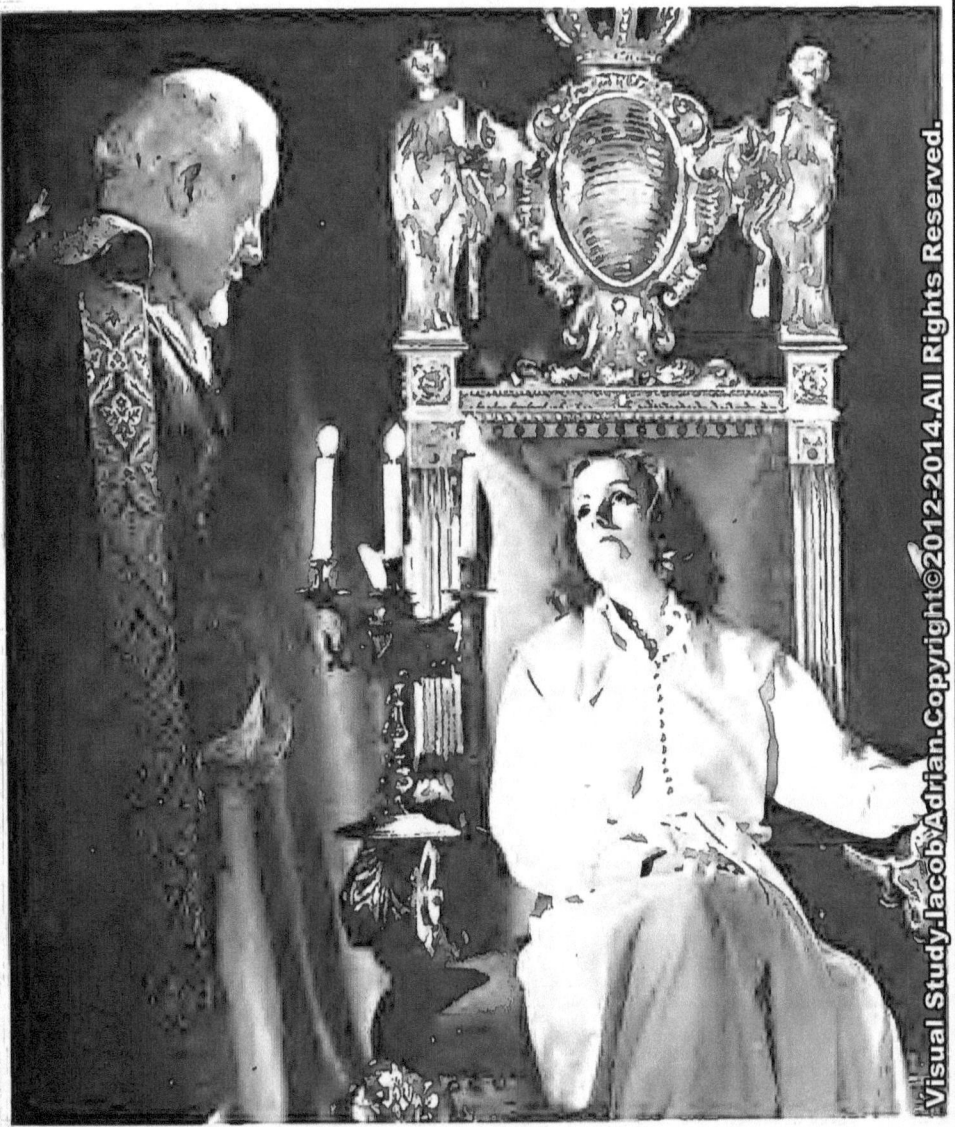

Lewis Stone and Greta Garbo in her new M·G·M picture "Queen Christina."

"She didn't say much. Just kept looking at me round-eyed while I spoke with Stiller. Finally she turned to my interpreter and she said:

"'Mr. Voight—tell him he looks just like Richard Barthelmess.'

"Gosh, when she said that, I thought she was simply swell. Anyway we stood there a moment and finally I thought it best to take them to a hotel, so I called an old cab waiting down below and drove them to the Commodore Hotel. . . ."

He laughed hard and protractedly at that recollection.

"THE Commodore's all right . . . but it is so funny to think of Garbo in an old cab in a black and white checked suit going to the commercial place that it was . . . you, know the sort of places the movie stars always go. . . . I remember on the way there, she wanted to see the Woolworth Building . . . she had heard of it and was so impressed when she saw it. I painted a swell picture

I Loved Garbo

of New York for her. She had tears in her eyes over the big buildings, but Stiller was placid and hunched down in his seat, in the corner.

"She thought I was a lot of fun. I think it was probably because I was the first American boy she had ever met . . . she was such a kid . . . about nineteen, I think. I got them all settled at the Commodore and then I went home. I couldn't sleep. I could feel her power even then."

He lit a cigaret quickly.

"The next morning I began talking about this girl. Everyone treated it as a big joke. They told me not to get infatuated with immigrants right off the bat. They all thought it was just because I was so new in the game that I should like this—they couldn't even think of her last name. Finally, I persuaded one person, Gladys Hall, to interview her. It was certainly an inspiring interview . . . all that Gladys could get Greta to say was:

" 'Mr. Stiller, he is a great director.'

"This Stiller had the biggest hand. The biggest one I'd ever seen. But then everything about him was tremendous. He had a great soul. And if a young girl like Garbo loved him, it is understandable. As I look back on it and think of her expressions and her mannerisms when near him, I recall her as being decidedly filial and most reverential.

"GARBO got sick with a cold. You see she had worn a heavy suit, and I think that it was the only one she had . . . we took her to Coney Island after she begged us for two days. She wanted to ride on the rollercoaster. She stayed on the darn thing for almost an hour. I was nearly broke. She ate all sorts of hot dogs and popcorn and taffy and she shouted like a little boy over the different amusing things there . . . because of the cold she got that night, she was in bed for several days. But I had made an appointment with one man named Roberts to have an interview the following morning. I had got down on my knees and begged him to do it . . . we took along a little interpreter and went to Garbo's hotel. We knocked on the door, but she did not answer. We pounded. Still no answer . . . my heart was in my mouth. I was crazy about her and I thought of all sorts of things she might have done on account of some mood or other . . . Finally I shoved the door and it opened just so far where a chain lock held it.

" 'Greta!' I called. Then I looked in. She was sitting in bed reading calmly. . . . I told her why I had come, and explained that she must stay in bed and have the interview there. She finally glanced up at me over the top of her magazine. Her eyes looked very blue and clear.

" 'Hoobert . . .' she said. 'Hoobert, go avay, and stay avay!'

"I pleaded and cajoled until finally she nodded her tousled head. She nodded it, but we had the interview through the crack in the door. Then it was that I saw her 'I tank I go home' attitude for the first time . . . she simply crawled into her shell. She had moods occasionally that were frightful. They made her miserable, and me miserable, and everyone else . . . but she made up for them by the highs she

hit later . . . she would be so rollicking and so much more fun that I got so that I didn't mind them at all.

"When she got better, she wanted to go to the theater, so I took her to see 'Valencia' . . . Garbo started to hum the tune when we left the theater . . . she was singing it furiously by the time we got home . . . she loved that song. She doesn't sing very well either. I would try to divert her, but she sang on and on. She loves jazz. Well, then she wanted to go to the theater every night. I didn't have an awful lot of money, but I didn't care. She was worth every worried hour I spent with her. She was a marvelous companion.

"I introduced her to my boss, Dietz. But he was unimpressed. He just thought that I had fallen for this gal, hook, line and sinker . . . I phoned Nicholas Schenck and asked him if he wouldn't like to meet Garbo. She was Garbo by that time, you see . . . but Mr. Schenck said 'No-thank-you-he-was-much-too-busy.' Besides, he added, he had seen Miss Garbo in the lobby of the hotel and that was sufficient."

He looked very earnest when he made the following remark:

"I had such faith in her, you see . . . such faith . . . She was lovely and sweet, and her way was the way of a great woman. I couldn't believe that she was mere excess baggage in the Stiller contract—or if she were that she'd stay that way long . . .

"As I said, my resources were getting low. I had little or nothing, but finally I persuaded a photographer to make some pictures of her. The photographing took place in her hotel room. The photographer was Russell Ball. He was highly skeptical when I told him of my desire to have him make pictures of her—but when he saw his subject, he changed his mind. He saw greatness in her. He exclaimed later over her wonderful mobility of expression.

"The little Garbo went through her poses with much enjoyment. Finally, Ball said that he would like to do her in something colorful, but neither of us could speak Swedish and she could not speak much English, so I did a little pantomime, wrapping myself up in air and doing a Spanish dance and pointing to all the bright colors in the room . . . all to her dark amusement. Then as if she understood right from the start, she nodded very sagely and left. Ball and I chatted and he let me understand that he, too, was interested in helping this girl. We were deeply immersed in conversation when Garbo appeared in the doorway. She was very amused at herself and she had every right to be. She was like a child in her joy. She was wearing a veil of gossamer-like material—very alluring, and but for that had nothing on but her skirt. Those pictures were later used in *Vanity Fair*.

"She was so eager . . . she even went to Weingarten's, the inexpensive clothier in New York, to pose for some publicity pictures . . . they are in the *Times* morgue . . . someone ought to retrieve them . . .

"The time for her departure was growing to a close . . . we spent many days in conversation . . . I wanted her to understand a few words of English . . . she tried hard and did learn a few.

"She left.

"I didn't see her again until June. But a funny thing happened when she first got out to Hollywood. She was discussing her contract with Mayer and she asked him please to send the car around for her at seven every morning. Mayer, a bit bewildered, asked her what car. Garbo retorted, the car that every contract player received from the company, of course. She was a nice, naive person . . .

"I was sent out to Hollywood on a vacation that June. I thought of her all the way out. People said she was unapproachable, stern, haughty . . . I didn't think I wanted to see her . . . it was because I had cared and I did not want to be disillusioned . . .

"I went on her set, however . . . she was doing a garden scene . . . the picture was called 'The Temptress' . . . she was high above me . . . I was below. And I thought:

" 'It's funny . . . I stood below her once before. I stood watching her the same way, as she stood on the top deck. But before she was nobody and now she's the Great Garbo' . . .

"I can't tell you how I felt . . . I felt—oh, gosh . . . And while I stood there, John Gilbert, for whom I had done publicity work while in New York came past me. He didn't see me. Well, maybe, he didn't see me . . .

"FRED NIBLO, the director, stood beside me. Garbo came down the stairway. She threw a cloak around her shoulders and walked quickly past me. I wanted to run away and cry like a kid. We had been such grand friends. I took off the dark glasses I had worn—my eyes are sensitive to movie lights. Suddenly I heard this voice,

" 'Oh, Hoobert! Oh, darling! Oh, Meester Voight!'

"I felt dizzy and Niblo was staring at me. She threw her arms around my neck.

" 'Oh, but dis iss fine!' she cried happily. 'Meester Niblo—feex it up with the cameraman to take us a picture for a memory.'

"That's how I got that picture on my desk . . ."

He gave it to me. There sat the queenly Greta very much astride a ladder with Niblo and myself . . . Her face was piquant and joyous . . .

"I remember," he went on. "I remember I told her that she spoke English very well, and she was so pleased . . . she had worried, she said, about that . . . as I was recalling some of the fun we had had together in New York, she said, very sadly and with a little look of loneliness buried in her eyes:

" 'I am so unhappy here, Hoobert, I theenk I would like New York.'

"I went home soon after our meeting, and I didn't see her again until the following June. Then I received a cable that she was coming from Sweden, after her vacation. Every one of those persons who had conscientiously refused to meet her on her first trip, simply begged me for cutter passes. I got Schenck one . . . I liked the irony of the idea . . . he bought her a huge bouquet of flowers and trotted alongside like a schoolboy. He could hardly speak when he met her. But Garbo was wonderfully calm and collected and well-mannered.

"I got her a suite free at one of the

I Loved Garbo

larger hotels in the midtown section."
He stopped suddenly as if perplexed over something or other . . .

"I think she was a recluse then . . . she was sort of strange about people . . . they had been cruel to her, don't you see? Well, I phoned her about five o'clock of the same day, and she was in bed.

"'There are a lot of people who want to see you and to talk with you very much, Miss Garbo,' I said. 'In fact, they very much want to talk with you . . . they want to do a lot for you . . . they are going to take pictures and write beautiful things about you—'

"She was laughing when she answered.

"'Oh, poor Hoobert . . . I am so popular now . . . with all dees people and I do not want to be popular . . . make them go avay like a goot boy and we will go out later . . .'

"'Miss Garbo,' I put all the tears I could into my voice . . . I pretended that my life just hung on getting those interviews, so I said:

"'Miss Garbo, I am going back to my boss and tell him that I have failed to get three little interviews . . . I feel just like you when you are told that you are not capable of playing a part that you very much want to play . . .'

"'But Meester Gilbert, he does not have to have interviews . . .'

"I said nothing.

"There was a long silence over the other end of the wire . . . then came a deep sigh.

"'O.K. Hoobert, I do it for you—but not for Meester Metro.'

"I kept those interviewers waiting on pins and needles. Those interviews later were classics. The poor victims who wrote them were shot through the ordeal before they knew what had happened.

"WELL, then later we went to an apartment where Lawrence Tibbett and his wife and Margaret Sangster, the poetess, were being entertained. Here Garbo threw off her reserve in the center of all these charming people and laughed with more gaiety than the rest . . . this is sort of cute: she got a wee bit tipsy on champagne and she was singing in Swedish so adorably that everyone was excruciated . . . I sat there watching her . . . I saw a new sophistication—a polishing off of the rough corners, but there, underneath—not bothering to remain hidden, was the real Garbo . . . a marvelous friend . . . and a child of the sun . . . and of joy . . . she was the most beautiful creature I have ever seen that night . . . simply shining with life . . .

"Afterwards, she wanted to walk home . . . but she hadn't made ten steps before she was mobbed. I shoved her into a cab and we drove her to the hotel. She crouched in the corner with her eyes moody and unhappy . . . it was such a contrast to the light dancing person . . . my heart bled for her future.

"Several nights after she was preparing to go home, so I helped her pack her bags . . . she had among other things some Swedish money which she wanted to have exchanged for American. I went out to take care of it for her but the only way that I could cash it at that time of the night was to lose one-twentieth of its value. I guess I couldn't have done any better in the day time either . . . this would not be necessary in California. When I told her this, she said, 'O.K.' and then she added, 'I have yoost enough for meals on the train . . . I'll save the ten.'

"On the way out of the hotel, she asked me how much she should tip the girls at the desk. I answered:

"'About five apiece. Write them a check for it . . . they'll frame it.'

"'Oh, Hoobert,' she cried gleefully. 'You give it to them! They'll like it much better coming from you!'

(Oh, thrifty Swede!)

"All the way down to the train she sang, 'I can't stop lovin' that man'—she had heard it in a speakeasy the night before.

"Before she left, however, she had contracted a bad sinus cold . . . she had to have a certain kind of light to afford herself any relief . . . I bought her the light, and had it put into her compartment with a special plug made and fitted into the wall . . . also, I remember, she begged me to get her a Swedish version of 'Anna Christie.' I could buy only an English version, so I had the little interpreter who had gone to the boat that first day translate it into Swedish for her . . . I wonder if she still has that . . ."

He seemed steeped in memories . . .

"You see," he said softly, "I don't know this person they are talking about today . . . I only know yesterday's Garbo . . ."

He looked at me strangely . . .

"SHE was so human . . . that second time, when we met her at the boat . . . I had given a pass to a little girl of ten, who had made a beautiful scrap-book of Garbo with her clippings and pictures in it . . . every clipping ever printed about her in New York City . . . she even had her name worked in colors on the crocheted cover . . . I had given her this pass so that she could see Garbo close. As we were going to our car, I saw this little eager face peeping out among a lot of people. I called the guard and had him bring the child over. Her face pale with excitement she gave the book to Garbo . . . Garbo smiled at her, and her eyes were very wet. The little kid gazed frantically at me, then at Schenck and then at Garbo . . . she fell in a dead faint on the concrete . . . the thrill was too much for her . . . later we learned she refused to eat her breakfast, she was that afraid of missing Garbo. The latter knelt beside her in her expensive fur coat, impervious to staring eyes and rubbed her temples with the water the guard brought . . . When the little girl recovered she reached for her beloved book, her eyes never leaving Garbo's face.

"'Yoost one minute,' Garbo said. 'Giff me a pen somebuddy . . .'

"She wrote her name in big letters across the first page . . . that is the end of my story . . . that is all I can tell you . . ."

The telephone rang. I walked to the door. There I turned around and glanced back. As he carried on the conversation, his eyes were fixed on a picture of a young girl laughing up at him, gaily astride a ladder . . .

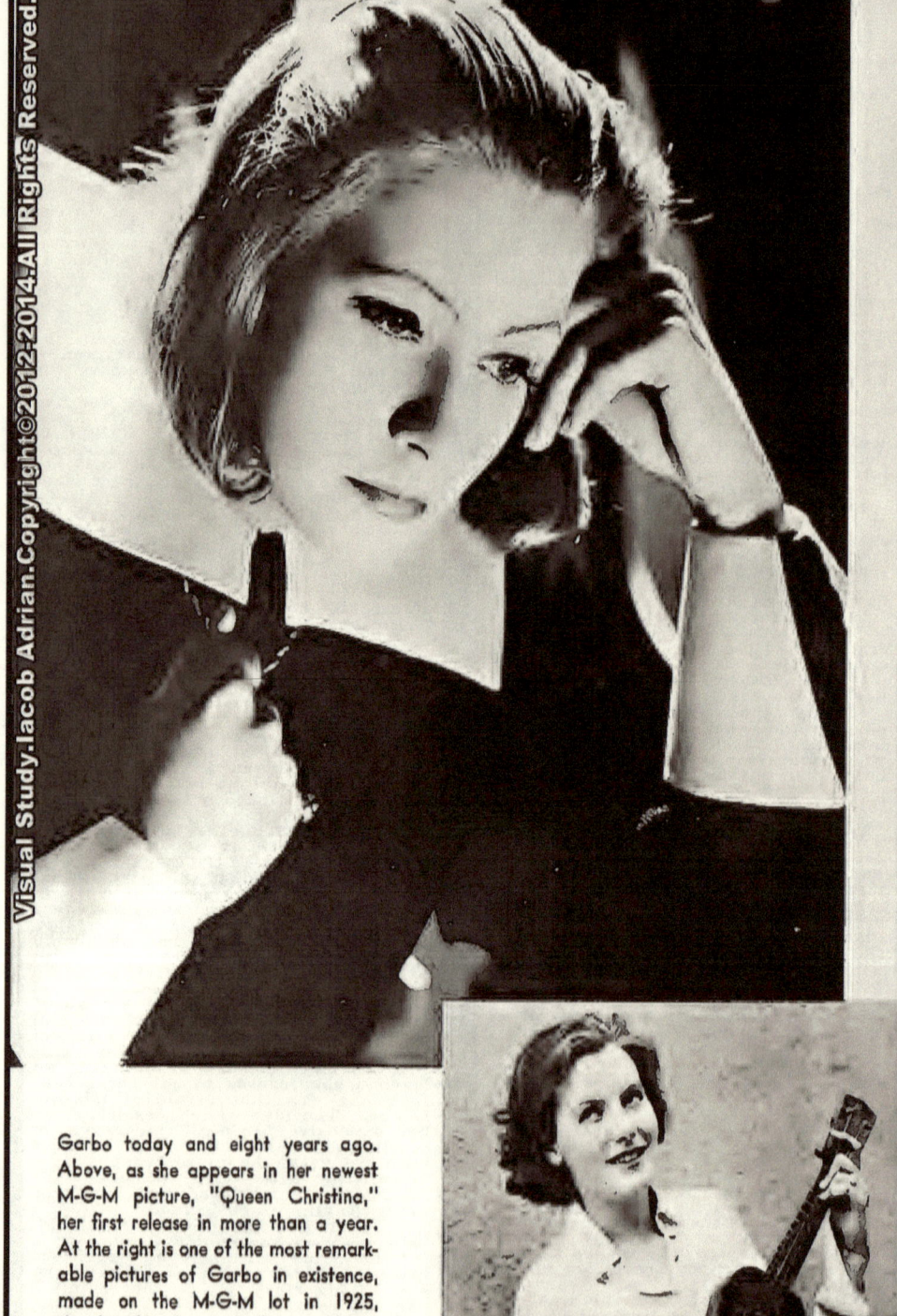

Garbo today and eight years ago. Above, as she appears in her newest M-G-M picture, "Queen Christina," her first release in more than a year. At the right is one of the most remarkable pictures of Garbo in existence, made on the M-G-M lot in 1925, shortly after her arrival in America.

YESTERDAY WITH GARBO

Strange as it may seem, these pictures are all of the great Garbo herself, and you will find it hard to believe that they were all taken less than ten years ago.

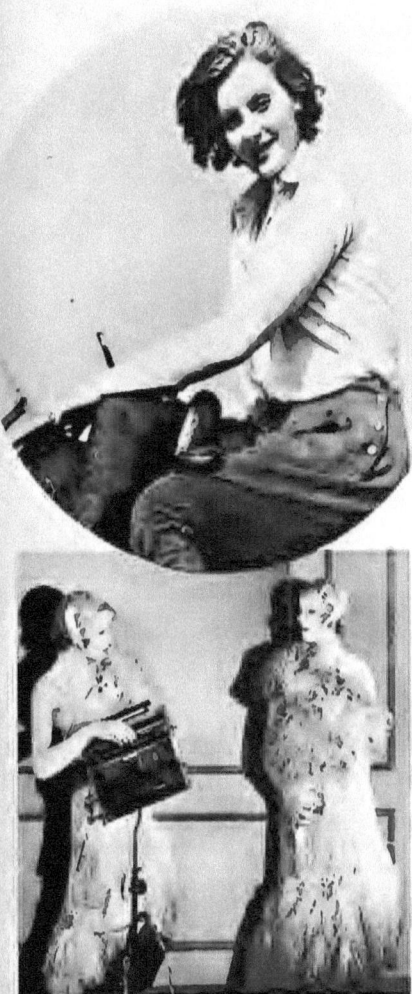
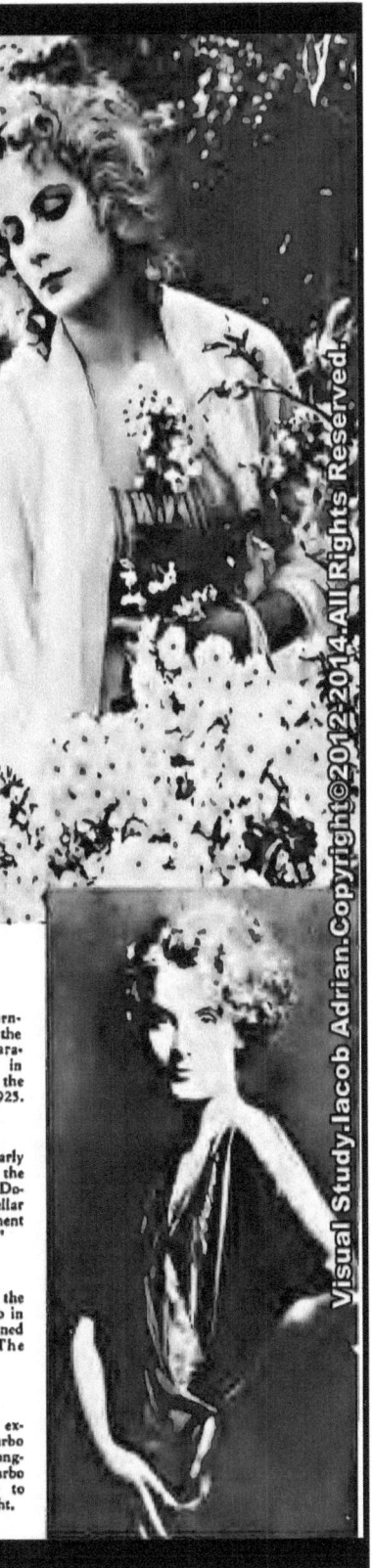

Left, Greta Garbo, learning to ride "Beverly," the famous horse, in preparation for her role in "The Temptress," at the M-G-M studios in 1925.

Above, right, an early portrait of Garbo as the Countess Elizabeth Dolina, in her first stellar role in "The Atonement of Gusta Berling."

At the right, one of the first pictures of Garbo in 1925 when she was signed by M-G-M for "The Temptress."

At the left, a double exposure picture of Garbo made by Buddy Longworth, in which Garbo shows herself how to operate a studio light.

I ACT WITH GARBO

By BARBARA BARONDESS

I'M going to loosen Greta Garbo's laces and show you the size mark inside her shoes. First time that's been done, too!

But more important—I'm going to loosen some of the knots of mystery about the great Garbo's soul. And when I get through you'll have something real to tell the girls around the bridge table because my own eyes and ears witnessed everything I'm passing on.

My first contact with Garbo wasn't a contact at all. If I'd been able to talk to the great actress then, I'd probably still be a newspaper woman in New York instead of what the critics call a "rising young actress."

That was late in 1931. Garbo was in New York but a small army of New York's best reporters and picture snatchers couldn't get near her. They climbed through windows, put on false beards, became waiters, plasterers, gas inspectors—but no result. Garbo simply wouldn't be interviewed.

I was in that crowd. And not a minute passed that I didn't remember what my managing editor had said:

"Get me a 10-word quote from Garbo and a picture showing you actually talking to her and I'll give you a hundred bucks bonus for each word. Don't worry about the expense...."

Well, I didn't worry about the expense. I replenished my wardrobe and checked into the St. Moritz Hotel where Garbo occupied an inaccessible suite. I ran up a bill of $350 in three days.

I bribed one of the floor maids and was actually

WILL GARBO

BY DOROTHY MANNERS

Rouben Mamoulian

THE Queen is in love! Or so they say! Adding there is no longer any doubt that the lonely Swede has fallen in love with Mamoulian, the dark, idealistic radical among Hollywood's directors.

For the first time since the tempestuous John Gilbert, Greta's name is being romanced from the Hollywood housetops, and for the third time in her seven years in Hollywood they are whispering, "Will Garbo marry?"

The first man, of course, was the soul-tortured genius who discovered

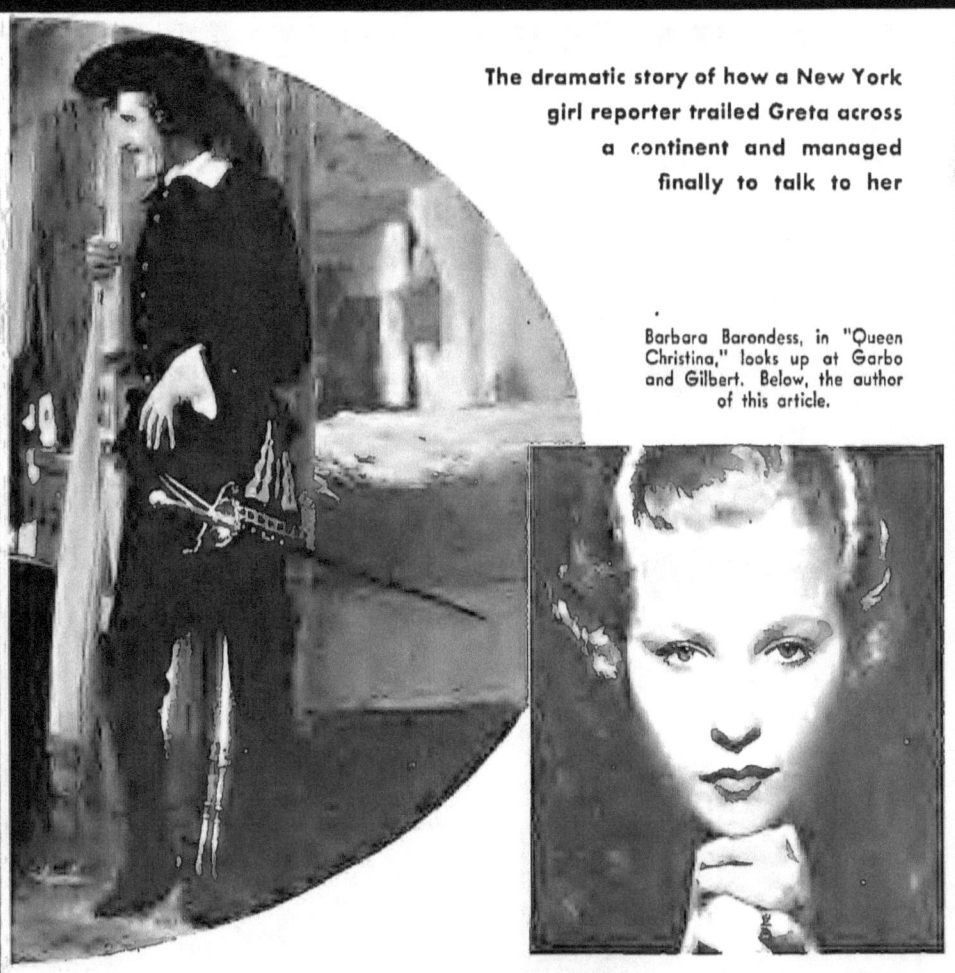

The dramatic story of how a New York girl reporter trailed Greta across a continent and managed finally to talk to her

Barbara Barondess, in "Queen Christina," looks up at Garbo and Gilbert. Below, the author of this article.

Marry MAMOULIAN?

in Garbo's suite twice. But, as they say on Broadway, the whole stunt "laid an egg"—never got within two rooms of the Great Lady of the Screen. That was that and I cussed in my best ladylike manner when I was dragged off the story; although my poor little pink tea words were nothing to the language spilled by my Managing Editor when he got my expense account.

But let me hurry on with the story.

A very famous newspaper man who thought Broadway was his private shooting estate hit just as big a snag as I did in Garbo. He did do a little better than I because he actually got a glimpse of her when he chased her down to the pantry which was her secret exit from the hotel. I went back to my office and confessed failure; but the very famous reporter went back to his office and wrote a story about Garbo's feet.

Now time passes and I'm back to my first love, the stage. After all, five years on the boards, winding up with a year-and-a-half as the ingenue lead in "Topaze," hadn't been (*Please turn to page 79*)

her and brought her to America, Mauritz Stiller. They say he died of a broken heart in Sweden after Greta's second Hollywood love came into her life.

John Gilbert? Perhaps Greta loved him. More likely she was swept off her feet by his impetuosity after the cold, moody affinity of Stiller . . . and lived to learn too late the mistake of her emotion.

Now it is Garbo and Mamoulian. They say the Queen loves again . . . and all Hollywood wonders.

Because it is impossible for anyone to know Garbo's heart, just what this alleged new love has brought into her life can only be guessed at and imagined. Is it merely an interlude of companionship in the span of a life which she once told a friend "will always be lonely"? Or is it so absorbing a passion that it can erase her plans for her strange existence?

Garbo, of course, says nothing . . . after her fashion.

Mamoulian only shrugs. "The story that Miss Garbo and I plan

HAS GRETA FOUND LOVE AT LAST?

to be married is absurd. Cannot people be friends in this town without all this pursuit?" This is the statement he made to a reporter who had insistently dogged his footsteps ever since the rumor was heard connecting his name with Greta's.

The reluctant interview took place on the rain-soaked steps of the home of Salka Viertel, Garbo's great friend and feminine companion. Mamoulian, Greta and Mrs. Viertel had been dining together, enjoying the quiet evening until the arrival of newspaper reporters and photographers. Mamoulian had hastily telephoned a studio publicity man demanding the removal of "these people."

The press agent had advised him to say something to them if he wanted them to go away. At first Mamoulian had protested. "I refuse to be browbeaten into making a statement about my private affairs. This is absurd." But they hadn't gone away. At last he spoke to them briefly, his dark, sombre face seemingly more moody than usual.

"But, Mr. Mamoulian," panted one of the rain-soaked news boys, "just last week you told me you were going to Yosemite on a little vacation. You said you would be there alone and yet news dispatches report Miss Garbo was vacationing there, too. Can we believe you mean it when you say this marriage rumor is absurd?"

There was no answer to this. The Viertel door had been politely but very firmly closed on his question.

That was the last, final and only statement made by either principal. *If* Garbo and Mamoulian are planning to be married the world may rest assured it will not be taken into their confidence. For the man Greta has fallen in love with is as silent, unapproachable and insistent on his rights to privacy as is Garbo, herself.

He is not in any sense a handsome man, this Rouben Mamoulian, but there is a dark, brooding distinction to his angular face. A great many people mistakenly believe him to be Russian. He is an Armenian, born in Tiflis, Caucasus, near the border between Georgia and Russia.

When he was twenty he forsook his law education at the University of Moscow to return to the love of his boyhood dreams . . . the theater. Before he was twenty he did not speak a word of English, but at thirty he was recognized as one of the great artistic stage directors of this country and England. For years he guided the destiny of New York's Theatre Guild.

At thirty-five he had conquered Hollywood with such dramatically powerful films as "Dr. Jekyll and Mr. Hyde," "City Streets," and Marlene Dietrich's "Song of Songs." Only these few facts about Mamoulian, the artist, are available for information. Of the man himself little is known except that he has never been married and that he makes his home in Hollywood with his father and mother.

It has been said this new enveloping influence of Mamoulian in her life has changed Garbo. That she is gayer. Happier. When she recently made a trip to a Hollywood beauty parlor to have her hair waved, it was kiddingly remarked

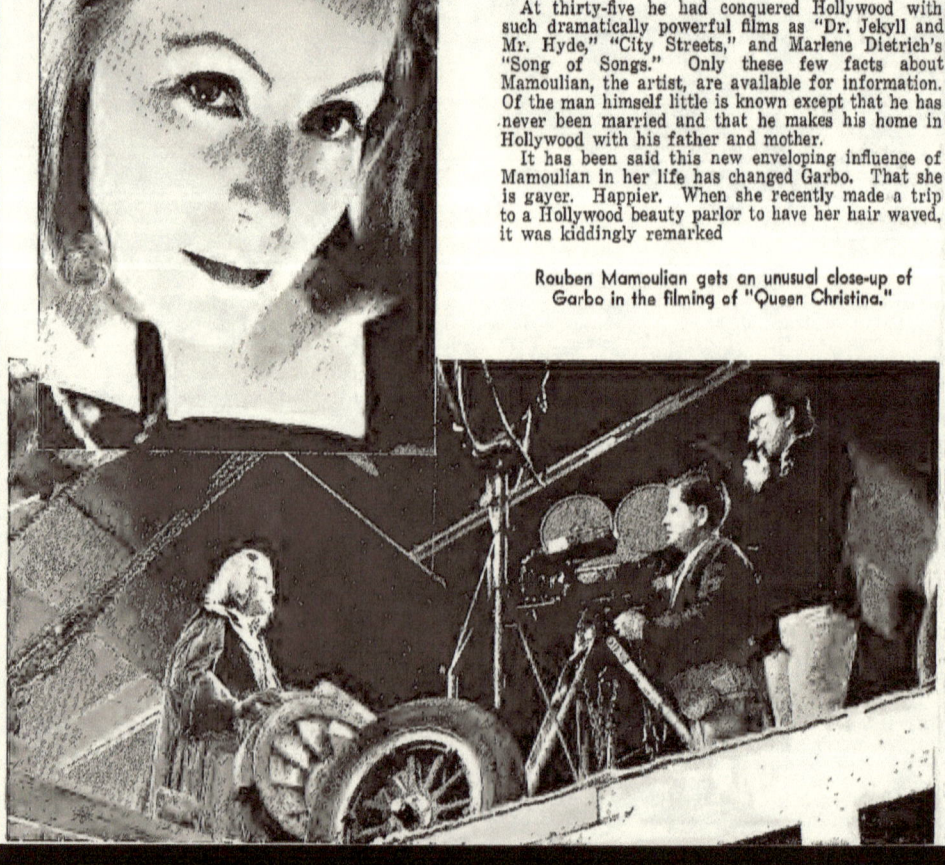

Rouben Mamoulian gets an unusual close-up of Garbo in the filming of "Queen Christina."

Will Garbo Marry Mamoulian?

that love had hit her so hard she was "even having her hair frizzed."

They believe Garbo has at last found a mental mate whose moods are as restless and unsatisfied as her own. It was not a case of love at first sight between them. In the very beginning, before the story conference sessions, they were, if anything, slightly antagonistic toward each other.

Garbo had never met Rouben Mamoulian before the early story conferences on *Queen Christina*.

With her close friend, Mrs. Viertel, she had worked out the details and action of the script. She demanded, and her fabulous contract permitted, that she have almost active supervision on every detail of the making and telling of her favorite story.

For days she sat in the studio projection room looking at the newest films of Hollywood's best directorial brains. Director after director was considered, and dismissed. She could not find the spark and the sympathy she was looking for. Late one afternoon, after three other pictures had been shown they began to unreel Marlene Dietrich's "Song of Songs," the one picture Marlene had made in America not directed by Josef Von Sternberg. The title sheet gave Rouben Mamoulian the directorial credit.

Garbo saw every foot of Marlene's picture. When it was over and the lights flashed up in the darkened projection room, she turned to David Selznick and said: "I like this man. He is an artist. What is his name?"

Selznick said: "Mamoulian, formerly of the Theatre Guild in New York. He has made other outstandingly successful pictures."

The next day Greta spent in looking at all the films Mamoulian had directed. She said: "I think this is the man."

To practically any other director in Hollywood, this Garbo preference would have rated as nothing short of a joyous royal command. But *Mamoulian did not want to direct Garbo in "Queen Christina"* . . . *not at first*.

He knew her only by reputation. But as the actual signing of his name to a contract came closer and closer he began to have definite misgivings about attempting the direction. Mamoulian has always demanded, and received as much artistic leeway as any star he has guided. The money, or the temporary fame involved in directing the great Garbo meant nothing to him compared to the knowledge that Garbo's contract permitted her to have as much say as he would in the filming of the story! He would not share both authority and responsibility of his work.

When the report of Mamoulian's reluctance at last reached Greta it must have intrigued her. For the first time in her career, a Hollywood director had not jumped at the opportunity of making a picture (and such an important picture as this) with the Great Garbo. She became definitely set on having Mamoulian, and no one else would do but Mamoulian, to guide *Christina!*

Garbo's strategy in her first meetings with Mamoulian was perfect . . . if it was strategy. In place of the almighty-star whose word was to be law, Mamoulian was introduced in Selznick's office to a shy, almost embarrassed woman who spoke only of her great feeling about the role *Christina*.

Their second conference took place the following day, very informally in Garbo's dressing-room over a luncheon table.

Not long after, they were seen entering the side door of a theater where "Song of Songs" was being previewed . . . though it was known Garbo had seen the picture several times.

By the time *Queen Christina* went into actual production Garbo and Mamoulian were on a basis of great friendship, which apparently revolved about their mutual absorption in the character they were creating.

Gilbert and Mamoulian were not a happy combination of star and director. It is rather foolish to suspect that jealousy might have been the root of the apparent antagonism between them, as the Garbo-Gilbert love embers had long since been laid to rest. And as for Garbo, it was only too obvious that her former love was merely the leading man of her picture . . . and nothing more.

But Mamoulian's direction irked Gilbert on more than one occasion. He frequently had "set" flare-ups and it was following one of these temperamental outbreaks when Mamoulian complained of a headache after Gilbert had retired to his dressing-room that their co-workers had their first indication that Garbo's feeling for her director might transcend mere "story" interest.

Even the men who are used to working with Greta, who have made picture after picture with her, nearly fell off their perilous perches with the lights when Greta went up behind Mamoulian and gently began to massage his aching temples, and the back of his neck, with her own hands! Mamoulian closed his eyes gratefully, and for a half hour this amazing massage treatment continued.

A dropped pin would have sounded like a bomb in the deep silence of the set. The glamorous Garbo massaging the head and temples of her director. What was this?

It was the first, but not the only evidence of Garbo's personal interest in her new director. They began to lunch together almost daily in Garbo's dressing-room. Holiday week-ends found them motoring to nearby resorts . . . the less frequented ones.

With any other Hollywood couple these romantic straws leaning in the winds of love might spell marriage. But Garbo and Mamoulian with their brooding, Europe-trained minds and hearts cannot be judged by Hollywood's gullible measuring rod on Cupid.

Only Garbo knows the answer of what has happened to her heart.

And Garbo does not tell!

I Act With Garbo

forgotten by the casting offices. So right when I thought I was going to be the first girl managing editor came the Hollywood offer from M-G-M for a part in "Rasputin."

My experiences in the film capital would make a good story, but this is about Garbo and I want to hurry on to her.

You've heard about "Queen Christina," Garbo's first starring vehicle since her return to this country. I can tell you that it is one of the most wonderful pictures ever screened.

And I am honored to feel that I played with Garbo as Elsa, a country-girl maid at a hotel. Garbo is dressed as a man and touring the country incognito to get real information on how her people are doing. She comes to the hotel with another young man—a real one—I should say he's real—it's John Gilbert.

As the story has it, I fall for Garbo and when she (remember she's supposed to be a man) drops into her chair, I rush over to take off her shoes. There you have the scene and I hope M-G-M doesn't mind my telling you about it. After all, they can't blame an ex-sob sister for seizing an opportunity like this.

I'm on my knees preparing to take off Garbo's shoes. It goes like a flash on the screen—but we rehearsed that scene all day long. Hour after hour we went through the motions because if there ever was a director who wants things exactly right it is Rouben Mamoulian.

I had been in scenes with many of the great names and personalities of the movies, but never before with Garbo and I'm frank to confess that all the stories I had heard about her had given me stage shivers.

But she didn't look so cold to me and I began to think of all the things short of murder I would have tried once to get five seconds with Garbo.

So when Bill Daniels, the only camera man ever to focus a lens on Garbo, was trying a new lighting arrangement, I looked up at her and said: "Wouldn't it be funny, Miss Garbo, if after five or six hours of this I actually got to the point of taking your shoes off. . . ."

I can assure you that my heart stood still and I called myself all sorts of a fool for opening my mouth. You know—all those stories about the Big Star with flashing eyes ordering the presumptuous young actress off the set and seeing that she never stepped on the lot again. After all when a career is at stake an actress had better not let her teeth know what her tongue is saying.

But nothing like that.

Garbo was just as human and friendly as any one of the extra girls back in the lunch room. And she smiled (what a smile) as she said: "That wouldn't be such a big job, Barbara—they come off quite easily. . . ."

I will always believe that she used my first name to put me at my ease because I don't mind telling you I was shaking a little.

Looking down at her feet shod in men's shoes, I came back with: "It's evident that your feet aren't as large as your public. . . ."

I Act With Garbo

She laughed right out loud. "No, they certainly aren't," and she continued with this story.

"Three days ago I dropped into a store on Hollywood Boulevard to get some sports shoes. The manager saw me coming and waited on me himself. Was it sports shoes I wanted? Yes, he had a splendid collection. And in a moment he appeared with a dozen assorted styles—but all—what do you call them—canal boats.

"There were sizes 8's and 9's and one pair was larger, maybe a 10. Perfectly enormous! So I said, they were too large, and I slipped out of one of my pumps and put my foot into one of his shoes where it rattled around almost like a peanut in a shell. The manager looked down almost startled. And then," continued Garbo with the lilt of laughter in her voice, "this manager said: 'Excuse me, I thought you were Miss Garbo.' . . ."

Now I ask you? When the greatest figure on the American Screen, which means the world, can tell a yarn like that on herself to a rising young actress who hasn't risen as yet even to her belt level, isn't she just a swell feller? I say yes, and I say it right out loud and I don't care who hears me!

And about the shoes.

I looked into Garbo's shoes right on that set. If you don't believe me, look at the picture illustrating this story and you'll see that I had all the opportunity in the world.

The marked size was 6½.

That isn't the tiny size for the little teetering feet of an old time heroine who couldn't walk across a set without wincing from tight shoes—but neither is it the canal boat dimension a lot of people have been led to believe Miss Garbo wears.

Just a normal, healthy American size, exactly right for Miss Garbo's height.

Personally, I have no patience with the general practice of trying to paint anybody and everybody on the screen as "just folks." Garbo is Garbo, you're you, and the shoe salesman around the corner may play the guitar at a fancy night spot during his evenings off duty.

But what I do want to say is that anybody who tries to picture Garbo as a cold personality compounded of temperament and icicles is so far wrong that . . . well, it would be like saying that Abraham Lincoln and King George III had exactly the same personalities.

Garbo has a warm, pulsing personality and I know it. And I know you'll agree with me when I tell you a couple of actual incidents which took place on the set.

During the filming of Garbo and Gilbert close-ups for "Christina," I wasn't wanted but I wasn't told to go home. Well, I fell asleep in one of the chairs out of camera range only to wake up with a start and a scared cry as Garbo passed me on the way to her dressing-room at five o'clock.

"I'm so sorry I awakened you," said Garbo. "Sleep is so sweet. And I think it's a shame they didn't send you home when they didn't need you. What, you are going to be needed now? Such nonsense! An actress is no good after eight hours on the set. How can they expect her to act? . . ." It was all I could do to stop Garbo from complaining to the director about his "cruelty" to me. No icicles in that temperament, are there?

On another occasion a little peewee of a sound man was pushing one of the microphone booms on to the set. It's built like a small derrick and really looks very heavy although rubber wheels on ball bearings make it easy to move around in spite of its bulk and weight.

Garbo looked up and her sensitive face clouded over at the contrast between the size of the boom and the size of the man pushing it.

"Now, why on earth can't they get a big man to push that machinery around?" she said to the rest of the people on the set who had never given it a thought before.

That's the first time in all my experience I have ever seen a genuine, hard-boiled, leatherneck sound man blush. He got red all the way behind the ears, up and down his neck and up on his bald spot.

You may have noticed that I specified Garbo was leaving the set at five o'clock. Which brings up one of the studio mysteries that I think I can solve for you. One of the questions still being asked by producers, actors, sound men and the rest of the people on the set including the "grips" and "props" is how does Garbo find out when it's 5 P. M. so she can smilingly announce her famous phrase: "I think I go home now."

After all, when you're on a set in costume and in the middle of a scene you can't look at clocks which may be out of sight and your wrist watch may be in your dressing-room. Folks became certain that Garbo had "an uncanny sense of time." And there was even a story in the paper by one of those psychology boys that actresses, like sprinters and locomotive engineers, develop an unusual faculty for noting the passage of time. That's true—but the story is much simpler in this instance. And I spotted the secret myself.

Here it is in a quick flash. Garbo always has her maid on the set. The maid watches the clock. A few minutes before 5 P. M. the maid holds up five fingers for Garbo to see. And that's all there is to it. Simple, isn't it? Yet nobody caught on.

Garbo feels very strongly about five o'clock closing. "All professions work certain hours," she told me. "Why not actresses? I work very hard all day—so I want to go home at night to get my rest. That is why I put it in my contract. . . ."

And the directors may tear their hair a little—but anybody will tell you that when Garbo is "working," she's all work. She "gives," as they say in the studios.

There you have Garbo as I've seen her—unvarnished, authentic and true. I hope she'll forgive me for what may sound like an interview when it is her policy never to give any. But I want her to know that I'm not writing this as a publicity story or as a newspaper woman.

I'm writing this as an actress and a Garbo fan and I simply couldn't resist the temptation and opportunity of telling the world exactly how swell I think she is both as an actress and as a personality.

Your HANDS in Hollywood

NO girl ever failed to make good in Hollywood just because she had ugly hands. No director, let us say, ever said to an ambitious young woman: "You have real dramatic talent. You have a magnetic manner and charming personality. Your face is appealing and your figure is better than the average—but you can never hope to succeed because your hands are not beautiful." The fact is that among the stars and near stars of Hollywood the average of perfectly proportioned hands, wrists, fingers and finger nails is no greater than it is anywhere else. Stars are not chosen for their beautiful hands and yet they all manage to have hands that look lovely. That is unless they are girls like ZaSu Pitts who do character parts and deliberately set out to make their hands look awkward and amusing.

Beautiful hands in Hollywood are not the result of special selection but of diligent care and careful management. They show conclusively what any girl can do to make her own hands lovely if she only tries.

Take nails first because they receive so much attention and because their shape and color have so much to do with the apparent proportions of the rest of the hands.

Expert manicurists in Hollywood have bent their heads over the manicure table with well-known actresses to produce effects that will give most beautiful results. And yet the tools and cosmetics they have to work with are of the simplest most usual sort, simply scissors, or clippers, files, emery boards, orange wood sticks, nail creams, polishes and enamels that almost any girl counts in her own nail beautifying equipment.

There is no cream nor other application that will make short nails long or that will give a graceful oval to nails that are naturally squarely shaped. But careful, regular and gentle treatment of the cuticle at the sides and base of the nails will enormously improve the general contour. Use of creams and oil will keep away hangnails and broken or calloused corners. The entire shape of the nails and fingers can be improved through the way the end is shaped with

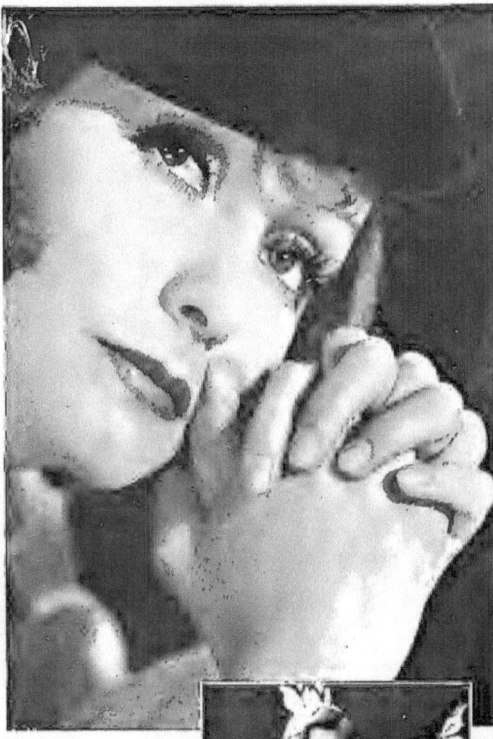

The Garbo hand is long and strong, with a magnetism all its own.

•

Charming indolence is revealed in Madge Evans' hand.

1. Dorothy Jordan's gentleness and highly sympathetic nature are indicated in the graceful contours of her lovely hands.

NEW MOVIE MAGAZINE'S

GALLERY

OF STARS

•

News you have been waiting for! Rumors that Garbo is returning to Sweden are untrue. With the release of "Painted Veil," our lady of glamour is signing a new, long-term contract and starting another picture.

By **SAMUEL GOLDWYN**
as told to Eric L. Ergenbright

WOMEN RULE

"WHY do you emphasize romance and glamour and beauty so heavily in your pictures? Why do you invariably favor love stories when there are other human emotions just as suitable for drama as love? Why do you stress emotionalism? Why do you avoid grimness and cruelty and sordidness and all of the other harsh but ever-present aspects of everyday life?"

If I have been asked such questions once, I have had them put to me a thousand times. And the answer is very simple:

Women rule Hollywood!

Any producer who disregards the established preferences of women is committing professional suicide. His pictures may be the product of genius. His actors may have the talent of Bernhardt, his director the finesse of Reinhardt, his scenarist the power of Shakespeare—but, unless the finished picture possesses that elusive quality called "feminine appeal," it is certain to fail at the box office.

I am ready to grant that life can be grim and cruel. In fact in my own experience I have too often found it so. But women are idealists, not realists. They are emotionalists, not analysts. And, since I have no wish to be a professional suicide, I try to produce pictures which will suit their tastes. Like most veteran showmen, my first instinct is to please the women in the audience. Women have always ruled "show business."

The average motion picture theater audience is *more than seventy per cent feminine!* In the average matinee audience, women predominate by an even larger majority. These figures, which are the findings of actual surveys and not haphazard estimates of my own, speak for themselves. Without the steady patronage of women, theaters and studios could not survive.

Still more important in establishing woman's rule over the motion picture industry is the fact that women almost invariably are the arbiters of their families' entertainment. Wives select the shows that their husbands take them to see. Unmarried girls dictate the shows for which their escorts buy tickets. Mothers select the screen entertainment for their children. And, in every case, the picture selected reflects the woman's tastes.

It is the woman who cons the drama page and reads the theatrical advertisements, while her husband, after glancing over the financial section, turns to the sports pages and checks up on his favorite football or baseball team. He knows from experience that his wife regards a motion picture as *her* outing and that she will determine which show they shall see. Show me the husband whose occasional objections have not been overruled in some fashion as this:

"I didn't say one word last Sunday when you wanted to play golf. I think you might at least take me to the show that *I* want to see!"

Naturally, most theater owners and most producers, being convinced from first hand experience that such an argument is irresistible, "slant" their advertising to attract women. Check up on the theater ads in your current newspaper and note how many feature the words "love" or "romance."

"Please the women and they will bring the men to the theater"—that is one of the oldest and most dependable rules for theatrical success.

It is women who are largely responsible for the so-called "star system" in the studios. They are much more inclined than men to become dyed-in-the-wool fans of the sort who idolize their favorite screen personalities, and flock to see the pictures made by those stars without bothering to ask what the pictures' plots may be. Such fans are the very backbone of the motion picture industry. Hollywood produces, each year, approximately 600 feature length films and it is difficult to find that many worthwhile stories. Without the feminine tendency to consider personalities first and plot second, picture making would be far more risky and far less profitable.

Men, no matter how much they enjoy seeing pictures, are by nature, and by training and habit, much more analytical. No matter how brilliant the cast, they are quick to detect and condemn story flaws. Instead of asking, "Who's the star?" they are more apt to demand, "What's the picture about?" The average man likes a western . . . or a costume picture . . . or any other type of story which appeals to his particular taste; the average woman likes *any* picture in which her favorite stars appear.

Not only "matinee idols" of the masculine persuasion but almost all outstanding feminine stars owe their stardom to the women in the audience. Women, even more eagerly than men, flock to see the screen's beautiful women —especially if those stars are pronounced intriguing by Mr. Average Man. "What makes them glamorous?" . . . "why do men find them intriguing?" . . . and women rush to the theaters to seek the answers to those questions.

Norma Shearer, I believe, is the greatest "woman's star" in screen history. For every one man who is her ardent fan, she owns the allegiance of at least five women. Norma Shearer, poised, intelligent, superbly gowned, sophisticated, beautiful, is to the average woman the very epitome of feminine charm, the personification of all the qualities which the average woman longs to possess. Furthermore, her pictures have been deftly and deliberately tailored to appeal to women. On the screen, she has moved continually through an ultra-glamorous world of sophisticated romance. She has challenged, in her pictures, the convictions which most women obey—and secretly resent. She has starred in dramas based upon the problems which are understood, felt and shared by most of the women in her audiences. Of course, she has many masculine fans—but the majority of men, I believe, have resented such pictures as "Strangers May Kiss." But, resentful or pleased, they nevertheless have seen them—for women select the family's entertainment.

Greta Garbo is another star who appeals far more to women than to men. Test my statement by taking a straw vote in any mixed gathering. You will find that almost every woman present will list her as a prime favorite—but that few men will include her name. Women like her because her pictures, like Norma Shearer's deal with *their* problems, and because her personality suggests exotic romance. The average woman's life is so cramped by the four walls of her home that she longs for an escape from routine and finds it, vicariously, in such

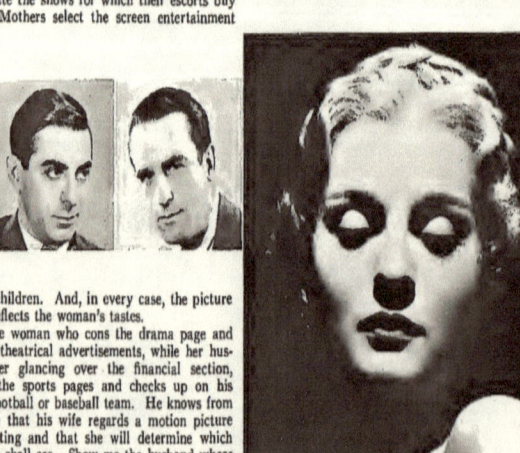

(Extreme left) Chaplin, Cantor, Lloyd . . . deans of comedy because their pathos makes women want to "mother" them. (Center) Anna Sten has uncanny ability to stir women's emotions. (Above) Gloria Swanson did it with gowns.

Men see the shows

HOLLYWOOD

If the men had their way, we'd have more slapstick comedy and adventure stories on the screen. Perhaps we'd have a different kind of star altogether from those shown below. If you're tired of love and problem pictures, blame Mrs. and Miss America!

Norma Shearer ... greatest women's star ever.

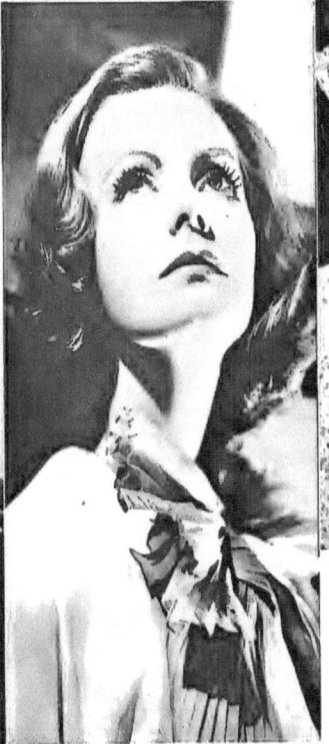

It is women, too, who adore the exotic Garbo.

Joan Crawford ... giving glamour to the girls.

pictures as those which Garbo has made famous.

Gloria Swanson was a great woman's star and she was shrewd in strengthening her appeal to women by wearing lavish costumes. Thousands of women stood in line to see her pictures—and her clothes. Thousands of women, every day, attend theaters—and conscript their husbands as escorts —because they want to see the styles which are being created by Hollywood's designers. And never think that motion picture producers, knowing the preponderance of feminine theater attendance, are blind to the importance of "dressing" their stars. A beautiful star, who has the knack of wearing beautiful clothes to the greatest advantage, is a recognized asset coveted by every studio.

Joan Crawford would be listed as a "favorite star" by many men, yet I think that she owes her tremendous popularity to the fact that she is an idol of the world's working girls. She represents the girl that they want to become—and her own life story, which is one of struggle and achievement, confirms her hold on their admiration. Recall and analyze her most successful pictures and you will find that they were tailored to fit, that they dealt with, and lent glamour to, the problems of America's working girls.

Anna Sten, I think, is destined to become one of the great women's stars, for she has uncanny ability to awaken emotional response in women. To date she has appealed to women more than to men.

In what, principally, do the screen entertainment tastes of men and women differ?

Chiefly in the fact that women are idealists and men are realists. Women are more concerned with the emotion than with the sequence of dramatic situations which give the emotion birth. They see pictures with their "hearts," whereas men see them with their "minds."

Both men and women are interested in love stories, for love between the sexes plays an important part in every normal life. Yet, in the life of the average woman love looms larger than in the life of the average man. The masculine audience does not demand love as the central theme of every picture; the feminine audience does. If men, instead of women, comprized three-fourths of the screen's audience, you would see the screen flooded with stirring adventure stories, many of them entirely lacking in love interest.

The magazine rack in every corner drug store reflects the difference in feminine and masculine entertainment tastes. The hundreds of "pulp" magazines are published for masculine consumption. Their stories drip action and adventure. Few of them contain any mention of love. Their heroes are red-blooded, two-fisted go-getters. The women's magazines, on the contrary, favor stories in which love is the predominant theme—and love, in every story, is idealized. Compromising the two extremes are "general" magazines. They bid for popularity with both sexes—and that, of course, is just what Hollywood tries to do in selecting its screen material. But Hollywood never loses sight of the fact that women are its greatest audience, and, in every case, the canny producer favors their established tastes.

Traditionally, men love comedy. Being realists, they are quick to detect and appreciate exaggeration. They laugh at "slap stick" which leaves the woman's sense of humor untouched.

Yet, even in its comedy-making, Hollywood defers to woman's rule. The great comedians in screen history are those who have appealed to women, and, in every instance, you will find that the secret of their appeal is the flavor of pathos which is ever-present in their fun-making. Charles Chaplin, Harold Lloyd and Eddie Cantor are the deans of screen comedy because women like them. There is a wistful, pathetic, helpless quality in their portrayals which arouses in the average woman the "mother complex." They are funny, yet lovable. They exaggerate, yet in

women pick. Women audiences make and break the stars

Women Rule Hollywood

their exaggerations, no matter how ridiculous, there is always that sincere emotionalism that women love.

Chaplin's greatest comedy, "The Kid," is the perfect example of comedy "slanted" for women. The situations were amusing, but always they were actuated by sincere emotion. Every laugh floated on an unshed tear. I would list "The Kid" as one of the ten greatest women's pictures of all time.

What are the other nine?

There have been so many exceedingly fine pictures, rich in feminine appeal, that it is hard to make a choice. At first thought, I should list "Birth of a Nation," "Broken Blossoms," "The Miracle Man," "All Quiet on the Western Front," "Dark Angel," "Stella Dallas," "Robin Hood," "The Ten Commandments" and "Smilin' Through."

"All Quiet," the most gruesome portrayal of war ever screened, may at first glance seem an amazing choice—yet, if you analyze the picture, the reasons for its tremendous woman appeal are apparent. Through the eyes of its hero, a dreamer and an emotionalist, war was seen from the woman's viewpoint. And the scenes between the boy and his mother, alone, were enough to make "All Quiet" appeal to the average woman. Women, strange as it may seem, like to cry as well, if not better, than they like to laugh.

"The Miracle Man" and "The Ten Commandments" appealed to the deep religious emotionalism which is in almost every woman. "Robin Hood" was romance carried to the nth degree. "Stella Dallas" was an immortal drama of mother love. "Broken Blossoms," "Dark Angel" and "Smilin' Through" were among the greatest love stories ever told.

If entirely dependent upon the patronage of men, how many of the ten would have been stand-outs? I would feel confident of only three—"All Quiet on the Western Front," "The Kid" and "Robin Hood."

In still another way, women have made their rule felt in Hollywood—painfully felt at times, yet in the long run the pain is for Hollywood's own good. I refer to censorship. They have been its most active proponents.

There is no denying the fact that women rule Hollywood—or that they will continue to rule as long as they select the screen entertainment for their families, as long as they continue to be the great majority in every theater audience.

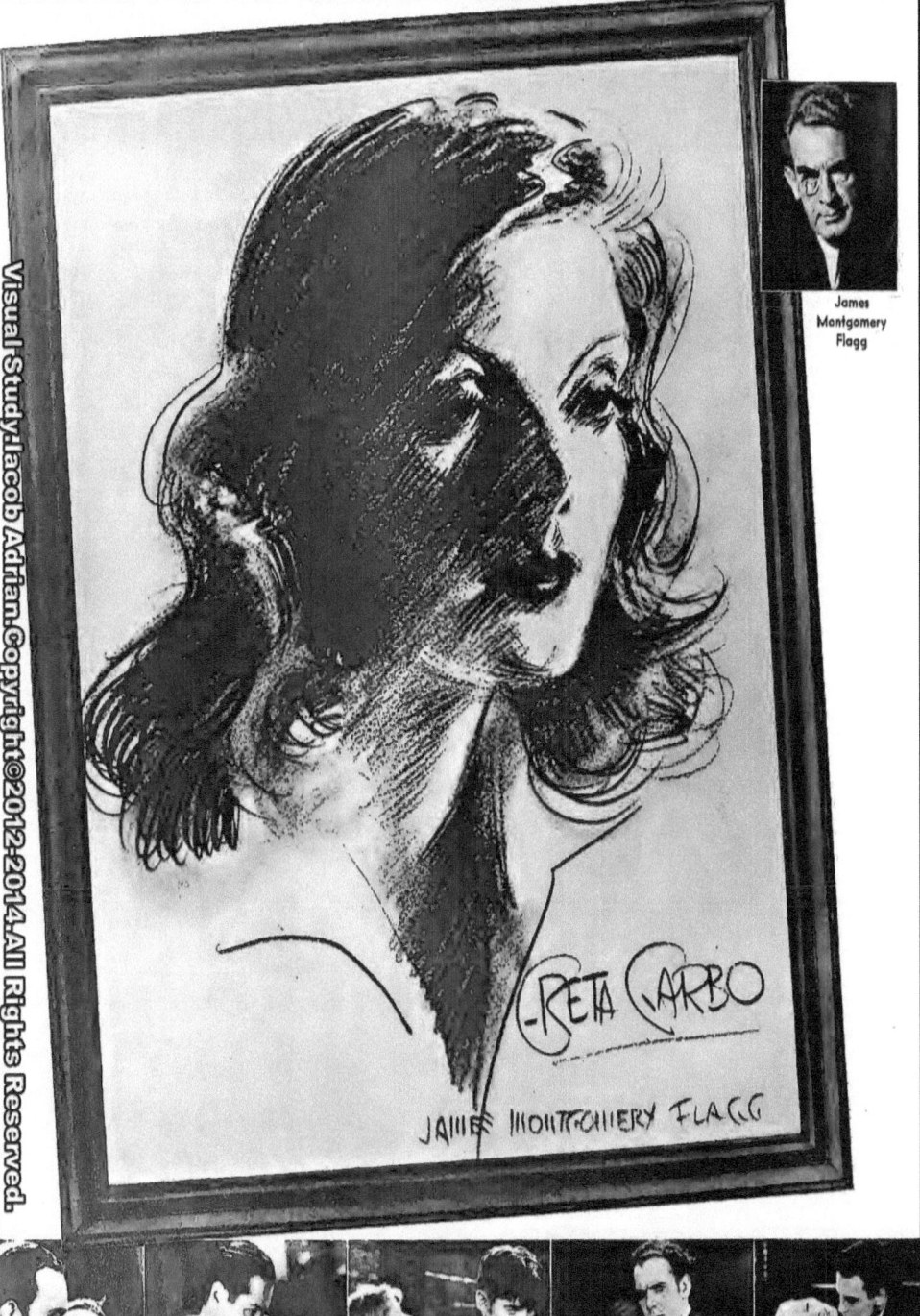

James Montgomery Flagg Reveals
The GARBO YOU NEVER KNEW

Continuing our series, of favorite stars of famous people, James Montgomery Flagg, famous illustrator, says, "Garbo's face has as much character as Abraham Lincoln's has for a man. Fortitude! She's magnificent!"

By DOUGLAS GILBERT

IT is the opinion of James Montgomery Flagg that Greta Garbo is the greatest of the film stars. The silent Swede, says the renowned artist, has everything. He places no crown on her golden head—but a halo. According to Mr. Flagg, Greta is greater than art.

It sounds like a Hollywood rave. Moreover, to your correspondent who laid siege to Mr. Flagg in his New York studio for his selection, it was—at first—a nuisance choice. I had never before contributed so much as a gram to the tons of tripe that weigh down the fabulous Garbo. And I hesitated, in the early stages of our interview, crestfallen at thus being forced to commit a violating act.

But, so help me, the Flagg Garbo is no one you have ever met before. She emerged through his summation, not the pseudo-sphinx shunning the quoted word, but a melancholy Swede, a mystery woman whose screwy reactions, indeed, rudeness, are born of sorrow. And I don't mean a yearning for the dead Stiller. It seems Mr. Flagg knows Garbo. Let us get to his characterization at once.

"She vibrates, does things to you. She has a terrific lot of dignity. She carries around with her a Swedish phonograph record of laughs; no words recorded, no music, just laughs—belly-laughs, hysterical chortles, loud guffaws, laughs that are insane, satiric, happy, derisive, sardonic—every degree of emotional response in laughter. Then she'll play it on her host's or hostess's phonograph and watch the reaction. I don't know what it means. . . ."

Perhaps I should explain that Mr. Flagg is picturing Miss Garbo after an all-afternoon social contact with her at a party given by a director some years ago when he was in Hollywood. She was Garbo in person. She was apparently at ease in his company and spoke, on the word of Mr. Flagg, with earnest freedom.

"We sat together on a sofa. I didn't find her aloof, reticent, or rude, as others are said to have found her. True, she wasn't voluble at the start. But something clicked in me when we met, and I have often wondered if she realized it too. Realized what it was. She certainly gave me the key at the start with an astonishing revelation. She confessed to me that she suffered from melancholia.

"Well, years ago as a youth, studying in England, I had been a victim of melancholia, and I was sympathetically bonded to her at once. This might well be a spiritual affinity. Moreover, she told me that she had experienced melancholy in her youth, so I discounted the stories I had heard of her sorrow for the dead Mauritz Stiller, her first director in Stockholm, and the man she is said to have loved—he who was responsible for her success.

"Success? I wondered just how much it meant to her. I recall how she characterized herself to me during her conversation; it was 'Svenska flicke,' which means, I believe, 'just a little Swedish girl.' While we were talking I asked her if she'd pose that I might sketch her. She agreed, graciously and with charming politeness, and I began to wonder again at the tales I had heard of her rudeness.

"She tilted back her head, revealing her lean neck, which is one of the most remarkable characteristics of her features, and I began. I was interested, tremendously interested, and took some pains to make a finished drawing, not just a hasty sketch. I said, 'you are tired?' And she said, 'no, I am not tired. You are the first real artist I have met in America.' It shut me up, for a moment. But she never betrayed the slightest sign of kidding me. She really sounded very sincere. I finished the sketch and gave it to John Gilbert.

"Then I did something unpardonable, and to this day I can't tell you why. I reached down, picked up her tea-cup, and drank from it. She looked at me for a moment, steadily, with just a trace of disdain. Then she said, 'Are those American manners?' I would have given an arm not to have had it happen. Yet it was worth seeing her coldness, an indescribable frozen contempt.

"Millions admire her I know. I'm not traveling with the herd; I just think they have good taste. And another thing, she hasn't got big feet, it's all damn nonsense. She's tall, about five feet six inches; if her feet were smaller they'd be disproportionate. And her face to me has as much character as Abraham Lincoln's has for a man. My feeling for her art is best summed up in her final scene in 'Queen Christina.' I shall never forget her bravery as she goes forth, standing there at the prow of her ship—such fortitude, such utter renunciation. She is magnificent."

Says Mr. Flagg. Now let's take a breather and get down to case histories. Frankly, I am at a loss to understand Mr. Flagg's rave. So far as I know he has never committed himself to superlatives with such abandon before. Indeed, as a forthright artist in New York for some forty years, he has always insisted upon calling a spade a spade and not a "garden implement." Now he goes haywire over Garbo.

I suspect that his affection for her artistry is more than "a melancholy affinity." They have more in common than that. Like Garbo, Flagg shuns the multitude. Both run on independent tickets. Both are courageous, Garbo shrewdly silent in her fortitude, Flagg with outspokenness. He once characterized the nation, indignantly commenting upon some mass response, as "the United Sheep of America."

He is really one of the remarkable characters of commercial art, so prolific he was once accused of being a syndicate. His was no beginner's garret. He was in the money almost from the start, earning when sixteen, a stipend for his drawings for *Life*, *St. Nicholas* and other magazines that would be a fairish figure today.

A native of New York born of New England stock, he studied in art schools for six years; all wasted time, he says, "unless I had gone to college in which case the time wasted would have been appalling." There is less nonsense about Flagg than almost any other commercial artist. Is the illustrator's field art or business? Flagg will tell you —business. Says it has to be so in an industrial nation where a man is appraised by what he has or what he earns.

He has no highfalutin' views about art for art's sake. A publisher of educational

The list of Greta's leading-men is staggering. See the photographs below.

With JOHN GILBERT ... HERBERT MARSHALL .. RAMON NOVARRO ... JOHN BARRYMORE ... and GEORGE BRENT

The Garbo You Never Knew

books once asked him to write him a thesis on art schools. "I will, but you won't print it," said Flagg. They didn't. He gave them a kick in the pants with such ideas as "art schools exist only for teachers and to keep students out of the rain. Nobody can teach a man to be an artist. All good artists should be subsidized; all bad artists shot." . . . And so on until the publisher, the Flagg script too hot to hold in his hand, dropped it and fled.

It must have been a circus when the NBC asked him to broadcast, along with John La Gatta and a model, his views on types of beauty. The Nice Nellies at the station carefully looked over his script and found this:

"I like a woman with full breasts, wide shoulders and long legs." . . . And promptly cut it out. Then Flagg go home.

You should hear his cathedral-like studio in the Parc Vendome, an un-Bohemian sanctuary, meet almost for a Bishop's study, echo with his gibing guffaws. (Garbo should have had a recording of that.)

"Why can't a woman's body be discussed over the air?" he snorted. "What is it that's so lewd, so disgusting, so obscene about a woman's body?"

Flagg had a taste of Hollywood in the silent days. It must have been a riot. He made twenty-six two-reel comedies for Edison and Famous Players.

"Comedies they made me call them. They were really satires, and so I labeled them. But the executives were a little puzzled by the word. They thought 'satire' was an evil person, half man, half horned-goat, and made me change the title to 'comedy.' "

He had a taste of Hollywood, when he saw Garbo, and later when he went back there not long ago, when he didn't see Garbo. "They are out there," he said, "just charming children. Most of them stem from humble beginnings. Then they make a lot of dough and go crazy."

This, then, is the brief expose of Mr. Flagg. Catch on? It might well be Garbo, suddenly voluble, citing her own views in a similar vein. What a story she must have.

But would the Swedish sphinx talk? A recluse of the films, the Unapproachable One it seems can be had for publicity. For if her wild ride to Kingman, Ariz., with Director Rouben Mamoulian last Summer—on the eve of the release of "Queen Christina"—wasn't a stunt, then Hollywood is a quaint little university town viewing the world from the cloister of its vine-clad towers.

Even her farewells have been as frequent—and as phony—as Patti's. Always she tank she go home; and always she tank she come back. She could easily quell the conflicting reports about her—reports she is said to hoot at, yet never takes the trouble to set right. Less than two years ago a swindler was sentenced to prison in New York for obtaining money from persons on the promise of getting their biographies printed in British publications. Garbo was on his list. Truly, Greta, the mysterious.

She wasn't always the hermit hiding from the vulgar gaze, but honest in her public appeal. In her early days, when \.ller insisted Louis B. Mayer take her over with him at $400 a week, she posed for publicity photos—in running pants with the University of Southern California track team, with a lion cub, etc.—the usual hooey.

But there can be little question of her art. A cold, Nordic type, she has the utmost in repression on the screen, getting over a subtlety as terrific in its power as it is understandable to even the most moronic mind. Her appeal has something of the saintly in it; indeed, something of the religious. I suspect that it is this faith, a sort of "follow me" faith, that claws at her public's vitals.

For she has, as Mr. Flagg says, the astonishing quality of renunciation carried almost to biblical poignancy. There is no scorn like hers; no bravery to match that of her art. Hers is the acme of assurance. It is a pity that almost every one of her vehicles is virtually the same character. She has enough pathos to play light comedy.

Yet no one knows, because of her casting, that she hasn't the versatility of Helen Hayes. What a blessing, an enlightenment, if her employers would take her just once out of studio drama and set her up on location in the sunlight. Until this is done, to me she will be, in the words of a Hollywood producer, "only a little colossal."

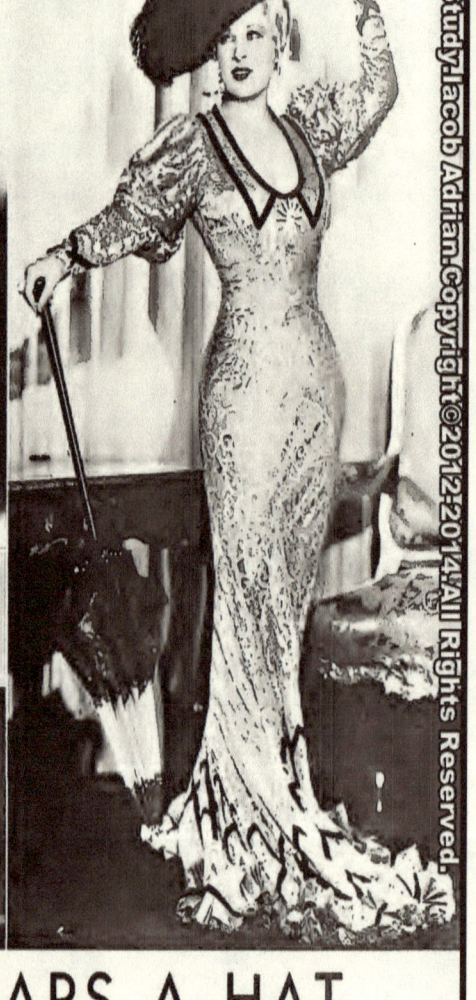

No matter how silly the hat, if Garbo wears it a new style is set. Mae West, at the right, brought back curves to millions of curve-less women. Katharine Hepburn started a rage for frou-frou bangs, Joan Crawford's leg-of-mutton sleeves swept the country and Kay Francis' generously exposed back was a shock heard 'round the fashion world.

IF GARBO WEARS A HAT

By

WHITNEY WILLIAMS

THE Hollywood influence is felt 'round the world.

Fashions, manners, romance, everything that affects the people of the globe . . . all have been swayed by the screen and its glittering stars.

There is, for example, Joan Crawford, who reclothed the girls of the land by the way she wore a dress.

It featured leg-of-mutton sleeves.

Who else but Joan could have started this old style anew, in "Letty Lynton," a style that experts for years have declared as dead as mutton? Yet, when Joan wore the dress, millions of girls all over the country rushed to the stores and dress-makers to order one, puffed sleeves and all, for their wardrobes.

To Greta Garbo the women of the world are indebted for the low bob. The Swedish actress came into prominence when most of the stars were cutting their hair short. Despite remonstrance from every expert in the studio, she refused to cut her hair like the others. Shortly after she appeared on the screen with this style of haircut, those girls and women who couldn't grow their hair fast enough were tacking on shoulder-length extensions.

Hollywood has been designated by many the style center of the world. Actually, it isn't (as yet) . . . and its fashion designers lay no claim to this distinction.

But the effect it wields on current fashions, through the vehicle of the screen, is undisputed. Many of the styles and fashions of the day, now so much in vogue, can be traced directly to Hollywood and its glamorous personalities.

The Cossack hat which Marlene Dietrich wore in "The Scarlet Empress" may be mentioned as a case in point. Shortly after this picture was released, the market became flooded with Russian chapeaux, all outgrowths of the Dietrich top-piece.

The muff she carried was responsible for the re-appearance of that feminine adornment.

And the hood on her cloak is seen this year on all the smart evening cloaks in the smartest shops.

Three pieces of feminine finery now popular throughout the country and in some sections of Europe . . . each had its creation, for general use, in one picture, a film that did not enjoy any particular success at the box-office but exerted a very definite influence upon the styles of today.

Going back a few years, and not so many, at that . . . feathers became popular following the showing of Miss Dietrich

If Garbo Wears a Hat

covered with them, literally, in "Shanghai Express." Travis Banton, who designs all the costumes seen in Paramount pictures, executed her outfit to be in keeping with the character she portrayed ... and was amazed when he discovered he had popularized feathers and boas once more.

One of the best-known designers in motion pictures, Banton designs gowns, slippers, hats, et al, not with an eye to their setting new styles, but for the sole purpose of the stars' being atmospherically correct when they wear his creations in a picture. He received a shock the first time he ever saw one of his gowns reproduced in the mode of the day ... and it is a never-ending source of astonishment to him to know that his fashions are constantly setting new trends in feminine attire.

The flowing draperies of the new gowns, jeweled collars, sandals, negligees, feathered turbans ... these fineries of the moment are directly traceable to the costuming of Claudette Colbert in "Cleopatra."

Mae West set a new style—or should I say a revamp of the old?—in her wearing of the hour-glass costume in "She Done Him Wrong." The effervescent Mae also brought curves back into popularity.

Kay Francis' bare-back gown in "Jewel Robbery" established that vogue, since found modified in many ways ... and the tunic dress Jean Harlow wore in "The Blonde Bombshell" has been widely copied by designers the country over.

R EMEMBER the silly little pill-box hat Garbo donned for "As You Desire Me"? It immediately created a demand for hats of this order. Shirley Temple and Baby Jane dresses have been on the market for some time, each a copy of a little dress seen on these starlets in one or another of their films. And, believe it or not, four of the dresses designed for "Little Women" are featured this season by a famous Paris gown shop, exact replicas of those old-fashioned styles. For the first time in history, the smart women's magazines are offering their readers elaborate layouts of new styles glimpsed on the screen.

The influence of motion pictures on fashions may thus be clearly seen. Fashion experts throughout the East acknowledge this without hesitation, and even from far-off London assenting voices may be heard.

Victor Stiebel, whose styles now are the rage of the English capital, on a recent visit to Hollywood confided that his journey to the cinema center meant at least ten thousand dollars additional each month to him. More women than ever would patronize him, he said, when he announced that he had made a personal study of some of the best-dressed women on the screen. Conclusive evidence, this, of the truth of the above paragraph.

And before we continue ... Lily Daché, noted millinery creator of Paris and New York, while she, too, was spending several weeks in Hollywood studying the fashions of the studios, became so intrigued with the clothes worn by Miss Dietrich in "The Devil Is a Woman," latest picture of the German star, that she told Travis Banton she planned copying some of the hats that will be viewed in that film. High praise, again, for Hollywood and its fashions.

W HENEVER a feminine star changes her hair-dress, immediately thousands of inquiries pour into the studio, asking for news on this new style of coiffure.

If Garbo Wears a Hat

The effect of Jean Harlow's platinum-blonde hair is well known. Many have attempted to emulate her. And, in days gone by, Colleen Moore's Dutch bob set a style for thousands of women and girls.

More recently, the "frou-frou" bangs assumed by Katharine Hepburn for her part of Jo in "Little Women" caught the fancy of the so-called "weaker sex" all over the world. To mention a single instance of their popularity, a hairdresser in a Kansas City beauty shop was obliged to cut out a picture of Miss Hepburn wearing the bangs and paste it on her mirror, so that she might study the full details, so many were the requests from her customers for that style of hair-dress.

Joan Crawford and Carole Lombard both have been important factors in setting new styles in hair, and each regularly receives a vast amount of fan mail from girls and women requesting advice on how to fix their tresses. Not infrequently stars are asked by beauty parlors to sponsor a new haircut, or some way of wearing the hair, and every smart shop religiously keeps up with the styles of coiffure as worn by the stars.

In furniture and house-furnishings, particularly, is seen the weight of the films. "Our Dancing Daughters," one of Joan Crawford's first successes, will be recalled as having introduced modernistic furniture to the American film public.

Later productions utilized this type of room decoration still more, and ere long the pulse of the furniture-buying populace was touched to the degree that thousands, and possibly millions, of homes now are furnished along modern lines. To Cedric Gibbons, head of the art department of Metro-Goldwyn, and husband of Dolores Del Rio, goes the credit for the inception of this type of furniture on the screen.

Almost unbelievable are the number of requests from designers and manufacturers for new ideas in design. The point has been reached whereby a studio finds it nearly impossible to purchase furniture to dress any modern set, so marked is the influence of previous pictures on the pieces in the stores and in the factories. For this reason every studio has its own art department, which designs all modern furniture used in its productions.

Among recent pictures, "The Gay Divorcee" stands as an excellent example of a film play influencing the art decoration of the day. As you may recall, ultra-modern sets and furnishings featured every scene. The chromium fixtures especially intrigued the attention of the nation, and since the release of that hit, public and decorators alike have become "fixture-conscious." From all over this country and Europe, as well, there have been a large number of requests regarding new lighting effects.

Entire sets, too, prove a lure for the public to write to the studios. A wealthy surgeon of Boston, for instance, asked Paramount to send him a detailed plan of the Revolutionary-period living-room used in "Pursuit of Happiness," since he was building a summer home at Cape Cod and wished to construct his house about such a room.

A LARGE majority of the pieces played by orchestras were first heard on the screen. Particularly noteworthy is the fact that since "Stingaree"

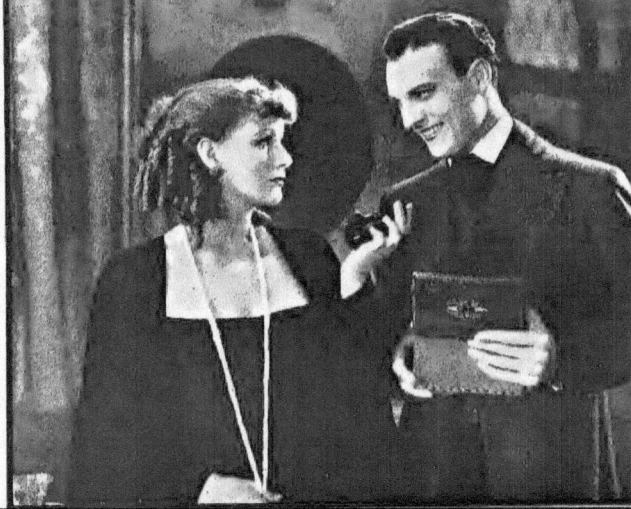

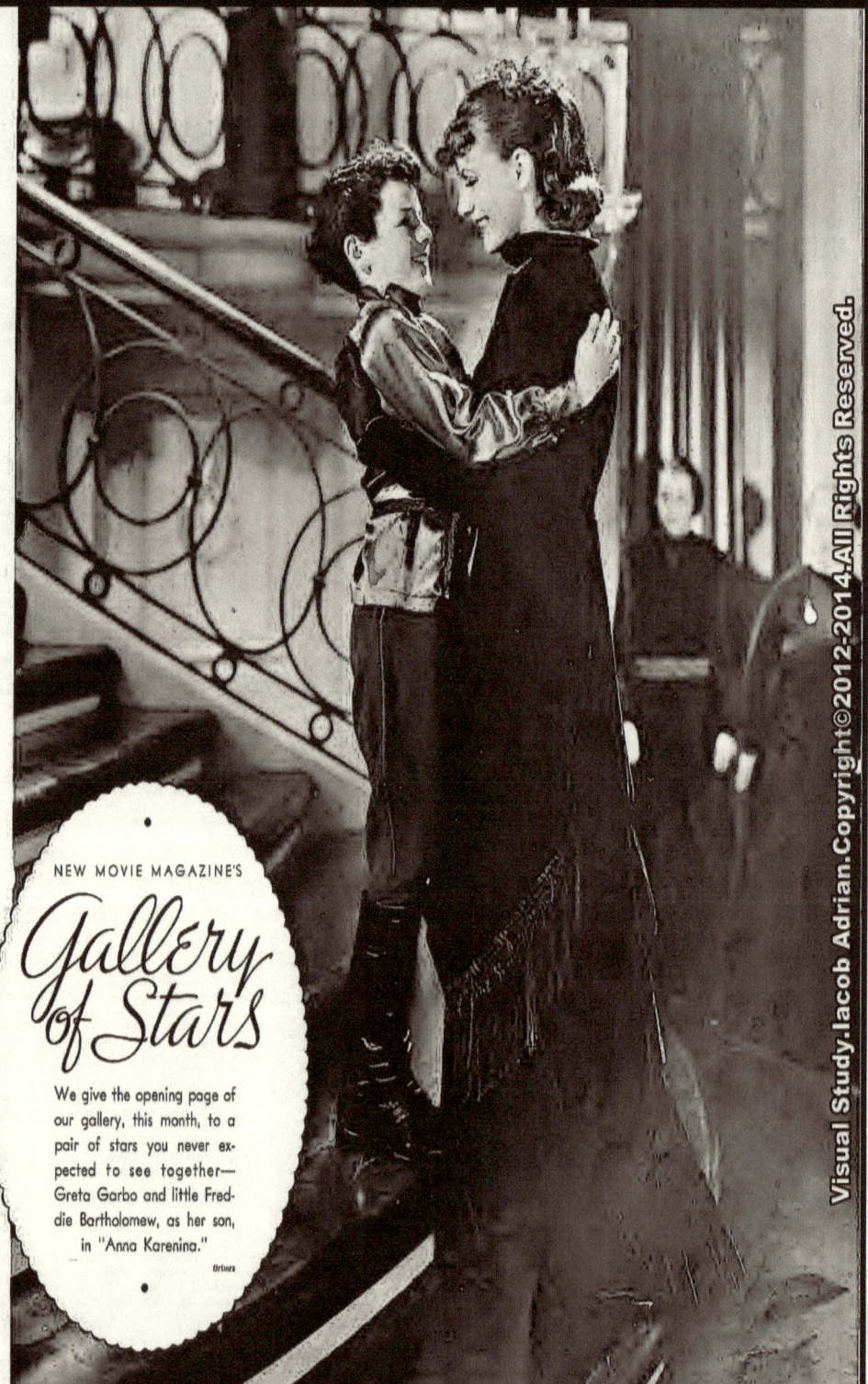

Come on the Set with Garbo

When we took you on the "No More Ladies" set with our candid camera we gave you something new under the sun. We again do the impossible. Here, for the first time ever, we take you right on the set with Greta Garbo, making "Anna Karenina."

4 "Mr. March on the set, please." Fredric March, too, comes out of his dressing-room.

5 Fredric and Greta take their places. Greta sees New Movie's camera man and smiles.

6 Poling them back to shore, the gondolier gives a little girl player a ride and Greta talks to her.

10 Another angle, focussed on Garbo. The scene is over. Now we go indoors for Scene Two.

11 Her costume changed, Greta waits, seated on the side lines. Her maid holds her make-up.

12 She rises to chat with Maureen O'Sullivan and supporting players, while cameras are adjusted.

 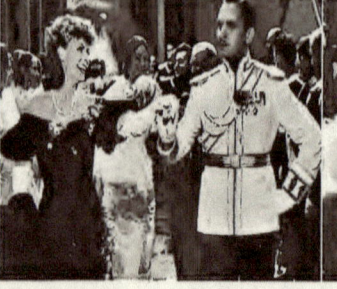

16 Hale has stepped away. Garbo pauses to think, while Fredric March waits for her to turn.

17 They step into the scene. The music starts, the cameras turn. "Action." They go into character.

18 Our high speed lens catches the scene in full motion, as Greta whirls in the intricate dance.

1. "Cameras ready." William Daniels, Garbo's camera man, turns to wait for her to come.

2. Director Clarence Brown has finished lining up the scene in his finder. "All right, Bill," he says.

3. And Garbo promptly leaves her portable dressing-room, her stand-in seated at the left.

7. Down to business. Director Brown steps into the boat and gravely gives them instructions.

8. Freddie Bartholomew steps into the boat to rehearse his lines as final adjustments are made.

9. The tape line checks the focus and a close-up of Freddie is taken between the other's heads.

13. Clarence Brown (in foreground) steps into the group to tell Greta the dance director is ready.

14. A split second later, Brown's arm is raised, and Greta is caught in the act of leaving to join him.

15. Chester Hale, dance director, gives his instructions for the lavish Moscow ballroom scene.

19. The circle of the dance closes and a smiling Fredric kneels before his partner.

20. Greta spins around to him. He kisses her hand. "Cut!" calls Brown.

These pictures were specially taken for New Movie and you with the latest invention in speed cameras, so sensitive that it will take snapshots after dark. To call them history-making is not at all extravagant. From No. 3, showing Miss Garbo leaving her dressing-room, to No. 19, catching her in the very middle of a scene, they offer you a thrilling experience, such as few movie fans have ever known.

ALL ACTION PHOTOS BY GRIMES

GRETA GARBO'S Girlhood

The True Story of Her Life in Stockholm Is Told Here For the First Time

By Siegred Nielson

When Greta Garbo first landed in America, she wanted to begin a new life and to forget that she had once been Greta Gustafsson, millinery saleswoman in a Stockholm department store

THIS is the story of Greta Garbo's girlhood. It is a story that you have never read anywhere before. Greta herself has been too proud and too sensitive to tell it, because poverty leaves a lasting hurt and is more shameful to admit than dishonor. But when you read it, you'll like Greta Garbo better than you have ever liked her before.

To understand the story you must forget about the Greta that you know on the screen. You must forget all the stories you have read about her since she arrived in Hollywood. You must put aside the memory of her temperament, her love affair with John Gilbert, her cold indifference to the small glories that dazzle most stars. You must not see her as a gorgeous woman with unfathomable eyes and a worldly mouth.

You must see her as she was nine years ago. A pale, gawky school-girl, rather plain but with a strange fascination. And very, very poor.

The exact date of Greta's birth was September 18, 1905. Her real name is Greta Gustafsson. She was born in a remote part of Stockholm called Montmartre. It is not a fashionable section. Greta's first home was an ordinary lodging house at 32, Bledinggatan. The Gustafssons were in what is known as humble circumstances. Which means that they were just plain poor. Greta was the youngest child. From her babyhood she had to learn that the world is a hard place, that one must accept responsibilities, that one must make the best of any chance, however meagre and unpromising.

It wasn't exactly a happy childhood, not only because of the family poverty, but because Greta was not, by nature, a happy child. She

What is the mystery of Greta Garbo's life? Here are the hidden facts of her career

This is the first portrait made of Greta Garbo in this country. It was widely published and it established her as an interesting photographic type even before she appeared on the screen

theatres. One was a cabaret and one a legitimate theatre. When she was seven years old, Greta used to stand in the stage entrance of the theatre and wait for the actors and actresses to come in for the evening performance. The theatre had a small back porch and a little backyard and the door was always open. By hiding on the porch, she could hear the performance going on inside; she could smell the fascinating scent of backstage; she could catch the voices of the performers as they went to and from their dressing-rooms.

And then she would go home and, with a little box of water colors, she would paint pictures on her face and pretend that she was an actress. Sometimes, but not often, she allowed her brothers and sisters to join in the game.

At fourteen, Greta's father died. It was a heartbreaking shock to her, because Greta loved him dearly. And it meant even less money in an already poor household. There was no way out of it; Greta had to do her share towards keeping the family afloat.

For all her diffidence and moodiness, Greta was a good child. Her mother thought that she was too young to leave school. In Scandinavian countries education is something that is highly prized. Going to school is not a lark, but a serious and earnest preparation for life. So, in spite of her father's death, the Gustafssons determined to keep Greta in school a little longer.

But in face of a real need for money, Greta couldn't remain idle. She took a part-time job. In a barber shop. Working every afternoon when the other girls were playing. Greta learned soaping. That is to say, she mixed the lather and looked after the utensils.

Probably she would like to forget about the barber shop because people have a strange way of wanting to run away from the memory of their bravest deeds. And when Greta came to this country, with its higher standards of living and its easy prosperity, the thought of her humble start as a wage-earner must have hurt her, must have seemed something to be tucked away and hidden. Foreigners are quick to sense the fact that poverty, in America, is somehow immoral.

But the few coins that Greta earned in the barber shop meant a lot to the Gustafsson family. And they gave Greta the great

was shy, remote and she disliked strangers. But she loved her family with a single, warm-hearted devotion. They were an affectionate family, these Gustafssons. They explain much about Greta; her homesickness, for instance. Only those who have been raised in a large family will understand Greta's persistent loneliness during her first months in Hollywood. And this devotion to her own clan also explains her economical manner of living. Back in Sweden there is a mother who must never know want again.

Greta went to public school in Stockholm. She was a diffident scholar. History she liked, but geography appalled her. She made few friends and cared for few sports, except skiing, skating and throwing snowballs. Like all children, she had her day dreams. In Greta's case, these dreams all centered about the theatre. This was odd, because there were no stage people in her family and no money to waste on amusements.

But near her home were two

The Swedish colony of Los Angeles turned out to pay tribute to Greta Garbo and Mauritz Stiller when they arrived on the West Coast. Greta is always at her best and happiest when she is with her own people

My, how they love voices in Hollywood these days! Jack Oakie, who now is approaching stardom with Paramount, is listening in on New York. You'll next see Oakie in the collegiate musical comedy, "Sweetie"

At the right, Marion Schilling, of the Metro-Goldwyn Studios, presents the newest in sleeping garments. Yes, they're pajamas. Fashioned of Celenese silk in an overblouse style with pajama trousers ending at the knees

Greta Garbo and Conrad Nagel in a close-up scene of "The Kiss." The intent gentleman close by is Jacques Feyder, the French director, who is making the picture

Greta Garbo's Girlhood

satisfaction of feeling that she was helping mother.

In 1920, when Greta was fifteen, she definitely left school. She got a position in a department store, selling hats. By this time, her beauty had established itself. She had outgrown her gawkiness and her height made her seem older than her years. Her shyness had turned into a restraint that gave her an air of breeding. The serious, poised young girl—so pathetically eager to make something of herself—was obviously no ordinary salesgirl; she had refinement and education.

As a business woman, Greta was a success, even though she was very young. The customers liked her. The other girls in the department liked her because she wasn't pushing and because, in spite of her aloofness, she was pleasant. And the store manager quickly saw that she was a valuable asset to the millinery department.

Greta has clothes sense. Although Hollywood has been amused by the carelessness and simplicity of her wardrobe, Greta is wiser than most film stars in that she never is foolish enough to overdress. She wears her clothes with an air. Moreover, she has had an immense influence on the fashions of the world. It was Greta, for instance, who first introduced the long, shoulder-length bob. It was Greta who first wore hats that were turned back off the forehead and wide-brimmed at the back. It was Greta who made popular the stand-up collar.

If Greta had remained in the department store she would have become a fashion expert and a successful business woman. When, at fifteen, a girl can make her influence felt in a large shop, then she must have a very definite talent for her job.

But in the back of Greta's mind was still the longing for the theatre. Now, with money of her own, she could afford to go to the movies and she could treat herself to an occasional play. The theatre was the luxury of her life.

Very likely, with her good position and with money of her own, Greta gloried in her independence and thought herself fortunate. She was getting along in the world. She found that, in selling hats, she could make a quick sale by trying the hats on herself. Even in those days, women in Stockholm, wanted to look like the obscure little salesgirl who was some day to be Greta Garbo.

The chief of her department asked her to pose for photographs of hats that were to illustrate the Paul U. Bergstrom catalogue. And the sixteen-year-old Greta's pictures were a feature of the catalogue in 1921. Other stars have had their first start as fashion models. Alice Joyce and Mabel Normand both posed for fashion photographers, and Frances Howard, who is now Mrs. Samuel Goldwyn, was one of New York's best models.

One of the customers of the store was Erik Petschler, a film manager. He noticed Greta's unusual beauty and saw that she was decidedly the photographic type. He asked her if she could accept an occasional movie engagement. This was, of course, the chance of Greta's life. At first she was afraid of giving up a good position for the precarious life in the studios, where in Sweden the wages are small, even for established stars.

Greta herself says that leaving the store was the most daring step in her life. Her family realized that, for the good of their talented girl, they must

The New Movie Magazine went to great lengths in getting exact facts about Greta Garbo's early life. All the details were verified carefully. Above, the first page of a lengthy cable from Stockholm carrying the complete story.

make sacrifices. The Gustafssons must have been a loyal and far-sighted family.

At the studio Greta, for the first time in her life, was thrown with theatrical people—those fascinating folk she had admired at the stage door when she was a little girl. One of the men with whom she worked was Franz Envall, prominent on the Stockholm stage. Envall is dead now but his daughter is an actress in Sweden. Envall saw that the girl had talent and decided to help her in her ambitions. Through him she was recommended for a scholarship in the Dramatic School of the Royal Theatre in Stockholm.

This was a great honor for a young unknown. The tuition was free, but attending the school meant that even Greta's small earnings in the movie studios would have to stop. Again the Gustafssons held a conference. The Dramatic School meant more sacrifices, more hardships. But again the gallant family decided that Greta must go ahead—at any cost.

For six months she studied and finally passed the test. Before a jury of about twenty people—critics, theatrical people and instructors—Greta enacted a scene from "Madame Sans Gene" and a bit from a Swedish play by Selma Lagerlov. This was in 1922—and she was just seventeen. The jury voted her the scholarship and she was accepted. This moment, probably, was the happiest in her life.

The rest of her story you know. It has been told many times. How Mauritz Stiller applied at the school for a girl to play a small part in one of his pictures and how Greta went to see him and was accepted immediately. That was in 1924 and Greta was already one of the School's best scholars and so entitled to a small salary of one hundred and fifty krone a month.

Greta never forgot her great indebtedness to Mauritz Stiller. It was he who first brought her to the attention of the film world in "The Saga of Gosta Berling." It was he who, when he was offered an engagement in Hollywood, insisted that Greta be included. He loved her and believed in her. He knew that she was an artist. And when he was separated from her, he died in Stockholm of a broken heart.

Out in Hollywood they make a mystery of Greta; she is an oddity, because she won't talk about herself, won't splurge and won't live up to the film colony's idea of grandeur. She withstood the tempestuous John Gilbert—and that, too, was incomprehensible to Hollywood. She prefers solitude to company and she remains strangely alien in her simplicity. If she weren't so sincere and if she weren't so disarmingly natural, she would be accused of posing. In Hollywood, in spite of her three years' residence, she is still a foreigner.

But in Stockholm, where she is not a "mystery woman," Greta is an actress who has brought glory to her country. Her story, with all its poverty and struggles, is well-known—and no one would dream of holding her humble beginning against her. When she returned to Sweden, last Christmas, she was given a welcome that must have surprised her. Even members of the royal family entertained her. At quiet, unostentatious social gatherings, she was the honored guest of some of the finest men and women of the country. With unobtrusive cordiality, her fellow countrymen and women did all in their power to obliterate Greta's memories of her unhappy girlhood.

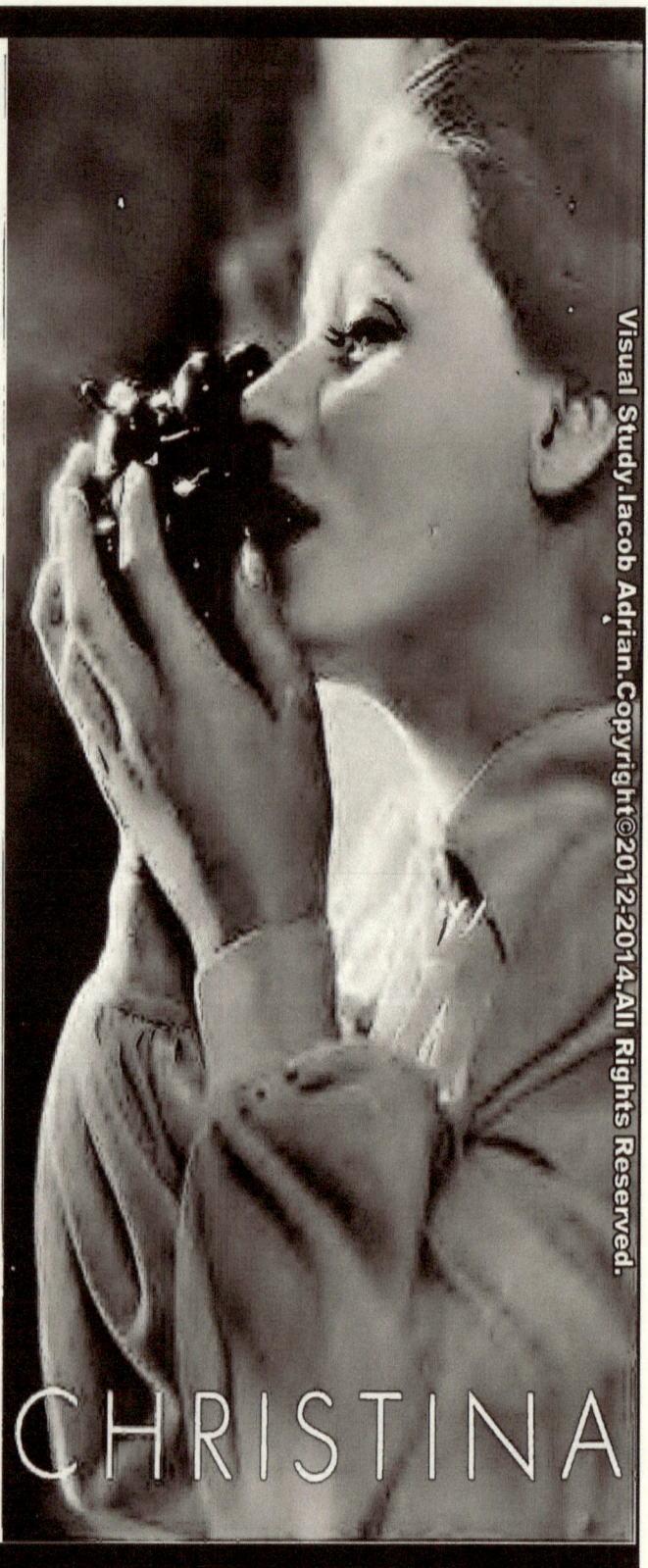

CHRISTINA

The NEW MOVIE MAGAZINE

10¢

GRETA GARBO
by

The FASHION REVOLUTION in HOLLYWOOD

ADELA ROGERS ST. JOHNS · HERB HOWE · HUGH WEIR · HOMER CROY
THYRA SAMTER WINSLOW · WALTER WINCHELL · DICK HYLAND

RICHARD BARTHELMESS GRETA GARBO JOHN BOLES

WE HAVE WITH US

Ladies and Gentlemen: A toastmaster always likes to introduce somebody from home, and so I turn to a girl who came from the best state in the Union, bar none—Missouri—and from the second best town in the state, Kansas City, first place going to Maryville.

On Christmas morning, twenty years ago, Santa Claus very carefully set down a basket on a doorstep in Kansas City and blew on his hands. Now the former occupant of that basket makes more money in a week than poor old Santa Claus does in a year. It just goes to show that there is more money in acting than in driving reindeer.

I refer, of course, to Marguerite Churchill. For years she lived quietly at home, boarding with her father and mother, and never going out unless accompanied by an older member of the family. At last she grew up as people will who are early to bed and early to rise. Her father was interested in a chain of theatres in South America and, after a time, Marguerite picked up and went down there and lived a year in Buenos Aires. She and Lupe Velez and Dolores Del Rio are the only girls in Hollywood who can pronounce it correctly.

Growing tired of beans, she finally came back to New York and looked around and got herself a job acting. One day W. R. Sheehan of the William Fox Company saw her and signed her up for the big open spaces of Hollywood.

Thousands of girls arrive annually in Hollywood with their mothers but, so far as history goes, Marguerite is the only one who ever arrived in Hollywood with both a mother and grandmother.

She still has them and, in addition, she also has a grotto. You're just simply nobody in Hollywood if you haven't got a grotto and a couple of thin-tailed Japanese goldfish swimming around in a pool. But Marguerite has them and can lift her head socially.

Toastmaster's favorite performance: as the Oklahoma girl in *"They Had to See Paris,"* the same having been written by—ahum—the toastmaster himself.

RICHARD BARTHELMESS. I will now direct your attention to that young man sitting there at the end of the table and who is beginning to fold his napkin and look nervously toward the door. Look upon him well, for he is a movie actor born in New York City.

The great event occurred May 9, 1897, and the name that was handed the Bureau of Vital Statistics for recording was Richard Semler Barthelmess. His father came from Nuremberg, Germany, where he was a toy manufacturer. The lady Richard chose for his mother was an American, and thus we have his ancestry. His father was a Bavarian, and his mother an actress, so Dick came by it honestly.

Ambition slumbered in young Richard's bosom, and when he was eighteen he packed the family suitcase and went to Trinity College, Hartford, Connecticut, where he studied hard and rose rapidly until he was cheer leader.

During his four years in college he acted, but no one took it seriously. One day the dean of the college, who had been watching him act, said:

"Some day that boy is going to make his mark in engineering—or something."

There are probably 188,888 mothers who have taken their daughters to Hollywood to put them into pichers. Some have and some haven't. But here is a new angle. Mrs. Barthelmess stayed at home and put her son into pictures. She then was teaching

Homer Croy, The New Movie's Ambassador Extraordinary to Hollywood, acts as Toastmaster at our Second Banquet

OUR OWN MR. CROY NANCY CARROLL VICTOR McLAGLEN MARGUERITE CHURCHILL

TONIGHT

By Homer Croy
Drawing by Herb Roth

English to Nazimova, and at this time Nazimova was starting a picture entitled, "War Brides," and Mrs. Barthelmess got Son Dick a job actin', and now Son Dick gets 6,000 or so letters a month.

Richard Barthelmess has been married twice: First time was to Mary Hay, and soon little Mary Hay Barthelmess came to live at their house. His second marriage was to Mrs. Jessica Sargent and now they have a lovely little yacht named *Pegasus*.

Dick has just signed a new contract which is to run until 1933, and which calls for him to work only two months a year . . . so don't ever make fun of a college cheer-leader again.

JOHN BOLES. I will introduce to you somebody, the like of whom I have never before presented to you—Dr. Boles.

Dr. Boles arrived in Greenville, Texas, October 27, 1898, and lived quietly on Alamo Avenue, attracting little or no attention except among his relatives.

In him ambition burned as steadily and unwaveringly as the flame in a gas ice box, and, packing up his carpetbag, he went to the University of Texas, at Austin, and walked among the intellectuals. He spent four years there and now, girls, comes the sad part of the tale—the day before he graduated he took unto himself a wife and has been married ever since.

After his name on the diplomy they wrote A. B., but he wanted to be an M. D., and have a little sign out in front of his house which said: "Office Hours 9-12; 2-5." But this was never to be, for the war came along and he joined up and spent eighteen months in France—and in what department do you suppose the mighty brains of the army decided to put him? As a detective. In the intelligence section.

When he got back to Texas it was too late for him to go on with his medical career and, as his wife had developed the habit of eating three times a day, our John began to raise cotton.

But the only place where they grow big crops of cotton is in the talking pictures showing negro life, and, being unable to change his wife's habits, Dr. John came to New York to see if he could do a little singing. It wasn't easy for a cotton planter to get started singing in New York, but pretty soon Luck came and tapped him on the shoulder and he got a job. Every time he sang he made friends, and soon he was leading man in a musical comedy.

Soon he was in films, playing opposite Gloria Swanson, and since that time hard times ain't ever come a-knocking at poor ol' Massah Boles' door.

NANCY CARROLL. My eyes wander down the table and come to rest upon somebody who, I am sure, wants to say a few words this evening. I call upon Nancy Carroll. But let me tell you about her first:

Look upon her well, for you have never seen her like before—a movie star born on Tenth Avenue, New York City. This is not the avenue that Vincent Astor was born on; he was probably in long pants before he was allowed to venture into that region.

When Tenth Avenue first gazed upon her, she was named Nancy LaHiff, and her father was straight from Oirland, me lad. This was twenty-three years ago, November 19.

But Tenth Avenue didn't gaze upon her long with wonderment, for this same Tenth Avenue was filled with 'em—seven LaHiff children in all.

Still, Nancy was a little different, for she was the seventh child of a seventh child. Try that, if you want to be lucky in the movies.

Her father was a fine man in every way, although he was addicted to playing on the concertina. And as he played, the LaHiff children would dance. It is said that rents in one section of Tenth Avenue went down sixty per cent in one year, but, of course, this may be exaggerated. Y'know how people like to tell things around.

Her first job was with a lace company.

She couldn't keep her feet still and worked up a vaudeville act and got a

The SPHINX SPEAKS

Elsewhere in this issue Herb Howe refers to Greta Garbo as the Hollywood Sphinx. But the Sphinx speaks in her next Metro-Goldwyn picture, a new talkie version of Eugene O'Neill's "Anna Christie," once done by Blanche Sweet. At the immediate right Director Clarence Brown is introducing the Swedish star to the microphone. The background is an old-fashioned saloon, in the pre-prohibition days, of course.

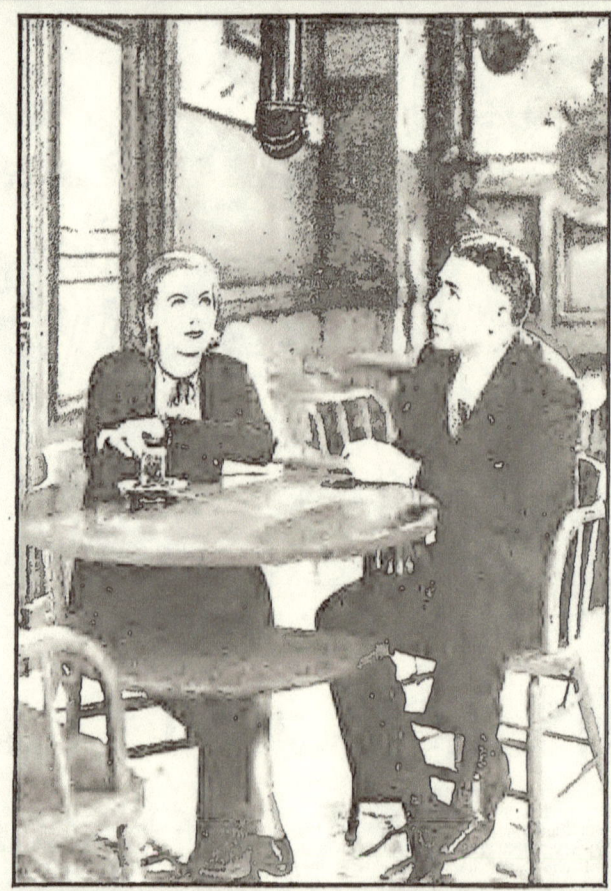

Below, Miss Garbo is reading the dramatic lines of "Anna Christie" with George Marion, who plays her sea captain-father. Director Brown is seated facing the players and the battery of electricians is watching the light effects. The menacing microphone hangs just above

GRETA GARBO — The exotic Swedish star plays a great game of tennis. This isn't just a posed sport picture. It's the real thing.

The Hollywood Boulevardier

While Greta Garbo continues to be the Sphinx of Hollywood, says Herb Howe, her fame is safe.

candidates for office to go into training the same as any Hollywood star who wants to make good. I recently reviewed the screen performances of the four mayoralty candidates in New York. Mr. LaGuardia got a laugh because, not knowing his best camera angles, his tongue showed, and he plainly had neglected his eighteen day diet. Mr. Thomas had only one gesture and no IT. Mr. Enright kept pointing his finger at the audience and shouting "YOU!" which has the same effect on people as tickling them in the ribs. Then Mr. Walker—whatta find—slim, collegiate, well-costumed, with plenty of IT and a certain droll humor suggesting Mr. Stepin Fetchit—naturally he was picked to star.

Candidates no longer can win by speech alone. They must develop other talents, be entertaining, versatile, winsome, not necessarily handsome but the sort a girl would like to write to, more like Gary Cooper and less like Cal Coolidge.

Any boy in this great country of ours may grow up to be president but he should start crooning and hoofing at as early an age as possible. The talkies demand performances, not promises.

THE bearing off of Broadway beauties by the Hollywood producers suggests a picture as poignant as the kidnaping of the Sabine women, and I know just the man to do it: that twelve-year old artist whose canvas in the Roosevelt hotel in Hollywood depicts Napoleon and his staff with the faces of Joe Schenck, Sid Grauman, Charlie Chaplin and other braves. If desired as a companion piece the new picture might be titled: Napoleon Defeats Ziegfeld.

PAUL MUNI is starred with "Seven Faces" but Lon still has the edge by 99.3.

IT'S so noisy on the Western front with the invasion of crooners, hoofers and songsmiths from Broadway that I decided to come to New York for rest and quiet, figuring the town must be pretty well emptied of noise by now.

But I didn't realize how completely Broadway has gone Hollywood until I got here. Hollywood talkies have chased the Broadway speakies down the sidestreets and, if the movies hauled down their electric signs, the street would be as dark as "Hallelujah." Even the vaudeville houses feature sun-kissed stars: Leatrice Joy, Carmel Myers, Theda Bara. Rector's, proud old landmark, is now The Hollywood Restaurant, proudly quoting Walter Winchell to the effect that it's the only place in town with revues like those in the talkies. Opposite the Capitol there now arises The Hollywood Theater, describing itself shyly in the Hollywood

Interviewing the famous movie stars in your spare time at home is a simple matter, if you follow the rules of J. P. McEvoy, given on the opposite page. We do not guarantee results — but you will have a lot of fun.

How to INTERVIEW
GRETA GARBO
In Your Spare Time at HOME

By J. P. McEVOY
DRAWING BY JOHN HELD, JR.

J. P. McEvoy is known wherever humor is appreciated. Remember his delightful "Show Girl"? And his more recent sequel, 'Show Girl in Hollywood"? He is going to contribute to THE NEW MOVIE MAGAZINE from time to time in his characterstic vein.

THERE should be more opportunities for you—and you, too—to get into the writing game, as we playfully refer to it among ourselves.

Us writers do have the bestest times. Of course we used to be very snooty about whom we let in. Longfellow was, anyway. Used to say writers were all right but they got in his whiskers. A crotchety old meanie, if ever there was one—and there was, too. His name was Longfellow.

But things are much brighter now under my régime. (*Theme song: "Climb upon my knee, McEvoy."*) The first thing I did when I came in was throw all the writers out. They went over and joined the Authors' League, and a good riddance. In their places, I mobilized squads of ex-presidents, non-stop aviators, flag-pole sitters and other literary lights, who, after just a few lessons from me, could out-write any writer you *ever* saw.

BUT still there is lots of room for you—and you too—and fun no end. Do you know where the big money lies? (lays?). Writing articles like this. Yes, sir! And how easy it is! I tell you sometimes my conscience hurts me like anything. Kind of a dull ache. (*Though you're only three, McEvoy, McEvoy!*)

My first course will consist entirely of "How to Write Those Interviews with Motion Picture Stars." And the best way for you to learn is to watch papa. He is going to interview Greta Garbo right now. Stay close behind him, and keep your sticky hands off the walls.

"HIGH on the jutting brow of a high jutting hill jutting over Hollywood is that mysterious mansion, Smorgosbord, home of Greta Garbo, sometimes known as Greta, but better known as Garbo. It is a modest place, as modest places go in Hollywood. Forty-two black marble master-bedrooms open off the patio, which is paved with Swedish health-bread—one of those little homelike touches which endear one to one."

(*That's about all you need to do in the way of introduction. You have established your locale, introduced your principal character, and from here you can go anywhere. And it might be a very good idea if you started now.*)

INTERVIEWER—"Miss Garbo, your adoring public would like to know the real You. Your shadow on the screen, luminous though it be, is but a shadow, alas! And even though you speak to us now, as through a glass darkly, we feel somehow you are ver' ver' remote —too remote for us, luminous though you are (be?). Will there come a time when you will emerge from your scented silence, and stand revealed to your adoring public?"

Greta Garbo—"Ach!" (*In Swedish it really sounds more like "Uk."—Ed.*)

Interviewer—"Now, let's take talking pictures. Do you think they will finally replace silent pictures entirely, or do you think there will always be a place for good pantomime, artistically conceived and artistically executed?—or do you?"

Greta Garbo—"I bane tired."

INTERVIEWER—"What is your real opinion of American men, Miss Garbo? How do they compare with European men as husbands, as lovers, as friends? Do you find more inspiration for your art in friendship with men than in a similar relationship with women? Do you understand what I'm talking about? Does anyone? Who is your favorite author?"

Greta Garbo—"Scrow!" (*Well-known Swedish poet and mystic, whose epic saga, "Scram," is being adapted for Nancy Carroll's next picture.*)

Interviewer—"What is your reaction to the new styles for women, Miss Garbo? Do you agree that, in reverting to long skirts, they are surrendering a bit of that precious heritage of freedom in the course of human events one for all and tea for two and Molly and me and the baby makes three?" (*I make it six.—Ed.*)

Greta Garbo: "Ugh!" (*A Swedish idiom untranslatable into English. But it doesn't mean what you think.*)

INTERVIEWER: "What is your idea of the relative importance of Love in a man's life and a woman's life? Is Love the most important thing in your life? Do you love your work? Do you know the song, 'Love Me and the World Is Mine'? Would you rather make love than be President? Are lovers in love because they are lovers or are they lovers because they are in love? Have you any other ideas along this line?"

Greta Garbo: "I go home now."

Greta Garbo's HOME
Photographed for the First Time

The famous Swedish star never tells where she lives. Even her studio bosses don't know. But THE NEW MOVIE photographer tracked down her home. Above, a panorama of Beverly Hills with the Garbo maison in the foreground. It is the bungalow with the beach umbrella beside the sun bath, where the star takes her sunning every day she does not work. (Aviators, please note!) Below, a close-up of the place, which Miss Garbo rents. No expensive castle for this star. Just a hired bungalow. And we won't be mean enough to tell the address.

WHAT to EXPECT in 1930

By FREDERICK JAMES SMITH

A Few Predictions About Film Personalities and Events

Joan Crawford

Gloria Swanson

THE big event of 1930 in the film world will be the unveiling of Greta Garbo's voice. That event will occur when "Anna Christie" is released. Until that moment, the public will have to wait with bated breath. After "Anna Christie," Miss Garbo will do "Romance." Between these two excellent plays, this star will get a very fair audible break. Our bet is that Miss Garbo will go on to greater popularity.

A year ago the big leaders in popularity were Clara Bow, Greta Garbo, Jack Gilbert, Harold Lloyd and perhaps Lon Chaney. Perhaps there has been a very faint waning of the Bow popularity. It isn't apparent in box-office returns but it has been hinted here and there.

The Bow voice, it seems to me, just fits the Bow personality. Hence there is no real reason why her popularity shouldn't continue this year, unless the passing of the flapper mode has something to do with it.

JACK GILBERT made a disastrous start as a talking actor in "His Glorious Night." The general critical theory seems to be that Jack's voice is microphonically wrong. Maybe, but Gilbert used to act on the speaking stage. Why shouldn't he get across in the talkies? 1930 will be the crisis year in his career.

The two big male bets in the film world are Maurice Chevalier, who will electrify filmdom when "The Love Parade" gets general release, and John Boles, the hit of "Rio Rita" and "The Desert Song." Boles already has arrived with a smash. Chevalier's success should be even bigger. His may be the biggest male popularity since Valentino. Chevalier has everything to make for success in the American talkie.

Bebe Daniels will bear watching, after her startling hit in "Rio Rita." Her coming production of the opera, "Carmen," ought to do a great deal for her. Gloria Swanson made a smashing come-back last year in "The Trespasser." 1930 may do more for her.

Richard Barthelmess steadily has been doing fine things before the microphone and the movie camera. He ought to go on to even bigger things during the next twelve months. Joan Crawford has had something of an off year. As yet she isn't fully adjusted to talking films.

Lon Chaney says that he is going to do talkies after all. Not only that, but he is going to sing, too. Why shouldn't he? He used to sing and dance in musical comedy. With the right rôles, Lon ought to hold his old public.

AMONG the younger players, Mary Brian, Nancy Carroll and Jean Arthur stand out. Buddy Rogers, Gary Cooper and Richard Arlen are among the leaders of the younger Hollywood talkie set. Watch these six young folk.

1930 will decide whether or not Lillian Gish is to continue as the acting leader of the screen. It wasn't so long ago that the critics hailed Miss Gish as "the Duse of the films." Her voice will tell the tale in "The Swan."

Watch Claudette Colbert, who scored in "The Lady Lies." Keep an orb observing Fifi Dorsay, too. And don't forget Lauretta Young.

Greta Garbo

1930 ought to be a great film year. An avalanche of costume and historical pictures is headed towards us. There will be a lot of musical comedies. Also more straight talking dramas, minus songs.

IF you want our selection of the twelve most interesting film events for 1930 as yet scheduled, here they are:

Maurice Chevalier and Claudette Colbert in "The Big Pond."

The coming Paramount-Famous-Lasky revue, "Paramount on Parade."

"The Vagabond King," with Dennis King and Jeanette MacDonald.

John Boles' appearance in "La Marseillaise," with Laura La Plante.

BOULEVARDIER

By Herb Howe

Illustrated by Ken Chamberlain

the misty wraith that presides over waters. The ineffable thing called "soul" is attributed ineptly to wax dummy faces with shining glass eyes, whereas it is the burden of those mortals who suffer a vague nostalgia, those to whom the earth is never quite home.

OLD debil doublin' is still rampant in Hollywood. Anyone can sing who can afford a voice.

They're even doubling for themselves, thus adding to their salaries by getting overtime. I mean to say they're not always singing when you see them singing. Sometimes they sing the song the night before and only make lip movements for the camera next morning. No, it's not because of a hang-over or because "Sweet Adeline" sounds a lot better the night before than the morning after. It's because the temperamental mike is jealous of the camera, wants all the attention.

For instance, Paul Whiteman and his orchestra, which is as expansive as Paul himself, play the numbers for Universal's "The King of Jazz" for the mike at night and for the camera next day. The reason is that one mike can't hear it all. To avoid confusion, each set of instruments has a mike of its own—strings, brasses, drums. If the camera were let in she'd show them all up, and so the deaf old gal is only permitted to watch the show after the mike is recorded. It's twice the work for Paul but he needs exercise.

Eddie Cantor's suing a manufacturer because he says his advertisements carry a likeness of him. This gave Bull Montana an idea and he's hot after

Greta Garbo, at a dance performance in Hollywood, held the theatre audience breathless. And when Greta trances them, says Herb Howe, they stay tranced.

Greta Garbo speaks for the first time in Eugene O'Neill's drama, "Anna Christie," and loses nothing by the vocal revelation. Indeed, with the addition of speech, Miss Garbo is going on to new and greater successes. Be sure to see and hear her—in "Anna Christie."

George Arliss, below, as the Rajah of Rukh in "The Green Goddess." Maybe you saw Mr. Arliss in the silent film version. The talkie is even better. At the lower right, William Powell in "Street of Chance," in which he hits new histrionic heights. His performance of the master gambler is a remarkable one.

The Month's BEST PERFORMANCES

WHEN THE TEN BEST PICTURES OF 1930 ARE CHOSEN

CHARLES BICKFORD brings a vivid reality to the rugged character of the sea-hardened mate who learns the tenderness of love from Anna Christie.

GEORGE F. MARION recreates for the talking screen the hardy role of Old Mott, the unforgetably powerful characterization he made famous in the original stage production.

MARIE DRESSLER has made the world laugh with her gayety—and now she shows a new and amazing dramatic power in the role of Marthy. A portrait of the talking screen you will never forget.

CLARENCE BROWN has directed many mighty entertainments for the screen but the greatest of all is his superb picturization of O'Neill's soul stirring drama.

GRETA GARBO
IN HER FIRST ALL-TALKING PICTURE
ANNA CHRISTIE

Adapted by Frances Marion from Eugene O'Neill's play "Anna Christie"

A CLARENCE BROWN PRODUCTION

Charles Bickford George F. Marion Marie Dressler

This soul-stirring drama of America's greatest playwright, Eugene O'Neill, will surely be selected for Filmdom's Hall of Fame! Gréta Garbo sounds the very depths of human emotions in her portrayal of Anna Christie, the erring woman who finally finds true love in the heart of a man big enough to forgive. A performance that places her definitely among the great actresses of all time. Don't miss this thrill!

METRO-GOLDWYN-MAYER
"More Stars Than There Are in Heaven"

The Cock-Eyed World. Funny but rough sequel to "What Price Glory?" The comedy hit of the season. With Victor McLaglen, Edmund Lowe and Lily Damita. *Fox.*

Group B

Puttin' on the Ritz. Introduces the night-club idol, Harry Richman, to moviedom. The romance of a song plugger. Mr. Richman gets swell support from Joan Bennett, Lilyan Tashman and James Gleason. *United Artists.*

Men Without Women. The action takes place in a submarine trapped on the floor of the China Sea. The harrowing reactions of the crew face to face with death. Grim and startling—and full of suspense. *Fox.*

Seven Days' Leave. The tender and moving story of a London charwoman in the maelstrom of the World War. Beautifully acted by Beryl Mercer as the scrubwoman and by Gary Cooper as the soldier she adopts. *Paramount.*

Son of the Gods. Notable for another fine Richard Barthelmess performance. The yarn of a young Oriental who collides with racial prejudices. Superb performance by Constance Bennett as the girl he loves. *First National.*

This Thing Called Love. A racy and daring study of marriage and divorce with Constance Bennett and Edmund Lowe giving brilliant performances. *Pathé.*

The Marriage Playground. Another study in divorce, based on Edith Wharton's "The Children." Sympathetic story and beautiful acting by Mary Brian. *Paramount.*

Half Way to Heaven. Buddy Rogers as a kid aerialist in love with a pretty trapeze performer, Jean Arthur. Buddy was never better. Pleasant entertainment. *Paramount.*

Sally. Delightful eye and ear entertainment, with

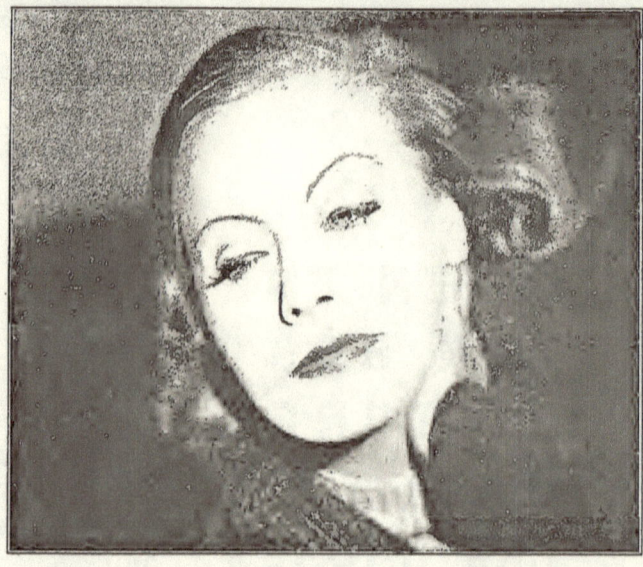

What do you think of Greta Garbo's voice? That's the question of the hour. You can't afford to miss "Anna Christie," because it is splendid screen drama, and because you will want to hear Miss Garbo's voice.

Marilyn Miller won over to the talkies. Miss Miller is altogether lovely. *Warner Brothers.*

The Vagabond Lover. Rudy Vallee, the idol of the radio, makes his screen début as a young bandmaster trying to get along. He does well, but Marie Dressler runs away with the picture. You will find this entertaining. *Radio Pictures.*

The Kiss. Greta Garbo's last silent film. All about a young wife on trial for murdering her husband. The jury does just what it would do if you were on it. Well acted, particularly by Miss Garbo. *Metro-Goldwyn.*

The Thirteenth Chair. Margaret Wycherly in Bayard Veiller's popular stage thriller. Well done, indeed. *Metro-Goldwyn.*

The Virginian. Gary Cooper giving a corking performance in an all-talkie revival of Owen Wister's novel of pioneer days. Mary Brian and Richard Arlen excellent. A fine panorama of the West that was. *Paramount.*

Gold Diggers of Broadway. A lively, jazzy musical show, in which Winnie Lightner runs away with a hit. Color photography above the average. *Warner Brothers.*

Young Nowheres. The simple story of an elevator boy and an apartment house drudge. Beautifully acted by Richard Barthelmess, given great aid by Marian Nixon. Tender and sensitive little picture. *First National.*

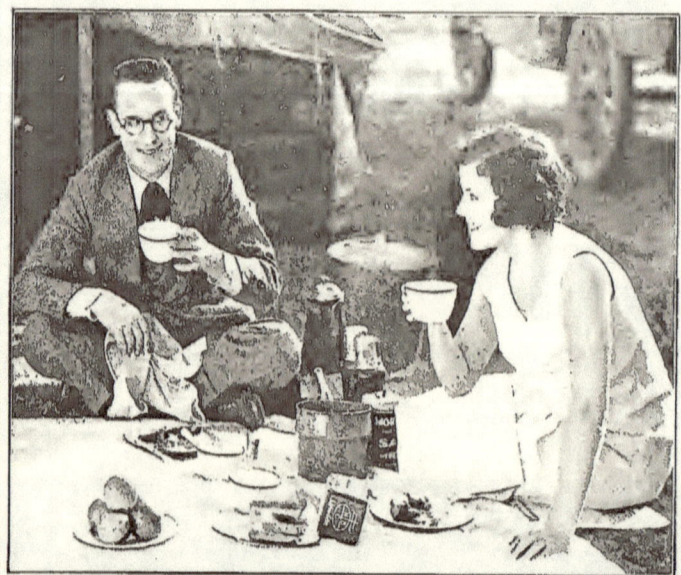

Harold Lloyd made a splendid talkie début in "Welcome Danger." Barbara Kent is a charming foil for Lloyd's comedy. If you haven't seen "Welcome Danger" yet, be sure to do so. It's a winner.

ROMANCE

Here are the first published shots from Greta Garbo's newest picture, "Romance," based upon Edward Sheldon's romantic drama in which Doris Keane starred for two seasons in New York and for a thousand nights in London. The play is built around the concert triumph of an Italian singer, Mme. Rita Cavallini, at the Academy of Music in New York in the late '60's. One of the big scenes shows the Golden Nightingale being drawn by her admirers in a carriage down Fifth Avenue to her hotel, the old Brevoort. Much of the action of "Romance" takes place at No. 58 Fifth Avenue, just across from the editorial offices of NEW MOVIE. Lewis Stone appears opposite Miss Garbo as Cornelius Van Tuyl, a wealthy banker of the day and Mme. Cavallini's patron. A newcomer, Gavin Gordon, is seen as the young rector, Thomas Armstrong.

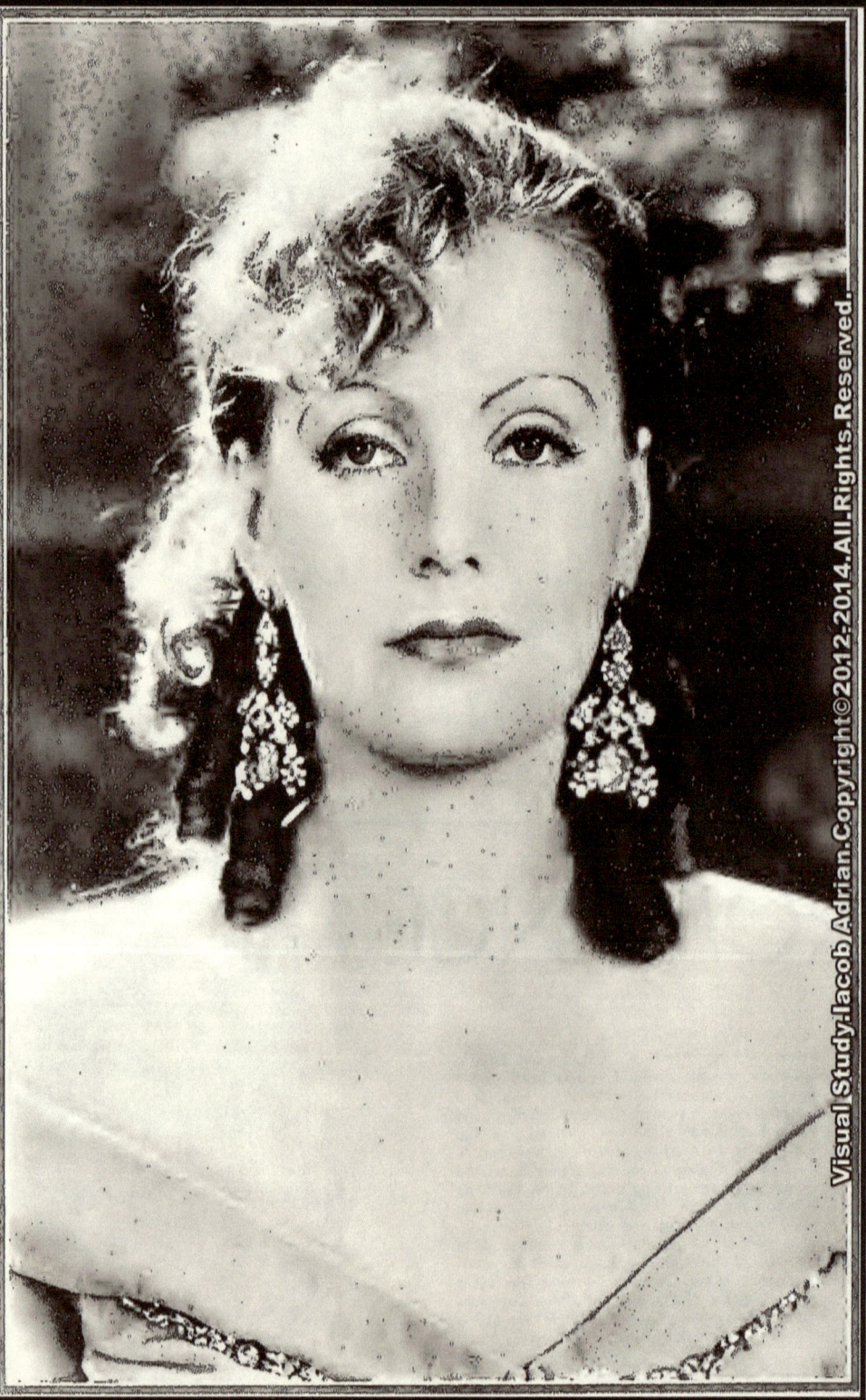

The NEW MOVIE ALBUM

What do you want to know about your favorite film stars? Their start in pictures? Their best roles? Their hobbies? How they work? How they live? The NEW MOVIE ALBUM will give you all these interesting facts and many specially posed portrait photographs.

10¢ IN U.S.
15 CENTS IN CANADA

SOLD AT MANY F. W. WOOLWORTH CO 5 AND 10 CENT STORES

The HEART of GRETA GARBO

How the Tragic Plight of Her Leading Man Touched the Sympathies of the Star Who Walks Alone

By ADELA ROGERS ST. JOHNS

THIS is a story about Greta Garbo. The woman who walks alone. The mysterious hermit who never enters into the life of Hollywood. The girl who is known to no one and whom millions desire to know.

It is a revelation of the real Garbo which she herself would never make, a searchlight turned upon her soul.

When you have read it perhaps you will understand, as I did, a side of Garbo's character which has not before been revealed. For it isn't a cold heart which is hidden behind her strange silences and iron reserve, but something very different.

IT begins with a boy born and raised in the mountains of the South.

Until he was nineteen this hill-billy had never seen a motion picture. His world had been bound by the hills of Kentucky, inhabited only by the mountaineers, who are a people unto themselves. Stern, silent, illiterate people, inured to poverty and loneliness.

Then through the medium of the screen the world unfolded before him—the far places of the earth and sea—the glories of ancient times—the beauty and drama of life itself.

Motion pictures created for him a new universe, fresh from the hands of the gods, new, amazing, wonderful. He loved them and sought them whenever he might.

One day, in a newspaper some traveler had cast by the wayside, he saw an advertisement. A firm in Chicago was looking for actors to play before the camera and they mentioned the enormous salaries paid

Gavin Gordon was a mountaineer from the hills of Kentucky. He came to Hollywood drawn by one dream—the fantastic hope that he might act with Greta Garbo one day.

to stars, told in glowing terms of the unknowns who had arisen to great heights.

So Gavin Gordon left the mountains of the South and went to Chicago, wearing his boots, carrying his carpet bag, silent before the many strange things that he saw. With his slouch hat in his hand, he stood before the desk of the man who had written the advertisement and in the deep, pleasant drawl of his people, he said, "Air you the man that wrote in the paper fer movie actors? I aim to be one naow and I guess I don't mind startin' any minit. How much did you say a man gits for thet?"

But it turned out that they didn't want to pay anybody. They wanted to *be* paid for training aspirants in the art of motion-picture acting. Gavin

Gordon listened in stern silence, fingered the nine dollars in his pocket and walked out without another word. That afternoon he got a job in the stockyards—for he was hard and strong from working among the timbers. But his purpose was not altered. Others had become part of that glamorous life, others acted in motion pictures. Some day he would do it, too.

SILENTLY, persistently, he pursued his goal. New York, he discovered, was the nearest place to go, the nearest place where pictures were made. So, when he had saved enough money, he went to New York.

And there he had his first bit of luck. An agency to which he applied listened to his deep drawl and told him they could get him a small part on the stage because of it. He took it.

But he didn't stay in New York very long. For one afternoon, in a great theater on Broadway, he looked upon the silver sheet and saw a woman.

Women had never meant anything in his life. He knew nothing about women. He had been too busy. The loneliness of the big cities had been harder to bear than the loneliness of the hills, but the only girls he admired, those who drove along Michigan Boulevard and Fifth Avenue, were beyond his reach. They alone approximated the visions he had seen on the screen.

This woman was perfect. All other women became nothing. Here, though he did not so phrase it to himself, was the Helen of Troy who comes once to every man—the acme of feminine loveliness.

Her name was Greta Garbo.

GAVIN GORDON went to Hollywood, because he found out that Garbo lived and made pictures in that distant land of which he had heard so much.

The tall, tanned, handsome young man who got off the Santa Fe train in Los Angeles was very different from the boy who had made his way along the crowded streets of Chicago that first day. He had discarded boots, slouch hat. Already he had begun to assume some of the ways and habits of his idols of the screen. Quick to learn, terribly observant, he had copied as far as he was able. The vivid charm of John Gilbert, the nonchalance of Menjou, the manliness of Dick Barthelmess had appealed to him most. All these he had watched—and for three years continued to watch—and had taken from them such things as he felt he could use.

This newcomer had for his weapons in his attack upon the closed corporation of Hollywood a delightful voice, a certain shy reserve, and a lean face full of character.

But Hollywood would have none of him. For two years he went from disappointment to disappointment, trod the well-worn path from studio to studio, which has often enough been watered with tears.

> "It may be that Garbo had heard all the things Gavin Gordon said in his delirium, may have looked into the boy's heart and been a little glad to be the ideal of such a man. No one will ever know."

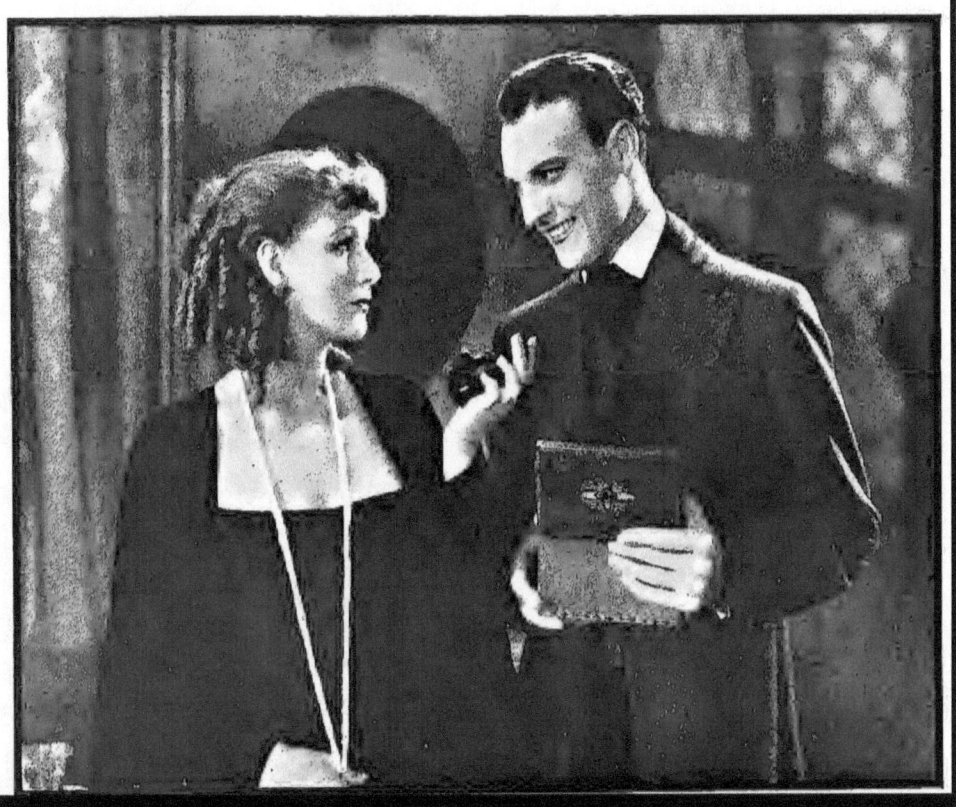

Greta Garbo and Gavin Gordon as you will see them in "Romance."

The Heart of Greta Garbo

Gavin Gordon shed no tears, knew no despair. His real sorrow was that he never saw Greta Garbo. Soon he discovered among the others he met that the great actress of the screen was difficult to know, even for the elect. She moved in mysterious ways, lonely ways, and there were hundreds of people right in her own studio who had never spoken a word to her. Even the girl who did stand-ins for her—to take the burden of standing for lights and camera angles from her shoulders—had never met her. No one, not even the studio officials, knew where she lived.

He had to content himself with going every night to see any picture of her that was running, sitting for hours wrapt in wonder at her art and her beauty. This woman of the silversheet filled his thoughts and his dreams.

If he could only get a chance. The friends he had made marveled at the steadiness of his ambition, the silent, smiling determination of this tall young man from the South. Knowing Hollywood, they wondered if he would be added to the thousands who had tried and failed and been heartbroken.

He might have been but for a chance, a coincidence such as fiction editors deplore on the ground that things like that don't happen in real life.

IN the dark projection room of one of the biggest studios, a group of worried people sat watching the screen. A producer, a director, a writer and a famous star.

They were looking at screen tests, sent to them from all the studios in Hollywood, searching for a young actor who could play a certain part. All the well-known leading men had been discussed and found wanting. All the newcomers being hailed had been considered. Stage actors had been eliminated one by one. Agencies had sent candidates without number.

No one seemed to be just what they wanted and the situation was desperate. So they sat running test after test, hoping somewhere among the unknown legions to make a lucky find.

Suddenly there appeared before them on the screen a tall, well set up young man, with a stern face marked by self-discipline and reserve, and through the sound tract came a slow, deep voice, with the softness of the South held in check by a delicate precision of enunciation.

The little group sat up, when as quickly as it had come on the picture faded, the lights went up.

"I'm sorry," said the operator's voice from above them, "that's not for you. It got here by mistake. That's for Mr. Vidor, I'll be ready in a minute."

"You run that test," said the producer.

"Okey," said the operator.

They ran it four times.

"Well?" said the producer.

"That's it," said the director and the star in chorus.

TWO hours later a publicity man in the Metro-Goldwyn-Mayer office called a Santa Monica number and asked for a name written on a memorandum before him.

"Mr. Gordon?"

"This is Mr. Gordon."

"We wondered if you could come in some time tomorrow and have some portraits taken. This is the publicity department at M-G-M. We'll need new photographs to go with the announcement."

"What announcement?" said Gavin Gordon.

"Why, that you're to play the leading rôle with Garbo in 'Romance'."

There was a long silence at the other end of the phone. Then a voice said, "My God!" and meant it.

It isn't often that it comes to a human being to have his every wish gratified. Had Gavin Gordon been given a magic lamp and one wish to be fulfilled, he would have chosen to play Tom, the young minister opposite Garbo, rather than to be President or owner of a million dollars.

When he first met her for talks concerning the story, he found her to be even more marvelous than he could have imagined.

"She was so gracious," he told me, "so beautiful, but so kind. I had heard how aloof she was. But even that first day she put me at my ease, made me feel confidence that I could do the part the way she wanted it done. She was queenly, yes. But with the queenliness of every great artist. Far above other women, but with the greatest sweetness of manner and the most natural way of talking to you."

THE starting date of the picture arrived. Gavin Gordon hadn't slept all night and when he got into his little roadster he was in a delirium of happiness. As he drove along Washington Boulevard, keyed to the highest pitch, ready for the great day of his life, another car turned out of a side street and crashed into him.

He was thrown out onto the pavement and struck on his left shoulder.

When he couldn't sit up, he found that the pain was excruciating. His arm hung at his side helpless. Red hot daggers plunged through him. But he thought of only one thing. "I won't be able to play the part. If they know I'm hurt they'll never let me start."

The mountaineer blood told. Gavin Gordon got to his feet, set his jaw stubbornly, and drove to the studio.

With infinite pains he put on a makeup. The sweat pouring down his face, he got into his costume. Holding himself rigid, he went out on the set. For a solid hour he worked, upheld by his nearness to his idol, by his iron determination to say nothing to anyone lest the part be taken from him.

At the end of that hour he fainted in Garbo's arms.

That time when he came to, he was in a hospital. He had a fractured collar bone, a dislocated shoulder and a mass of torn ligaments. But he tried to get up. He tried so hard that the nurses called frantically for the doctor.

"I won't stay here," the boy shouted. "I'm all right. I'm not really hurt. I can stand it, let me go back."

He struggled so, weak and half sick with pain and the worse torture of his fears, that he tore loose the dressings and rebroke the bone that had been set.

Suddenly he heard a deep, sweet

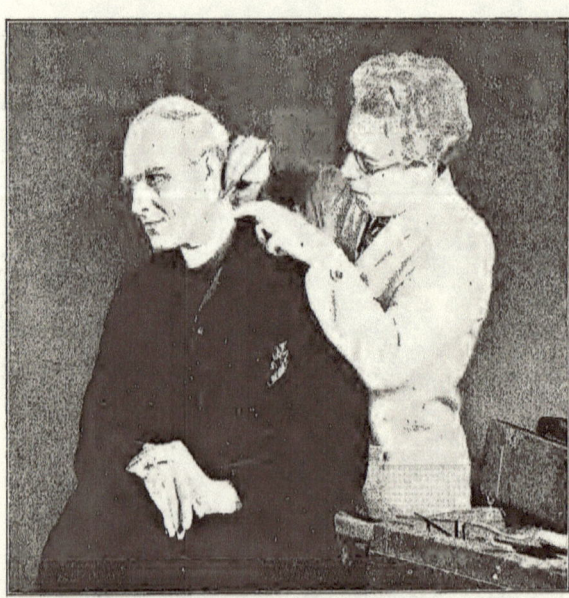

When Gavin Gordon was able to return to the studio after his accident, he did the pralogue scenes of "Ramance," in which he is an aged man. Above, George Wetmare adding a half century to Gavin.

The Heart of Greta Garbo

voice saying, "Please do not do that. You are hurt, Mr. Gordon. We are so sorry. But if you will be good and take care of yourself, we will wait in the picture for you. I, Garbo, promise you that."

Looking up, he saw Garbo, wrapped in a tweed coat, smiling down at him.

Speech deserted him. He was nearer to tears than he had ever been since he was a kid. He lay back quietly and from then on he was a model patient. When discouragement or fear came upon him, when he thought of how the hand of destiny had struck him at the one moment that might spell disaster, he looked across at a big basket of roses that stood beside his bed. They had come with only a card, but on the card was the magic word, "Garbo."

What he did not know until later was that at the studio Garbo was fighting in her own peculiar way to keep the promise she had made him.

It may be that Garbo had heard all the things he said that day in his delirium, may have looked into the boy's heart and been a little glad to be the ideal of such a man. No one will ever know that. But surely admiration of his courage and sympathy for his ambition—things she can always understand—had entered her mind. She saw at once what this chance meant to him, what a long struggle lay behind it.

IT had been a long time since Garbo had to threaten "I go home now." Her enormous popularity, the broken box-office records standing against her name, had made it easy for her to have things the way she wanted them. What Garbo wants, she gets.

Whether or not she had to threaten, she wanted Gavin Gordon given his chance, she wanted him to continue in her picture. She said so when they suggested that they could not delay work, that they must get another leading man at once.

"Gavin Gordon plays that part," said Garbo.

Having settled that, she did the fair thing to the company. With the director she mapped out all the scenes in the picture in which he did not appear—the scenes she had alone, or with Lewis Stone, who plays the other man. At no small inconvenience to herself, she shot any part of the picture that the director thought best. When Gavin Gordon was able to be up, they did the scenes in which he plays an old man, where he could bend over and ease his hurt.

"And she helped me through those scenes so wonderfully," he said. "She didn't think of herself and how it would be for her. She was so kindly, she always made it possible for me to do each scene. I have only seen her that one time outside the studio. But I know that Greta Garbo is a great woman, and the kindest woman in the world."

Maybe he is right.

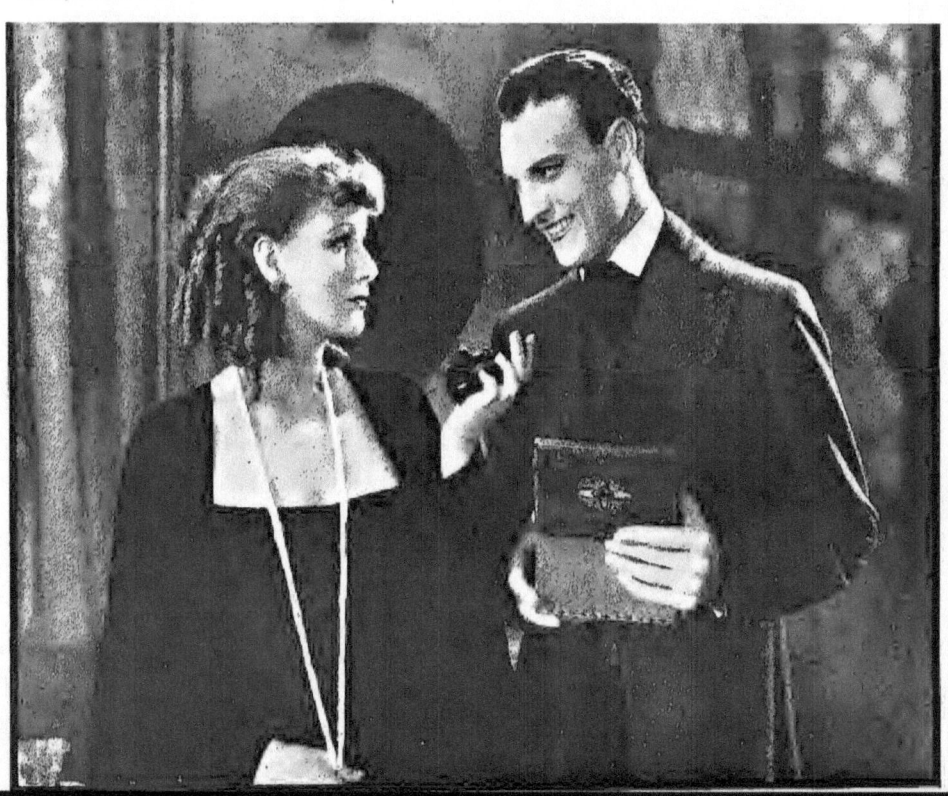

Watch for the new issue of the NEW MOVIE every month

ON THE COUNTERS BEGINNING ON THE 15th

THE FANS are fairly eating up The New Movie Magazine. "It's newer and newsier," they say.

Our representatives on the scenes in the movie capitols flash the latest news for each new issue. Our own photographers, too, send us special poses of the stars and exclusive views of their homes.

The most famous writers on screen activities and personalities contribute to The New Movie by exclusive arrangement.

It goes on sale in Woolworth stores on the 15th . . . and usually sells out shortly thereafter.

THE NEW MOVIE MAGAZINE

I don't care who knows it. Because with that weight I have put on—nearly thirty pounds—has come great relief. I am no longer 'Miss America.' No longer competing for beauty prizes. No longer worrying about whether I am looking just right. I'm no longer in the race.

"I'm just Fay Lanphier again—and happy."

She told me that she was really too heavy. But that for a while she enjoyed being that way. "For the same reason, I suppose," she said, "that a person dying of thirst would overdrink when he first got at a tank full of water." She weighs 157 now. She tipped the scales at 128 when she was "Miss America." She is a tall girl, and even the additional weight cannot hide the fact that she is proportioned along the lines so admired by the ancient Greek sculptors. She said ten or twelve of those pounds were coming off. Not because she cares how she looks, but merely because she thinks them too much to carry during the heat of the summer.

"I'm through working my head off for the sake of my appearance. You'll never catch me getting the same ailments some of the girls who win beauty contests work themselves into. Fifteen pounds overweight is more healthy than ten pounds underweight. So that is that. If they want me for the stage as I am, all right. If not, that is all right, too. Work is all I want now. Being 'Miss America' has been a wonderful experience. It has given me a background I could not have gained otherwise. Now that it is behind me I am glad I did it. But I do not want to do it again."

I LOOKED at this girl and wondered. Here she was in a studio lunchroom. She was one of a hundred stenographers on the lot. Fay Lanphier, who had been judged the most beautiful girl in America. She was attractive—very—yet. But a great part of that attractiveness was her perfect ease of manner, her restfulness, her joy of living. She ate what she wanted and how she wanted. She had not a care or regard about whether or not strangers were looking at her. She was herself, completely relaxed.

And then I looked around that lunchroom. Here and there was a star. Among their own kind, in a studio noon hour, they could relax if ever. Some of them looked as if they were. But not one of them had the carefree ease of manner possessed by Fay Lanphier. Each and every one of them was conscious, perhaps but subconscious, that someone they did not know was looking at them, judging them; and no one being judged on sight by a stranger can be relaxed or completely natural.

Thinking over what I had just been told by Fay Lanphier about the worry and fear which go hand in hand with such a situation, I wondered if the large salaries given some of the motion picture stars made up for that being continually on parade, that curse of never being able to relax in public.

I—well, no matter what I thought about it. We can have *one* definite answer. Fay Lanphier, having had the glory, the additional dollars which go with the spotlight of fame, has decided that the prize is not worth the game. She desires not to be "Miss America"; she wants to be plain Fay Lanphier. Who can say she is wrong?

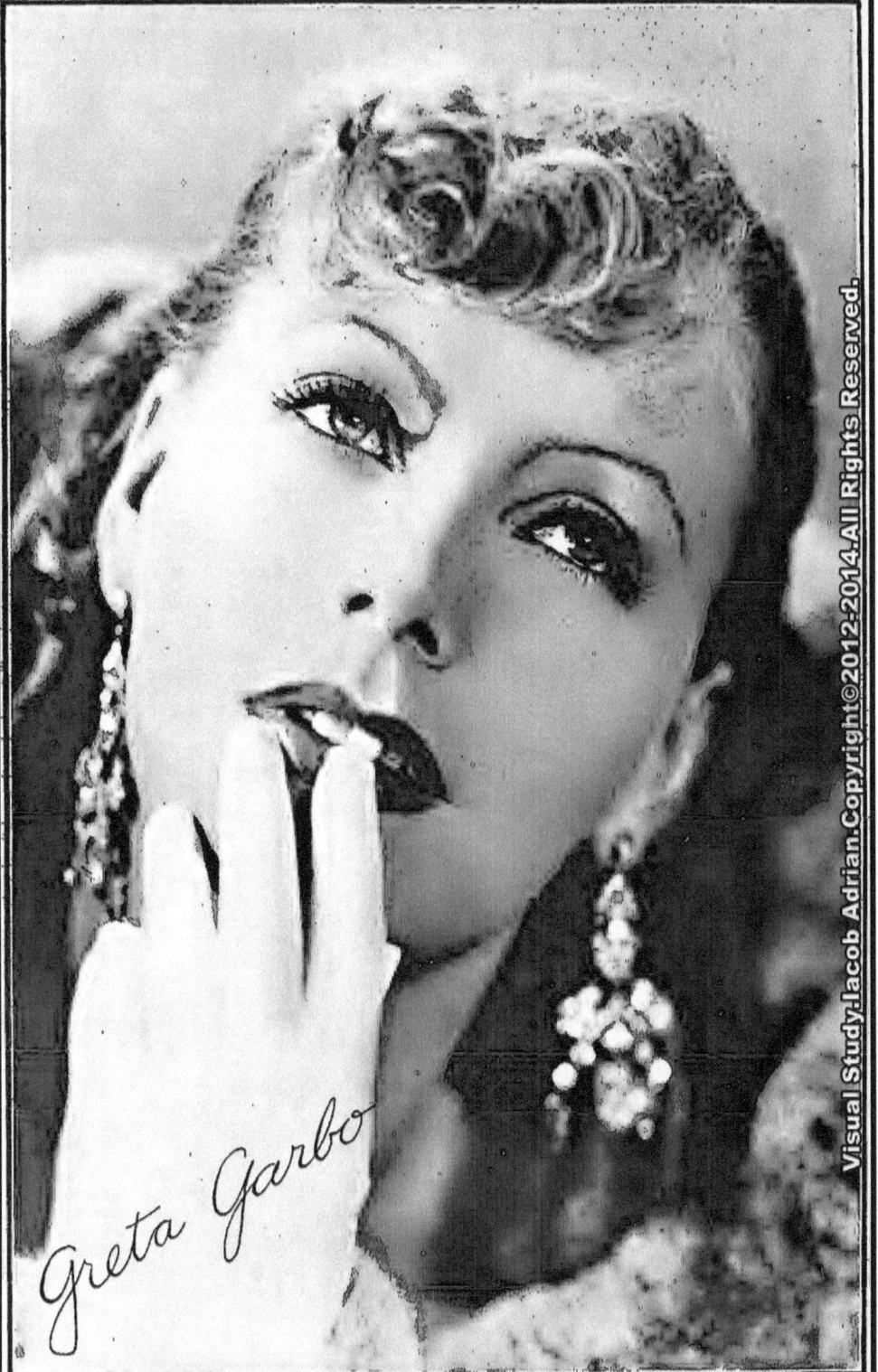

GUIDE to the BEST FILMS

contrived to fit the world-popular Mr. McCormack. *Fox.*

The Vagabond King. Based on "If I Were King," this is a picturesque musical set telling of François Villon's career in the days of Louis XI. Dennis King and Jeanette MacDonald sing the principal rôles, but O. P. Heggie steals the film as Louis XI. *Paramount.*

Street of Chance. The best melodrama of the year. The story of Natural Davis, kingpin of the underworld and Broadway's greatest gambler. Corking performance by William Powell, ably aided by Kay Francis and Regis Toomey. *Paramount.*

The Rogue Song. A great big hit for Lawrence Tibbett, character baritone of the Metropolitan Opera House. The tragic romance of a dashing brigand of the Caucasus, told principally in song. Based on a Lehar operetta. *Metro-Goldwyn.*

The Green Goddess. Another fine performance by George Arliss, this time as the suave and sinister Rajah of Rokh, who presides over a tiny empire in the lofty Himalayas. You'll like this. *Warners.*

Anna Christie. This is the unveiling of Greta Garbo's voice. Be sure to hear it. *Metro-Goldwyn.*

Devil May Care. A musical romance of Napoleonic days, with Ramon Novarro at his best in a delightful light comedy performance. Novarro sings charmingly. This is well worth seeing. *Metro-Goldwyn.*

Lummox. Herbert Brenon's superb visualization of Fannie Hurst's novel. The character study of a kitchen drudge with Winifred Westover giving a remarkable characterization of the drab and stolid heroine. A little heavy but well done. *United Artists.*

The Love Parade. The best musical film of the year. Maurice Chevalier at his best, given charming aid by Jeanette MacDonald. The fanciful romance of a young queen and a young (and naughty) diplomat in her service. Piquant and completely captivating. *Paramount.*

The Show of Shows. The biggest revue of them all—to date. Seventy-seven stars and an army of feature players. John Barrymore is prominently present and the song hit is "Singin' in the Bathtub." Crowded with features. *Warners.*

Welcome Danger. Harold Lloyd's first talkie—and a wow! You must see Harold pursue the sinister power of Chinatown through the mysterious cellars of the Oriental quarter of 'Frisco. Full of laughs. *Paramount.*

They Had to See Paris. A swell comedy of an honest Oklahoma resident dragged to Paris for culture and background. Will Rogers gives a hilarious performance and Fifi Dorsay is delightful as a little Parisienne vamp. *Fox.*

The Trespasser. A complete emotional panorama with songs, in which Gloria Swanson makes a great comeback. You must hear her sing. Gloria in a dressed-up part—and giving a fine performance. *United Artists.*

Sunny Side Up. Little Janet Gaynor sings and dances. So does Charlie Farrell. The story of a little tenement Cinderella who wins a society youth. You must see the Southampton charity show. It's a wow and no mistake! *Fox.*

The Lady Lies. In which a lonely widower is forced to choose between his two children and his mistress. Daring and sophisticated. Beautifully acted by Claudette Colbert as the charmer and by Walter Huston as the lonely widower. *Paramount.*

Group B

Safety in Numbers. A snappy comedy in which Buddy Rogers plays a handsome heir to a fortune and has for his guardians three beautiful Follies girls. Easily the best Rogers film in some time. Has plenty of charm. *Paramount-Publix.*

Raffles. Another mystery thriller, somewhat along the lines of "Bulldog Drummond." Ronald Colman is delightful as Raffles—so, too, is Kay Francis, who supplies the heart interest of the film. *United Artists.*

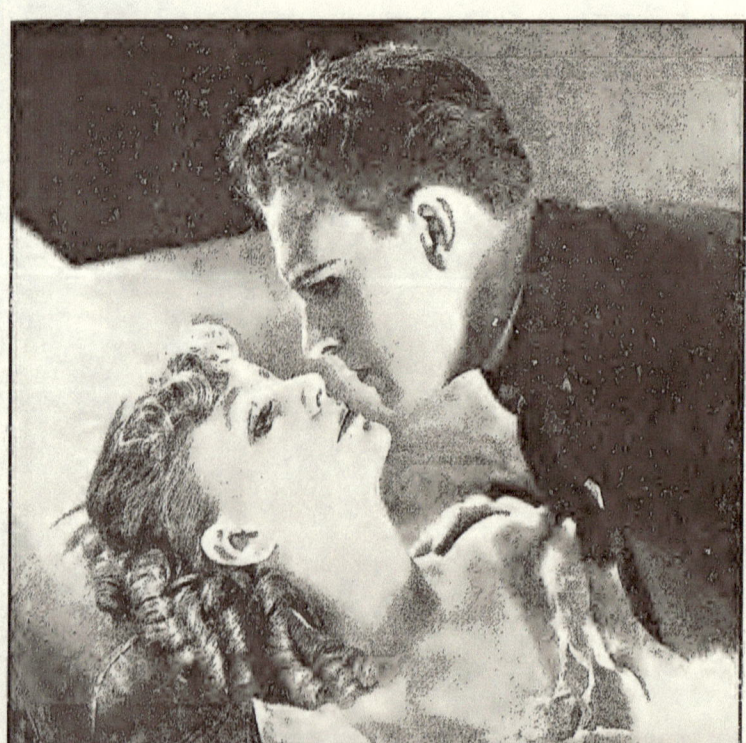

"Rita, I love you," exclaims the young rector to the famous opera singer in a tense scene of "Romance." Greta Garbo's newest Metro-Goldwyn talking film is highly glamorous and you will be won anew by Miss Garbo. Gavin Gordon is the rector.

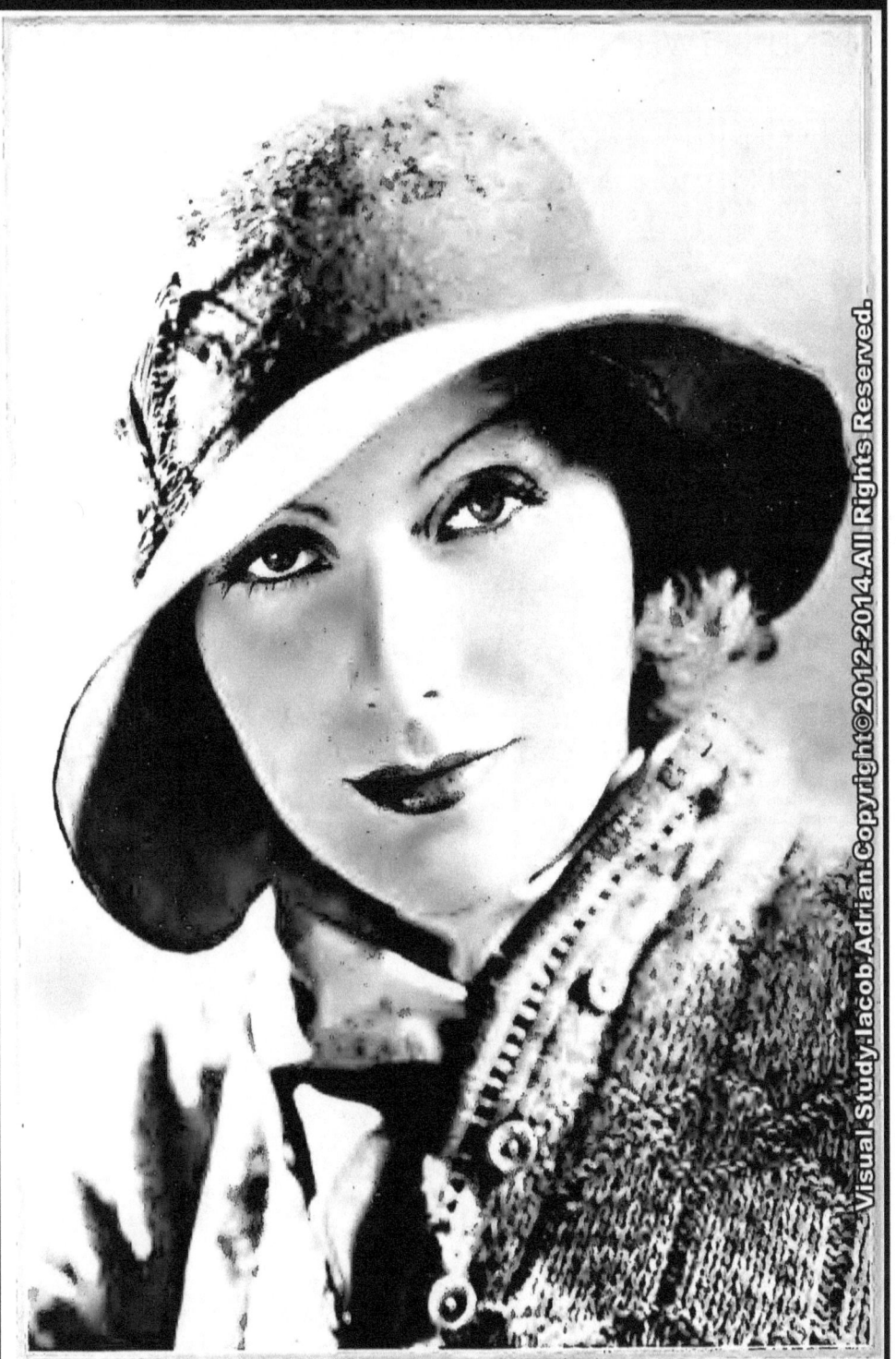

GRETA GARBO

SPEND BETWEEN $5,000 AND $25,000 ON CLOTHES

The glamorous Greta Garbo, away from the studio, affects dull tweeds and flat heel shoes. No expensive wardrobe for Miss Garbo. Yet she is Hollywood's most lavish purchaser of lovely lingerie. She spends thousands every year on fancy underthings.

biggest single item as she affects sports clothes largely; then come the evening slippers, or silk slippers for the very occasional afternoon event. Daytime kid slippers she uses almost not at all.

Estelle Taylor shops in Hollywood and in New York for her shoes; an occasional pair of evening slippers, such as she wears at times, elaborately embroidered for evening or formal afternoon may cost forty dollars. Estelle Taylor never wears sports clothes, hence few sports shoes come into her program. Smart colored kid slippers costing around $20 to $25 a pair, to match her costumes, are her biggest item in the shoe bill. Then come the evening slippers; not as many as the daytime shoes by half, and costing twenty to forty dollars. Fifteen hundred would buy her shoes for a year.

Colleen Moore figures that a busy social year would necessitate not less than sixty-five pairs of shoes. Her shoes run on an average of 25 dollars a pair; this amounts to $1,625 a year.

Nearly all the picture stars

Mary Nolan, at the right, is wearing blue satin, appliqued with real lace, and sewn with tiny seed pearls. This gown cost Miss Nolan exactly $500.

The NEW MOVIE MAGAZINE

10¢ IN US
15 CENTS IN CANADA

THE LARGEST CIRCULATION OF ANY SCREEN MAGAZINE IN THE WORLD

DECEMBER 1930

GRETA GARBO

Visual Study.Iacob Adrian.Copyright©2012-2014.All Rights Reserved.

Who is the Oldest Living Film Star?

CHRISTMAS in HOLLYWOOD
THE SALVATION OF CLARA BOW

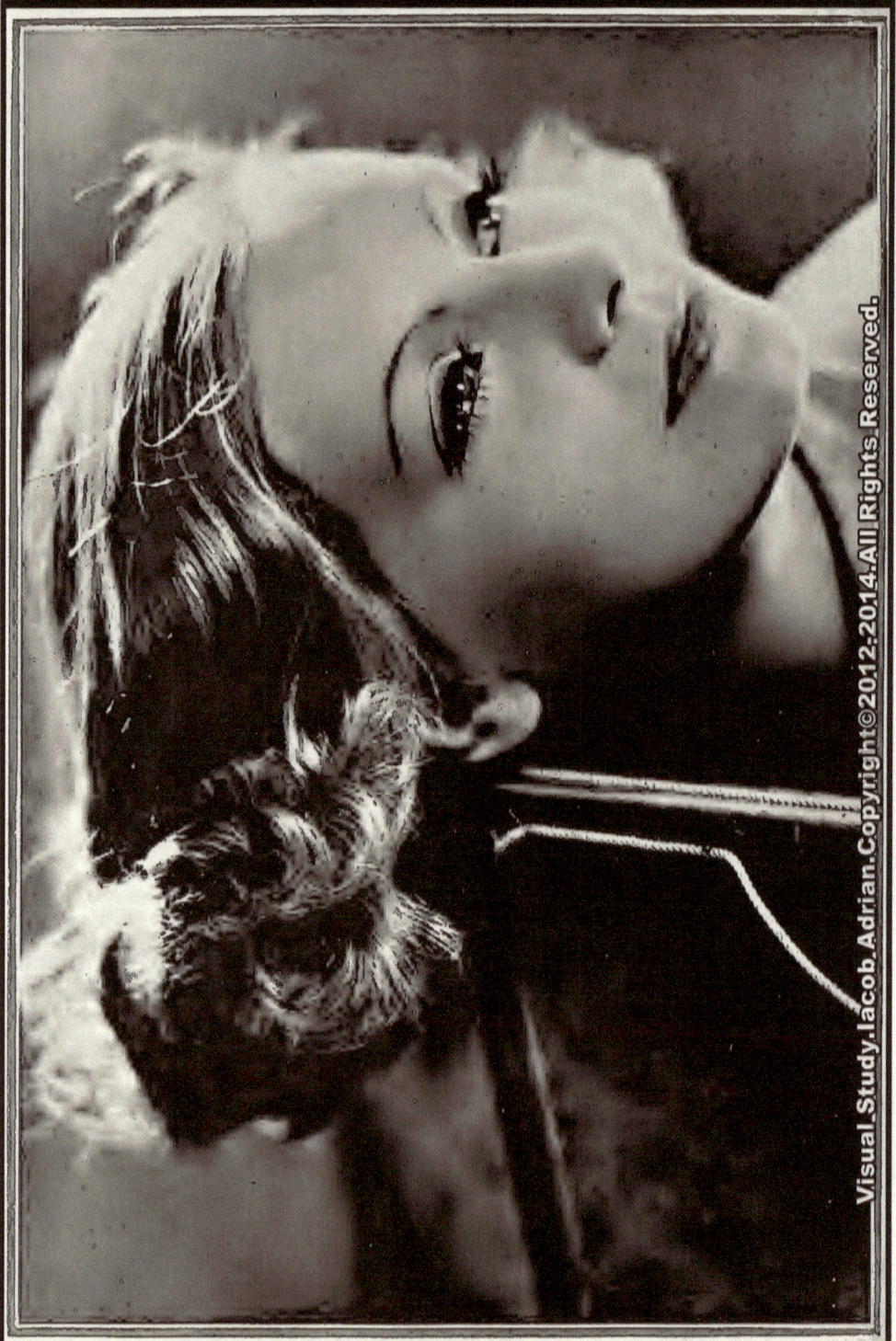

GRETA GARBO

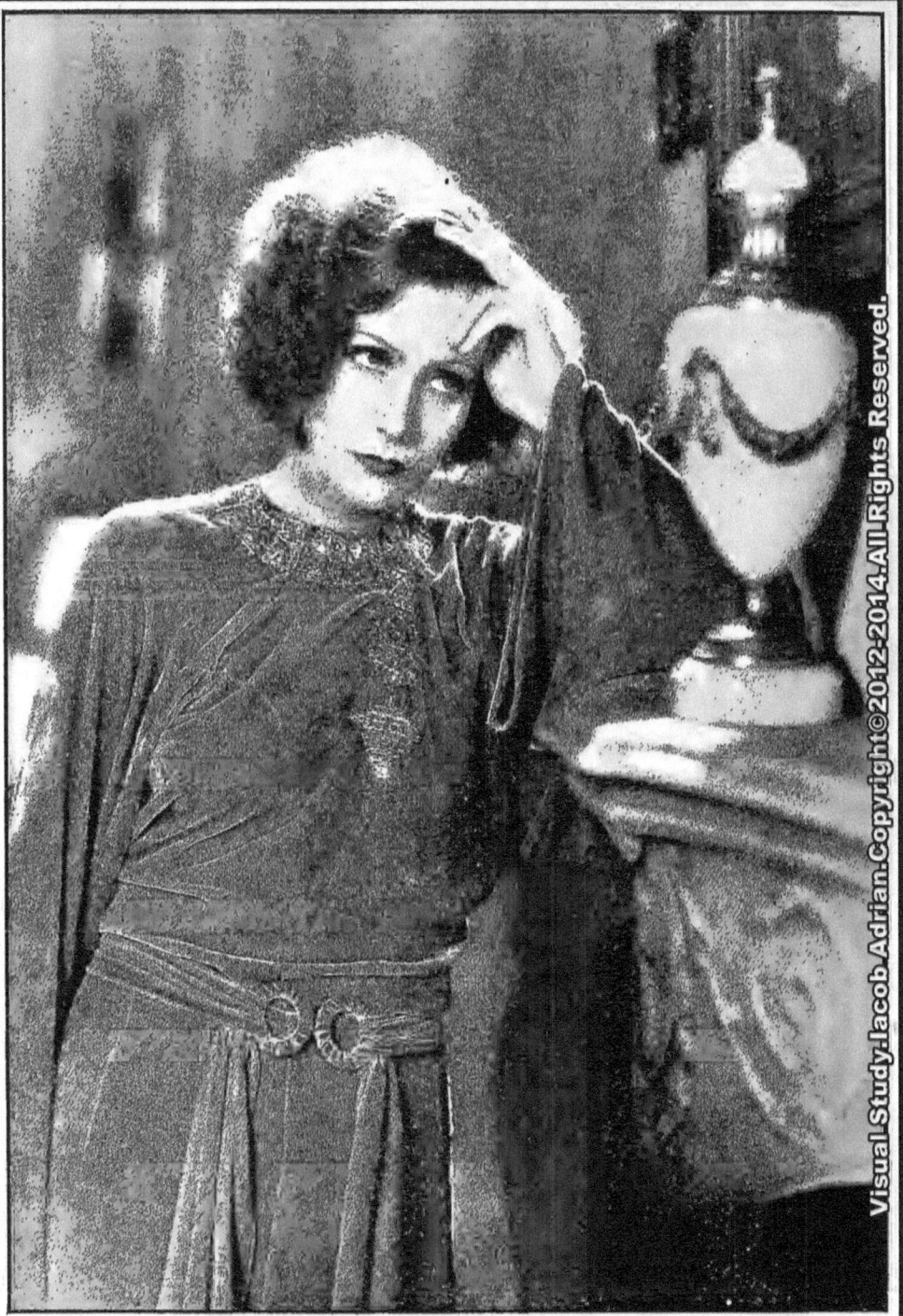

GRETA GARBO—as you will see her in her next talking film, "Inspiration." Miss Garbo plays Yvonne Valbret, the inspiration of all the artists in the Latin Quarter. No, she isn't a model. The scenario describes her as "world weary and a little aloof towards men, yet capable of charming and fascinating all of them." You know how well Greta does that. The popular Robert Montgomery plays the young artist who combats that aloof attitude.

THEN

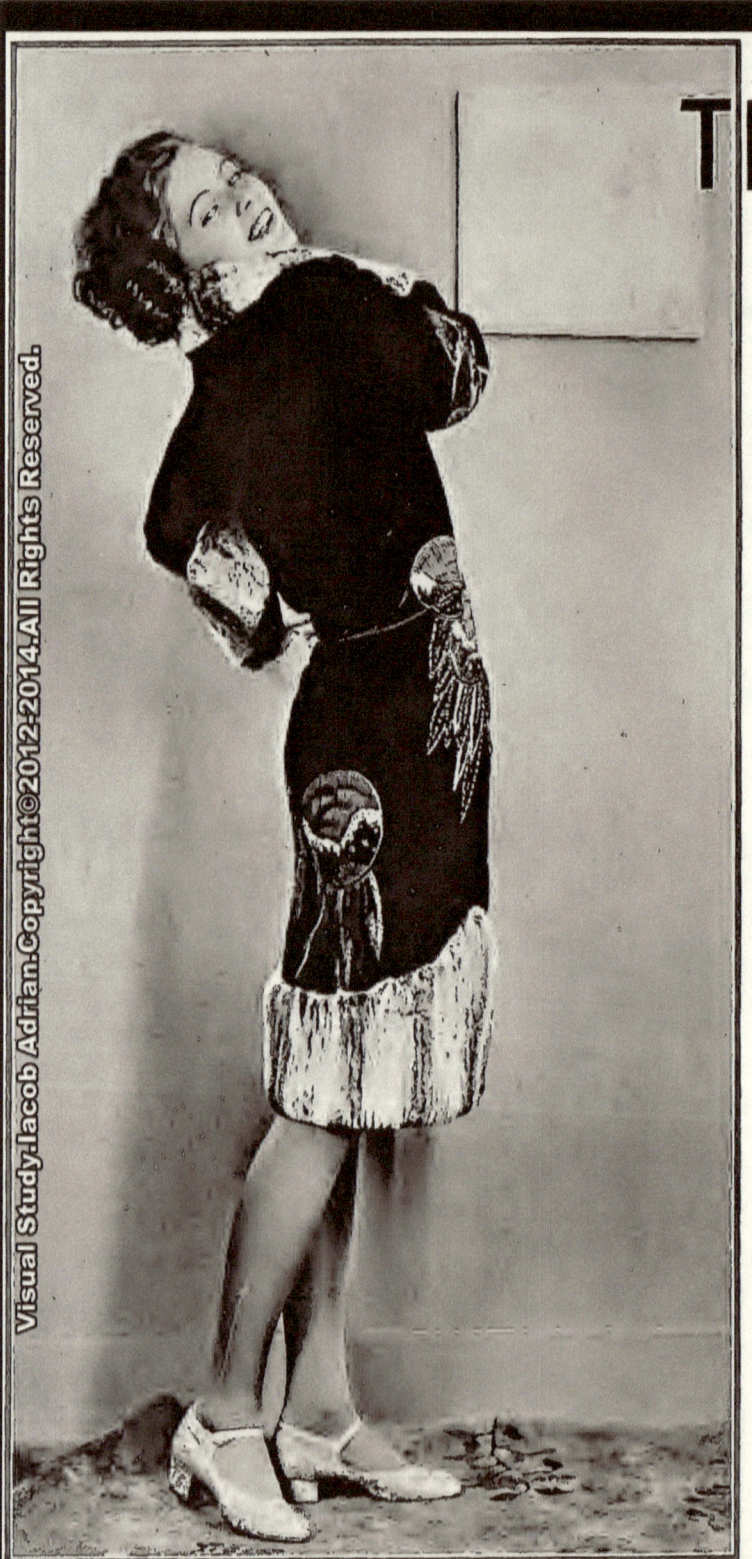

Back in 1925, when Greta Garbo first came from Sweden as the protege of Mauritz Stiller, the press agents probably thought it was necessary for the Scandinavian actress to look coy. Nobody foresaw her great future in the films. She was just another newcomer from abroad —and Hollywood had scores of 'em. Then Miss Garbo appeared in "The Torrent" and— presto—fame!

NOW

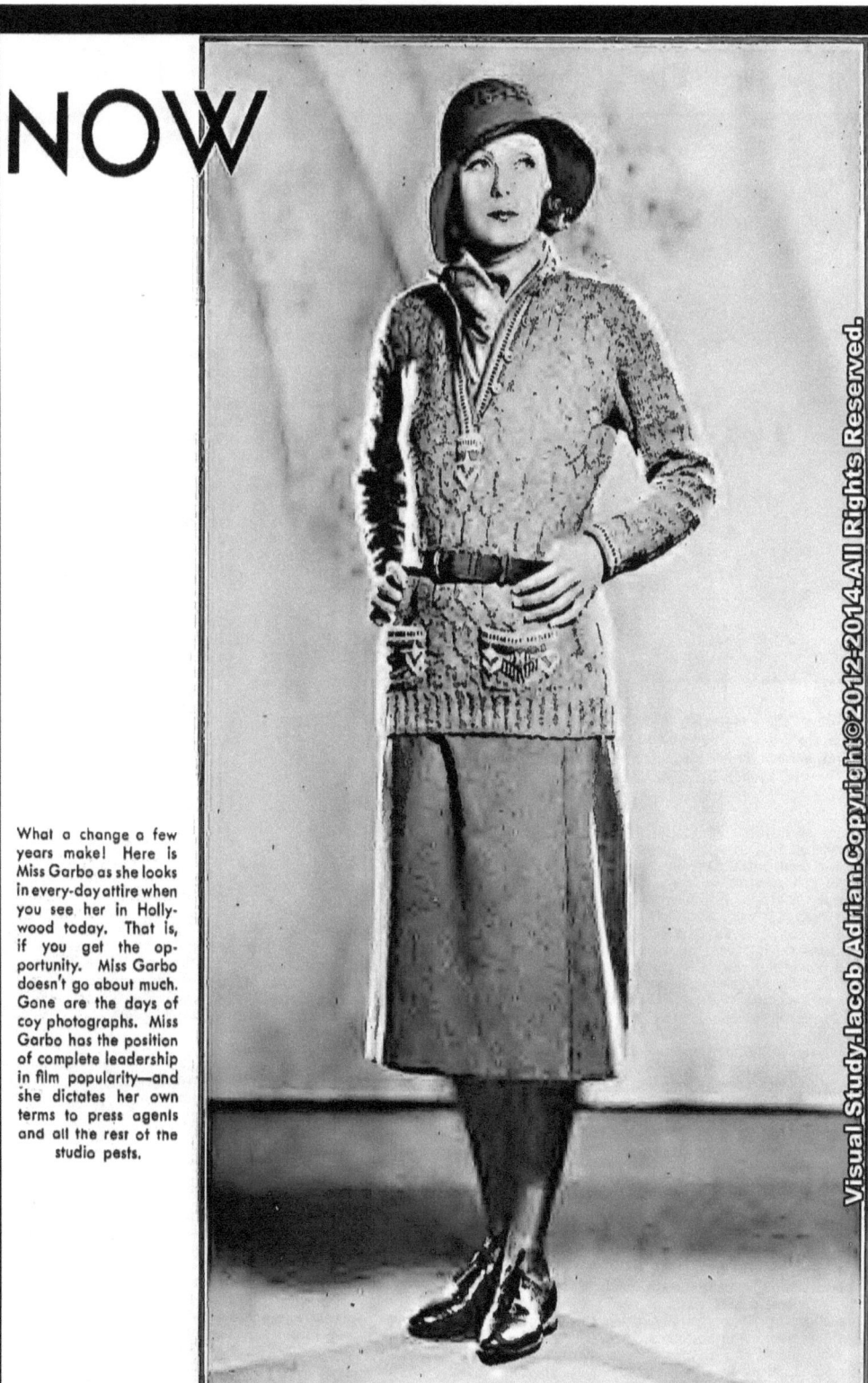

What a change a few years make! Here is Miss Garbo as she looks in every-day attire when you see her in Hollywood today. That is, if you get the opportunity. Miss Garbo doesn't go about much. Gone are the days of coy photographs. Miss Garbo has the position of complete leadership in film popularity—and she dictates her own terms to press agents and all the rest of the studio pests.

Kings Laugh at Comics; Queens Thrill to Sheiks

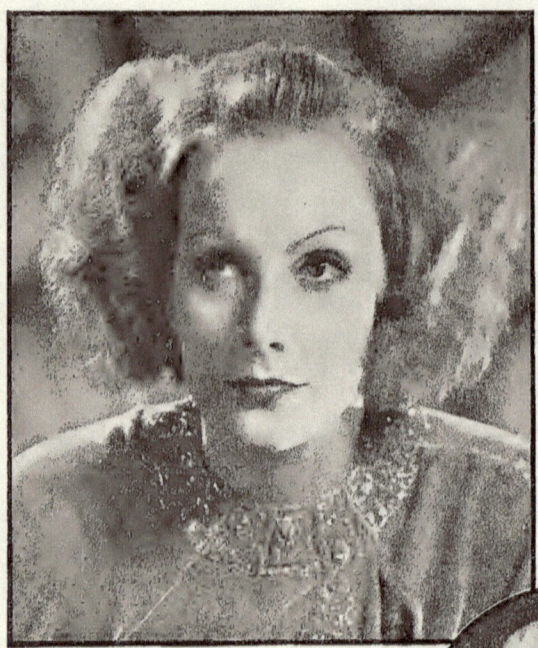

Maybe the Swedish royal family isn't proud of Greta Garbo! They admire her abilities and respect her for her discretion. King Gustav V of Sweden is shown at the right.

liked the picture but has avoided films ever since, deliberately, because he is afraid they will become an enthusiasm of his. His Italian queen, with movies in her blood, can be counted on to bring the films back into favor.

KING ALBERT of Belgium, on the other hand, needs no persuasion. Which is strange in a way because before the talkies came he was lukewarm on the subject. Al Jolson converted him. The King saw the huge promise of the new art and overnight became the most rarin' of them all. When Americans are received at the palace they leave a little dazed; His Majesty seems to prefer to talk talkies than the accepted hokum about international affairs.

Albert would walk a mile to see a good movie and admits it. What is more interesting, he did so recently. He happened to be in Paris a few days after Maurice Chevalier opened in "The Love Parade." This star is an old favorite with the King. Besides, sitting in a hotel suite with nothing to look forward to save a few dreary receptions is not the most amusing occupation in the world. And so Albert unstrapped his crown, donned a derby and with his chin in his overcoat collar slipped through the lobby unobserved.

You would know, if you had ever been a king, how it feels to be alone on a Paris street, walking along like any other mortal man, unobserved, unescorted, and free to do as you please. From the hotel which stands on the Rue de Rivoli to the theater on the Boulevard des Italiens, is only a little more than a mile, and the King did it on foot, not too hastily, and got there, together with the rest of Paris, in time for the second show. There was a long queue winding its way around into a side street. Albert, ruler of all the Belges, quietly walked around the corner, lit a cigaret and took his place at the end of the line, and waited until he came abreast of the cashier, paid his twenty francs, entered, and sank into the upholstery with a sigh of satisfaction, a waiter on one side of him, a clerk on the other.

MAURICE clicked with the King. But Jeanette MacDonald, the wistful, negligee-toting Jeanette, went over double-double, crowding her way into the special place in his affections His Majesty had reserved for Bessie Love and Garbo. And though few may know it, what happened to Albert happened to most Parisians when they saw that picture. They came to see and applaud their Maurice but it was Jeanette they were brooding over when they departed. The King was delighted with Chevalier but how could a mere man vie with a real queen of a girl playing the role of a queen to, you might say, the queen's taste. And what goes for Chevalier goes for the other male favorites of Albert; Lon Chaney, Fairbanks, the Beerys, and Bancroft, all more or less the raw, braw heroes of the tough-guy cinema.

native seem silly. Mussolini, himself the most theatrical figure in Europe, loves the theater and its twin art, the movies. He says he studies them and possibly he does, but he enjoys them, too, down to the last flicker. He glowers at the screen as if it were an assassin. He opens his mouth, and shows his teeth but he doesn't bite—he laughs. He sees the pictures as soon as they arrive in Italy, and sometimes he tells the censor he is a fool, and orders him to release a picture that he had banned. He once expressed a partiality for Anita Page, whose performance in that now ancient film "Broadway Melody," he enjoyed a great deal.

There can be no doubt that the King of Italy, Victor Emmanuel, envies the dictator his easy access to a private theater, for he, too, is a fan, of a family of fans. Recently he and the Queen went to four performances in a week, which, considering that all were in public theaters, is something of a record. At the formal opening of the International Cinema Institute, the King, after being shown a program of educational and industrial pictures, demanded a drama. It had not been intended to show one but to comply with the royal wish one was sent for and shown. It happened to be a film starring Bebe Daniels, which pleased doubly, this roguish star being the favorite in Rome.

When Boris of Bulgaria took as queen a daughter of the Italian King he laid the seeds of his undoing so far as the movies were concerned. He himself has seen only one movie, a Douglas Fairbanks picture. Boris

Queen Mary of England laughs at Mickey Mouse; Queen Marie of Rumania sobs over Sonny Boy

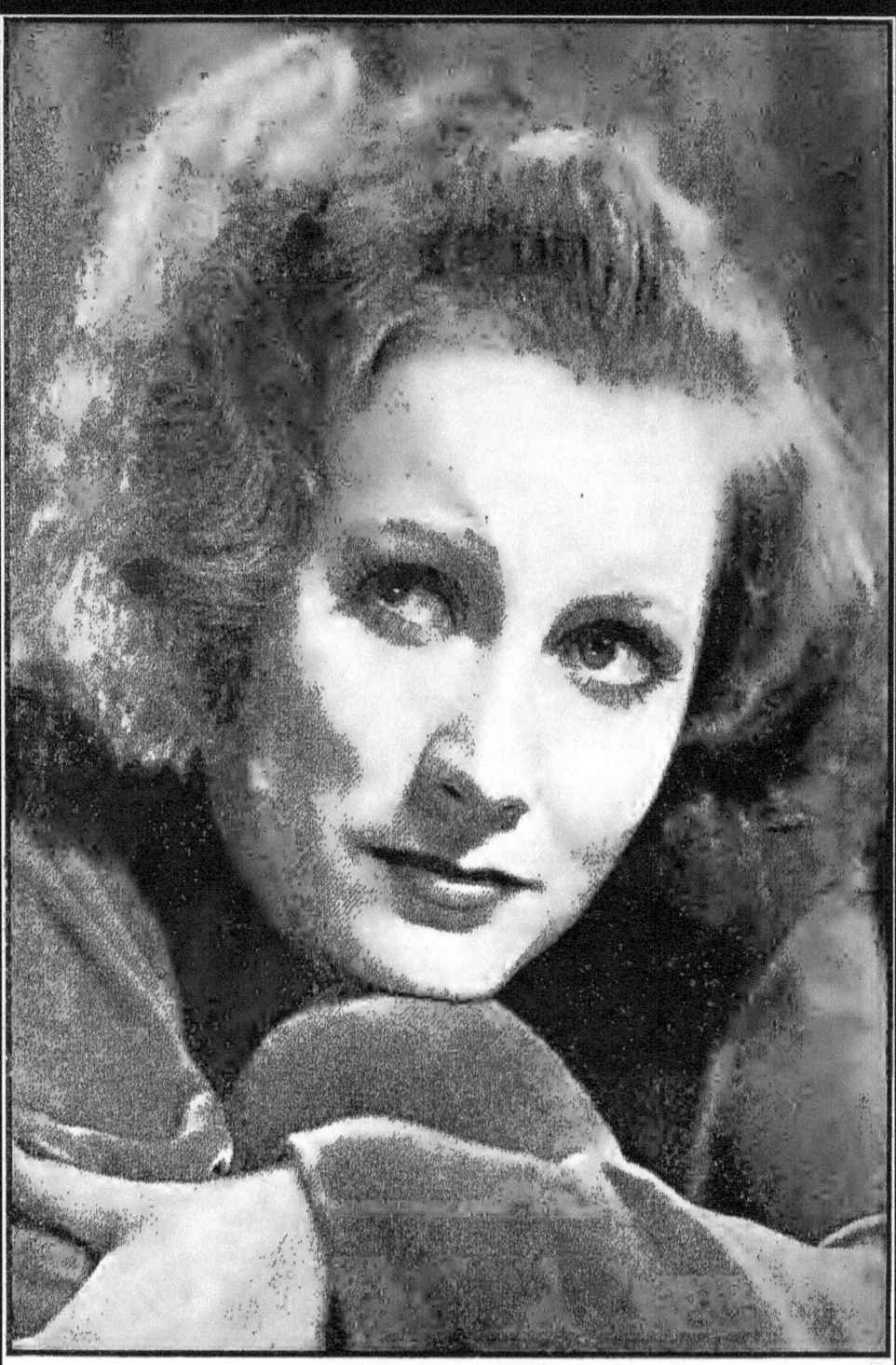

Greta Garbo was very young when Mauritz Stiller discovered her. Indeed, she was little more than a child. He was forty-five—and a director famous across the Continent. There can be no doubt that Greta Garbo's whole life and character were affected deeply and indelibly by Stiller. He was a lonely soul. He taught her solitude.

Great Love Stories of HOLLYWOOD

III

THE TRAGIC LOVE OF GRETA GARBO

By ADELA ROGERS ST. JOHNS

MORE and more the great Garbo shelters herself from the world.

The brief days when she emerged from her solitude and moved among a few friends have ended.

She is alone. There is no romance in her life today. She lived alone—but the few who know her whisper that she lives now with memory and the thought of a dead great man who loved her for company.

Few in this country ever came to know the name of Mauritz Stiller. Yet he created Greta Garbo as surely as Pygmalion created his Galatea. They lived a strange love story, an Ibsenesque love story if you will, and one that has left its imprint not only upon the silent, solitary Garbo, but upon the American public.

Garbo does not speak the name of Stiller. Yet she crossed the ocean alone to stand beside his lonely grave. And whether her thoughts were the thoughts of love, of gratitude, of grief, or of that idolatry with which she once regarded him, no one knows.

NOT so many years ago, the name of Stiller was a magic one in the European theater. In Sweden he held a great place. They regarded him as a genius. In the world of the theater, he ranked above all others.

A gaunt, tall man, with an ugly face illumined by startling eyes that saw through the masks of life, saw into the depths of souls, held those he looked upon with an almost hypnotic power. He was not young. He must have been almost forty-five when he met the young Greta, still in her teens. He had never been handsome. He had no social graces, no gayety, no outward attractions. Yet many women had loved him desperately, while he loved them a little. A very little.

A strange man, marvelous and terrible. With the deep pessimism, the brooding realism of his race. To him his work was paramount to all human emotions, all human contacts.

Only in the last year of his life did he yield to the madness of love. Then he found himself trapped unexpectedly in the embraces of his own creation. He never really loved Garbo until he knew that he was losing her forever.

At the height of his career in Sweden, he sought new material as a miner seeks virgin gold. First for his stage plays, later for his motion-picture productions. It was his joy and his satisfaction to discover raw talent and give it training and opportunity.

Upon such a quest he first met a girl we call Garbo.

In Stockholm, as in most European capitals, is an endowed dramatic academy, which gives courses of training, employment, to aspiring young actors and actresses. After three years of instruction they are ready to enter the Swedish Theater.

Every three months the students of the Royal Dramatic Academy gave a play.

Upon a certain Winter night the cast of an academy play, waiting in the wings for the rising of the curtain, were thrown into a frenzy of nervous excitement by the whisper "Stiller is out front."

> Greta Garbo crossed the ocean alone to stand beside his lonely grave. Whether her thoughts were of love, of gratitude, of grief or of idolatry, no one knows or will ever know.

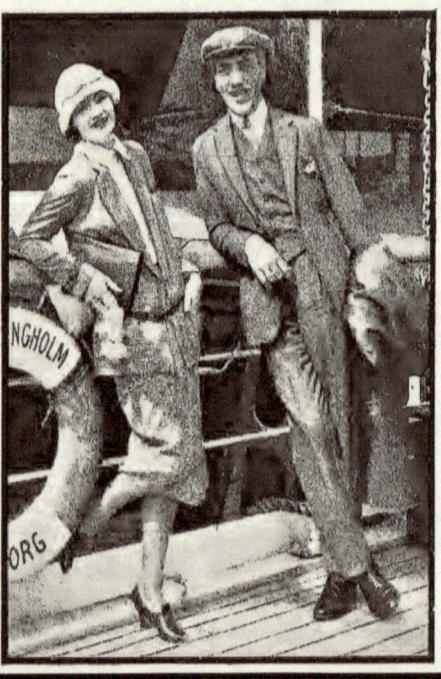

This picture was made when Mauritz Stiller and his protegee, Greta Garbo, arrived on the S.S. Drottningholm in 1925. Strange fates awaited them. To the famous Stiller came disaster and a broken heart. To the girl came fame such as few women have known.

He Created a Film Galatea—and Broke His Heart

When the great Stiller arrived in Hollywood, the Swedish colony turned out to welcome him. His protegee, Greta Garbo, shared in the reception. Who could guess that the unknown girl was marked for enduring fame?

The Great Stiller had come to see the performance. It was as though someone had told a group of college thespians that David Belasco was in the audience. The chance of a lifetime confronted each of them. If Stiller noticed them, if he approved them, success was assured. The slim, beautiful leading lady. The much-talked-of character actor. The suave heavy. They stared at each other, wondering which might be the chosen one.

They worked as they had never worked before, trying across the footlights to catch a glimpse of that ugly, brilliant face.

After the performance they waited. Would he send for any of them? Would he praise any of them? He was talking to their director. What would come of it.

At last the word came back. Stiller, on the morrow, wished to see a girl. Garbo.

GARBO? Oh, surely not. It wasn't possible. Why, she'd had only the merest bit in the play. They stared at her. A tall, silent, peasant girl, who spoke to no one, whom no one knew anything about. They had never even noticed her.

The following afternoon, Greta Garbo presented herself at the luxurious apartment of Stiller. Six thousand miles from Hollywood, which had then never heard of either one of them, began the strange romance which was to give to the American screen its most popular actress.

The girl was trembling with nervousness, voiceless and cold with fear. Silent, she stood before him, utterly overcome. No one had ever paid any attention to her before. At the academy she had battled her way, by sheer dauntless determination. Not a soul had taken her seriously. She had none of the facile ability, none of the ease and grace, of the other girls. Many times she had almost given up in despair, to return to that mysterious place from whence she came.

Looking at Stiller, she beheld in him a veritable god. He was The Master. She was in the presence of The Master. He had called her. She didn't really see the man at all.

Briefly, coldly, he studied her.

"There is no use doing anything or saying anything," he stated brusquely, "until you take off that fat. Go away. Lose some weight. I will send for you again."

HE did send for her again. Those hypnotic eyes of his had seen the power, the fire, the fundamental woman, beneath the awkward girl. Here was no ordinary, pretty-pretty, young thing, to please briefly. This girl would be great or she would be nothing. She came from the soil. She was real, burning, strong. With what he could teach her, she could do anything. They could conquer the world.

Three months later, he summoned her and she came.

In those three months, Greta Garbo hadn't eaten a square meal. Ruthlessly she had denied her healthy young appetite. Every morning she had walked miles and miles in the country around Stockholm. When she appeared before him the second time, she had lost twenty-five pounds.

"So," said Stiller, "you have done it. That is good. It is good not only for the thing itself, but because it shows you have courage, determination. Very good. Are you willing to work, work hard? Are you willing to give up everything else? Are you willing to think of nothing but your work? Can you stand pain, criticism, endless study, endless sacrifice? If so, come with me now. I will make you a good actress. You shall play in my pictures."

HER first picture with him was "Gosta Berling." They worked in Stockholm, in Germany, in Constantinople.

He labored with her for long hours. He taught her the minutest details about acting. He created for her a personality, showed her how to express herself. Slowly, the charm, the beauty, the buried talents began to emerge. But very slowly.

They drifted, naturally, into love. But it was a strange love on both sides. There was no equality between them. As they were separated in years by a quarter of a century, they were separated in position, in mentality.

Garbo was, like all Northern women, slow to awaken. She was, then, a child in years and a child in experience. To her, Stiller was simply the greatest man in the world. She idolized him, obeyed him, served him. His slightest wish was her law.

To him, she was then the clay he was molding. He loved her as man loves his own handiwork. He was selfish at times, he ignored her often, neglected her occasionally, took her for granted always. They were seldom apart, yet they were never really close. He didn't love her. He loved her work and he was fond of her. At times he was miraculously kind to her. At times he was heedlessly, thoughtlessly cruel. It made no difference. He was Stiller. The Master could do no wrong.

THERE can be no doubt in anybody's mind that Garbo's whole life and character were affected deeply and indelibly by this man. He was a lonely soul. He taught her solitude. There was brilliance in his mind, but no lightness. Society bored him. The ordinary

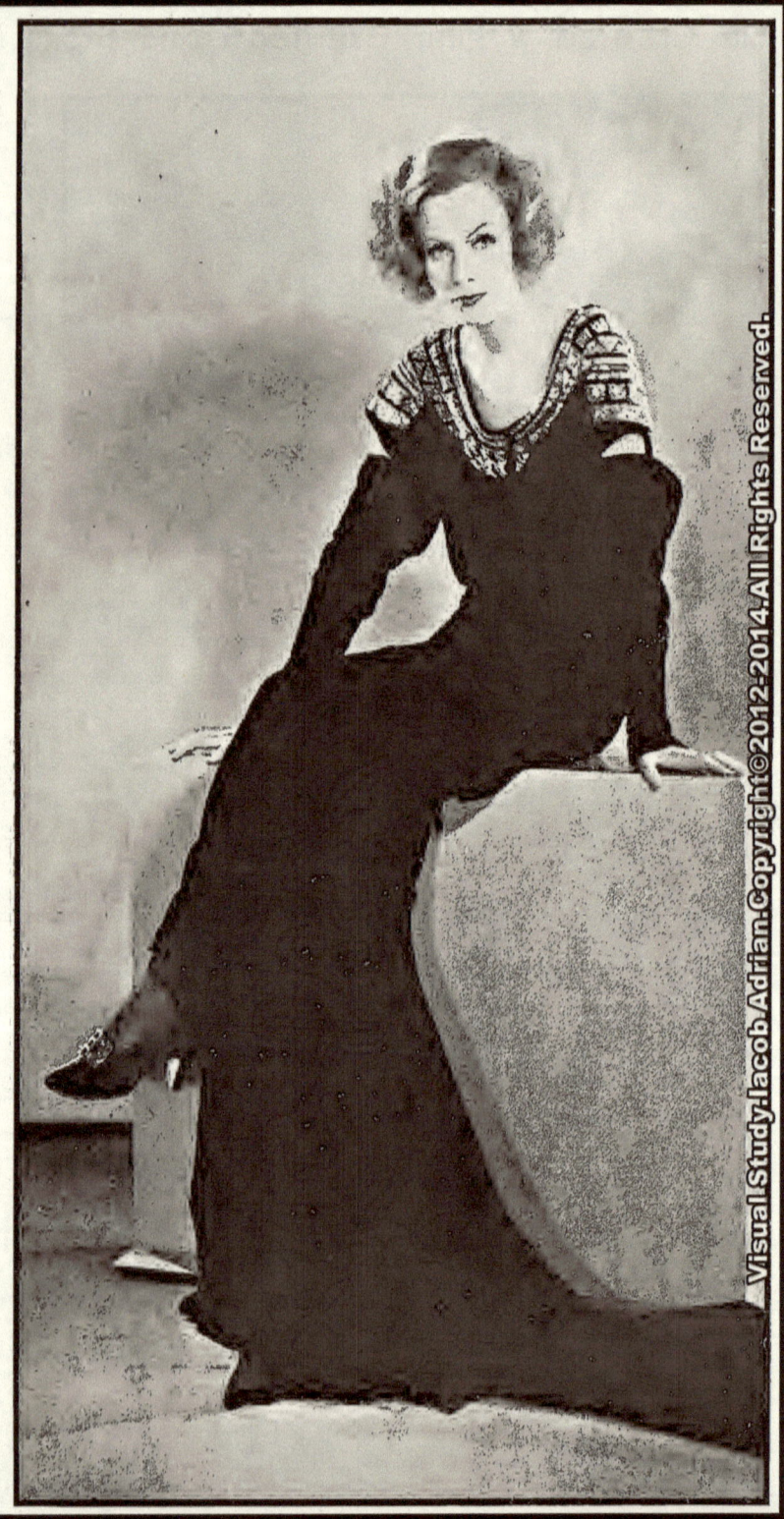

Greta Garbo as she is today. More and more she shelters herself from the world. She lives alone. There is no romance in her life. The few who know whisper that she lives upon memories.

pleasures which a girl of twenty might have naturally sought had never appealed to him, and at his age he regarded them as trivial, useless. Often he had moods of deep melancholy, when he stared with pitiless eyes at the human race and saw life as a formless, terrible monster.

During those years, Garbo was his reflection and his shadow.

In 1925, Louis B. Mayer and his wife and daughters arrived in Berlin. The story of their meeting with Stiller and Garbo is well known, but it must be told as part of this history of their love.

Mayer sought out the great Stiller. He considered him a genius and believed that he could do great things in the American film world.

"Will you come and make pictures for us?" he said. "We can offer you great opportunities."

"I will come," said Stiller. "I bring with me Garbo. I wish to direct Garbo. She will one day be the greatest of all your actresses."

So Mr. Mayer and his daughters were taken to meet Garbo.

They saw a big, quiet, expressionless girl, wrapped in a big coat, with a hat pulled down over her eyes. She

GUIDE to the BEST FILMS

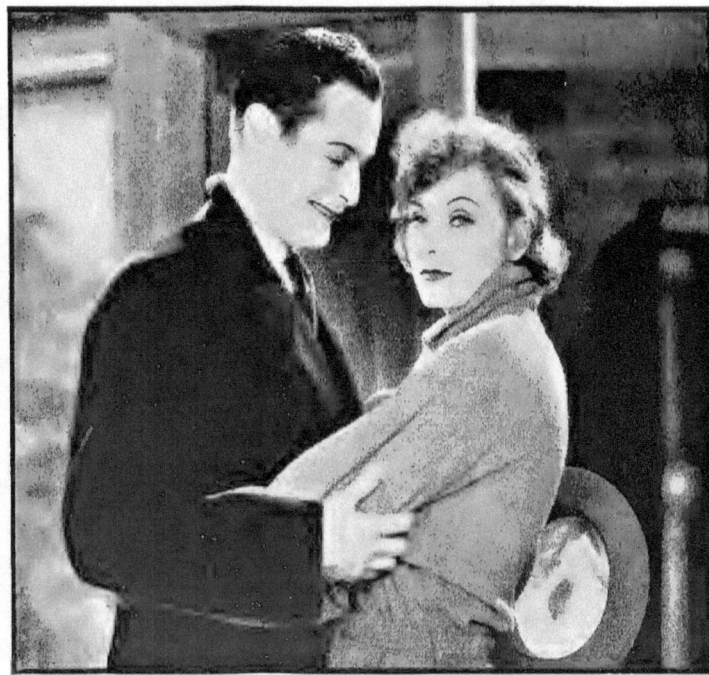

Metro-Goldwyn's newest vehicle for Greta Garbo, "Inspiration," is a "Sappho" in modern dress. Miss Garbo plays the inspiration of the Latin Quarter while Robert Montgomery is the young man who proves to be her first real love. Miss Garbo is better than ever in this film.

Chatterton is interesting in this dual rôle of mother and daughter in a sombre character story. A commendable effort to look into the hearts of two unfortunate women stranded on a bleak farm. Should be appreciated by the more thoughtful picture fans. *Paramount.* Class C.

Paid. They turned back to "Within the Law," a popular stage melodrama, for Joan Crawford's latest picture, released under the title of "Paid." The story is still good and so is Joan's performance. She is one of the best little emoters on the screen. *Metro-Goldwyn.* Class B.

No Limit. The tempestuous Clara Bow spins a mean wheel as boss of a gambling house. Incidentally, she spins herself into a pretty mess before fortune spots her for a comeback. *Paramount.* Class D.

One Heavenly Night. Not so heavenly as one might wish, in view of the talent concerned in its creation. An English musical comedy, Americanized by two well-known writers and acted by Evelyn Laye and John Boles. Pretty, but just a wee bit dumb. *United Artists.* Class D.

Kiss Me Again. Victor Herbert's famous operetta, "Mlle. Modiste" under a different title. Bernice Claire sings the provocative song number and Walter Pidgeon is the heavy lover. The picture is filmed in color, if that helps. *First National.* Class C.

The Bat Whispers. The spookiness in this mystery picture is slapped on with a too heavy hand, otherwise "The Bat" is an acceptable contribution to the shake-and-shudder school of screen entertainment.

Chester Morris will frighten all the children. *Paramount.* Class B.

Illicit. The wedding-ring marriage gets the better of the argument in this version of the love life of a modern Miss, played with emotional fervor by Barbara Stanwyck, who makes the most of her unhappy moments. *Warners.* Class B.

The Painted Desert. A drama of the rugged West that grows wearisome because of the unnecessary deliberate action, intended to be impressive. William Farnum deserves something better than this. *Pathe.* Class D.

Reducing. Marie Dressler and Polly Moran in a rough-and-tumble farce, the action laid in a beauty shop. Anita Page and Sally Eilers supply the beauty. Plenty of laughs. *Metro-Goldwyn.* Class B.

The Command Performance. It all happens in a mythical European kingdom where the heart of a princess is about to be exchanged for the national debt. But it doesn't happen, not with the dashing Neil Hamilton to interfere. Highly romantic. *Tiffany.* Class D.

Man to Man. Grant Mitchell, better known on the comedy stage, scores in a sincere portrayal of a small-town barber, unjustly sent to jail. The story is thin, but in its presentation there is a welcome note of feeling. *Warners.* Class C.

Beau Ideal. A feeble imitation of "Beau Geste" in which the French Foreign Legion gets caught in a sandstorm and in the seven veils of Arabian court dancers. To be quite frank, "Beau Ideal" is an unconvincing gesture. *Radio.* Class D.

The Gang Buster. Jack Oakie having a lot of fun with the racketeers. The audience enjoys it, too. *Paramount.* Class B.

Resurrection. If you want a nice, gloomy Tolstoian evening, this is your picture. Lupe Velez does some real acting as the much abused Katusha. *Universal.* Class B.

The Blue Angel. Important because it first presents that rare combination, Marlene Dietrich and Emil Jannings, Germany's biggest contribution to the screen. *Paramount.* Class AA.

Tom Sawyer. Just right for kids, big and little, long and short. Jackie Coogan has grown into the part of the immortal Tom Sawyer. *Paramount.* Class A.

The Man Who Came Back. Janet Gaynor and Charles Farrell share the honors in an adaptation of a former stage success which does not loom so large on the screen. *Fox.* Class B.

Reaching for the Moon. Douglas Fairbanks as a stock broker with bullish inclinations. He goes in heavily for Bebe Daniels and corners the market. *United Artists.* Class B.

GRETA GARBO

Organdies for Afternoon and Gayly Printed Chiffons for the Evenings Are Now the Vogue

Above, Greta Garbo herself poses for NEW MOVIE costume picture. The casual air accentuated in sports clothes is preferred by Miss Garbo, who wears them with the right carefree manner. Her silk dress of wide belt and scarf collar lines, with button trim, carries out the lines she likes to adopt. The vagabond hat is chosen to set it off properly. Left, Mary Doran wears this charming gown of red taffeta, with stunning black lace mitts and a lovely necklace of cut rubies and diamonds.

Behind the Screen Dramas

WHAT I LEARNED AT A HOLLYWOOD PARTY

AS TOLD TO VIRGINIA MAXWELL

*E*ACH month NEW MOVIE is presenting the real romance of a Hollywood unknown. You can read everywhere of the stars and the famous folk. These stories are of the people who never get their names into the electric lights.

This month NEW MOVIE offers the surprising drama of a little tourist and what happened when she actually met the movie star she had watched so many times in the little theater back home. This story, like the others of the series, is genuine. Some of the names are fictitious of course. But the little dramas are from real life, as they were gathered in Hollywood by Miss Maxwell.

The pictures, made by Stagg, the famous Hollywood photographer, were made on the actual locations described in the stories.

That tennis game was the beginning of everything, although I was far from realizing it then. The players were all well-known picture people. And it was there I met a very popular young star. Her first name is Mary. She took an interest in me—and that interest changed my whole life.

MAYBE we can start off understanding each other when I tell you I was a misfit. Just didn't belong to any clique of girls, never popular with the boys and when I had made up my mind to go in for some sort of career I found, after many disappointing experiences, that I just didn't make good at any of the artistic things I tried to do. I was a dreamer and dreamers are rarely practical people!

It was when I was twenty-three years of age that I found the glorious opportunity of going with my brother to the Pacific coast.

Mother had a cousin who had moved to Southern California for her health several years before. And when Harold's stamp collection business began to prosper and he decided to spend his vacation visiting Aunt Hattie, I was thrilled and delighted to be asked along.

That was how I made my simple and unheralded debut in Los Angeles, which, of course, means to every tourist a trip to Hollywood. No, I didn't get a job as an extra in the movies; nor did I suddenly swing to the heights of stardom through one of the lucky breaks we read so much about. I'm going to tell you about the amazing thing which happened to me at a Hollywood party one evening, just when I had begun to think

It Was Her First Hollywood Party But in the

Mary would never dream of offering me one of her gorgeous frocks to wear, even though I hinted strongly that I'd feel funny in my old lace dinner dress. She ignored the hint, being entirely wrapped up in making up her lips.

Hollywood was one of the coolest little spots on the map. Harold and I were awfully anxious to see Hollywood, for we, like everyone else in the world, had heard so much about it. Two days after we arrived in Pasadena, Aunt Hattie and Uncle Will got out their Ford and drove us over to Hollywood.

WE drove out to Culver City first and right up to the M.-G.-M. Studio gates and asked to see Greta Garbo. The uniformed guard looked us over appraisingly, asked us if we were long lost relatives, and when he learned we were just admirers, wanting to see her in person, he burst right out laughing and told us to write Miss Garbo for an appointment.

Only after several such attempts did we realize how silly we were—actually trying to talk with a world-famous personality for no good reason except idle curiosity.

You can imagine my surprise then when Harold phoned me breathlessly one afternoon to tell me he'd actually been talking with Leatrice Joy. Leatrice, who was formerly the wife of the famous John Gilbert and mother of his little daughter, Leatrice Joy, 2nd. How many times had I followed the story of their romance in the magazines back home. And here was Harold actually meeting Leatrice Joy herself.

Quite excitedly he told me how he was sitting in a stamp-collector's office (Harold always kept his business in mind no matter where he went) when in walked Leatrice Joy. She was making a collection of rare stamps for her baby daughter and had come to purchase some.

The broker introduced Harold and they chatted for quite a while. In fact, it was Harold who sold Leatrice Joy the stamps he had taken out to the coast to dispose of. He hurried home to tell us all the thrilling details of his afternoon, but the crowning glory was when he announced that his friend had invited him to join a group of movie tennis players at a friend's home Saturday. They needed an extra player, one of Harold's ability, anyway, and I was just imagining how Harold must have boasted about his tennis trophies after Miss Joy opened up the tennis subject.

It was funny to hear both Aunt Hattie and Uncle Will handing Harold a whole volume of advice before he went out to Beverly Hills that day.

As I look back upon it now, from my own beautiful home on the mountainside overlooking Hollywood, I chuckle with delight. But that is ahead of my story.

THE upshot of that memorable day was that Harold was asked to bring me along next time. He had told some of the players about lonely me and I guess he worked up a little sympathy in my direction so that they suggested I be dragged along next time. I have no illusions that they urged him or that anyone would ever have missed me had I not showed up.

For me, it was the beginning of everything, although I was far from realizing it then. The tennis game was like most tennis games, except that the players were well-known picture people. Most of the men were in white linen, while the girls wore bathing suits or tennis shorts.

I haven't told you everyone who was at the tennis match that afternoon, since one of the girls, a very popular young star, asked me not to mention her name in this story. Her first name is Mary. It was this beauty who seemed to take an interest in me and for no apparent reason we found ourselves sitting on the side lines, under a huge umbrella, chatting about home towns and linen frocks and layer cakes.

Before the day was over Mary gave me her private telephone number and asked me to call her up. She had a lot of special fan mail she wanted answered and

Moonlit Patio Garden She Found Real Romance

she thought my mind ran in just the right channel for replies. She would outline what she wanted to say and I would put it into lovely words for her.

I WAS delighted with this opportunity, for it not only gave me a few hours work to do each day, from then on, but it afforded me some money with which to indulge in a few of the delectable accessories one sees every day in the Hollywood Boulevard shops. Aunt Hattie was glad, too, for I guess she had begun to grow weary of seeing me hang around the front porch in between dish-wiping events.

To me, it was the open road to a group of charming movie acquaintances and the realization of the first childish desire I had, just to see, face to face, one of my own movie favorites. Before three months had elapsed I had met many of the stars at premieres, at teas, at informal dinners. For Mary had learned that I was more than a secretary. I was conscious of my lack of great beauty, although I concede I am fairly attractive; so conscious of my shortcoming that Mary seemed to appear more beautiful by contrast. She admitted this frankly to me one day during our confidences, so I'm really not being catty in remarking it.

And then came the memorable event of the season. It was a party given by a Beverly Hills society matron. Mary saw to it, for the reason I've told you, that I was included in the invitation. That was how I came to be asked to the grand occasion when we were to meet the most popular male movie star of the day, a movie idol whose fame was international. I had always adored him on the screen. His eyes were liquid pools of passion in close-ups, his profile one which artists came to Hollywood to sculpture. His body was exquisitely moulded and usually the scenario included scenes in which he could show his bronzed muscles covering his tall, slender frame like those of a Greek god. He had always been my favorite star and I know that millions of other girls felt the same way about him as I did.

WHEN Mary told me I was at last to have the opportunity of meeting the one star over whom I'd been raving ever since I got in with the movie set, I was fairly breathless.

So long had I kept this secret affection for him locked in my heart that it seemed almost like a fairy tale that I was to see him, actually be close to him in person, and if we were introduced, to feel the touch of his hand.

Little pins and needles seemed to play through my body all that day, though I tried to keep a poker face on before Mary. I was terribly afraid she would tell

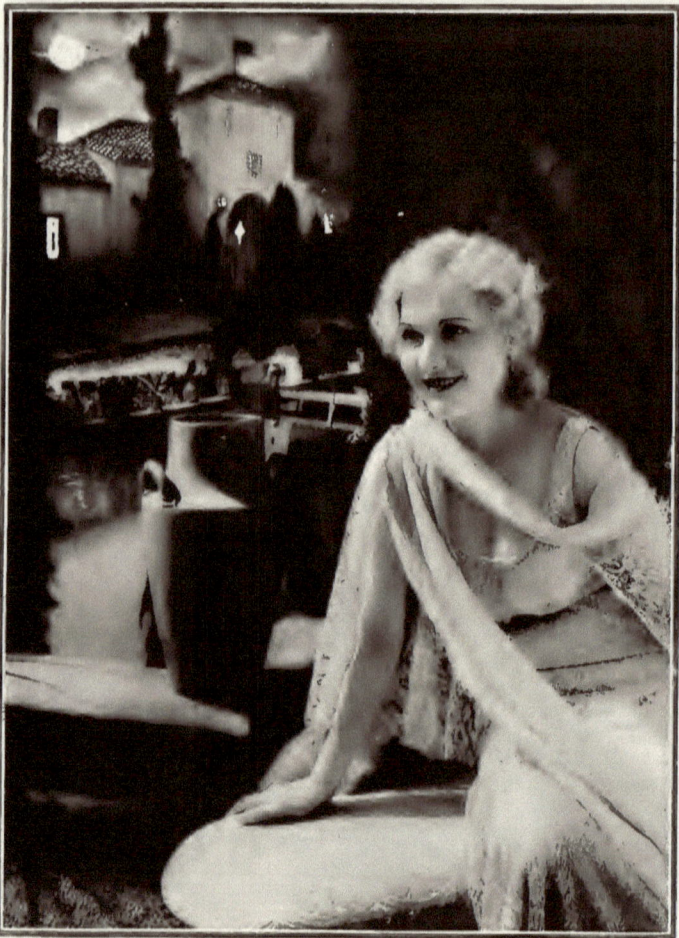

I wandered out to the moonlit patio. It was a glorious night, typical of California—a gentle mellowness in the air like the evenings of early Spring back home. I don't know how long I sat there dreaming, humming the music of the distant Hawaiian orchestra, when from somewhere I heard a familiar voice.

him, and if he laughed, as he probably would, I think I would have died of shame.

So I kept pinching myself that it was all true that night as I carefully dressed for the party. Mary would never dream of offering me one of her gorgeous frocks to wear, even though I hinted strongly that I'd feel funny in my simple lace dinner dress. She ignored the hint, being entirely wrapped up in making up her lips at the moment.

"Your big boy is very high-hat," she said suddenly, as she swung around from her dressing-table to face me. I was surprised that Mary was still thinking of my flattering words about him.

"High-hat? How do you mean?" I asked.

"Every picture star in Hollywood has tried to make him at some time or other—but he gives them all the freeze-out. Conceit, I guess, afraid of having anyone else cut in on his popularity."

It was the first time the thought occurred to me that Mary liked him pretty well

Behind the Screen Dramas

herself. I could tell by the tone of her voice she was slightly bitter toward him because her beauty apparently made no impression.

"And he's never been married?" I said, hoping for more information concerning my movie idol.

"No. He's too high-hat for any woman. Thinks he's a little God whom no one can approach."

MARY ordered her big car for that evening and her uniformed chauffeur to drive us. We had to go only a short distance, but we surely went in style. The car pulled into a winding gravel path studded on either side with huge palm trees and bordered with lanes of wonderfully colorful flowers over which spotlights played.

The house was a massive Spanish affair, set down in the center of a beautiful garden. At the door, two uniformed butlers stood to direct the parking of the cars. Inside, in the flower-decked foyer of this spacious home, our hostess waited to greet her guests. This society woman was giving the party in honor of the famous movie idol whom she'd met on the steamer coming back from Europe.

There was a luxurious buffet supper —everyone helped himself to the dainty bits of food spread out on a huge, lace-covered table in the alcove off the ballroom. Hawaiian string orchestras, in various parts of the house, sent forth their seductive, melancholy music as the guests lolled about on silver cushions strewn about the floor. Low lights and soft music! Beauty everywhere, and perfumes so exquisitely blended the air became almost anesthetic to the susceptible.

And then I saw him! He was standing against the little bar in the buffet room, chatting with an older man. I knew him instantly. He was even more handsome than he seemed on the screen, his hair was so black and his profile so perfectly chiseled. Against the immaculate whiteness of his evening shirt, his skin looked very bronze. I stood breathless for a long minute, studying his face, his build, his every movement while he was quite unconscious of being watched.

Suddenly I saw Mary approach him. She wormed her way through the crowd, got a place at the bar next to him and lifted her glass to his face in a toast which I could not hear. He bowed politely and lifted his glass to hers.

Behind the Screen Dramas

I FINALLY got over to them without seeming to rush things. Mary saw me and drew me to her in an effusive embrace. (That was also to show up her beauty by contrast—*meow!*)

When she introduced us, I couldn't utter a word. The handsome one looked at me from those wonderful eyes and suddenly extended his hand. I found myself grasping his hand and only some one who has lived through it could understand the thrill that ran through me when my fingers touched his. Maybe I did hold on to his hand extra long — I've heard so since — though I didn't realize it then.

No, you'd scarcely believe it, but he actually asked me to dance. Mary told me later he did it only to make her jealous. I felt myself in paradise as we stepped about the low-lighted room; his graceful body close to mine so that I could almost hear the beating of his heart against my own.

The music stopped, all too soon. He looked down at me and said, "Well, shall we have something to drink?"

I nodded, afraid to trust my own voice.

"I brought you some punch," he smiled, flashing his beautiful white teeth, "for I'm taking only vichy with a dash of lemon. Working, you know, on the new picture, and my close-up shots are scheduled for tomorrow."

We chatted a while about the studio, and it was then I believed Mary was wrong in her opinion of this matinee idol. He didn't seem the least bit conceited. I thought he was marvelous.

IN another moment, a slender brunette with eyes like turquoise gems had taken my movie idol by the arm and led him away to another group. He nodded to me as he left and I lifted my hand in a little gesture of farewell.

I couldn't find Mary so I wandered out to the moonlit patio which descended upon a garden of shadowy palms and flowers. It was a glorious night, typical of southern California nights—a gentle mellowness in the air like the evenings of early Spring back home, a soft sky overhead cupped like a huge blue bowl above the earth. Myriads of stars twinkled golden in the sky and in the distance a waxy moon cast its enchanting spell over everything. Not a sound to break the lovely silence of the garden. I stepped down and began walking across the lawn to the arbored pagoda near the swimming pool. From the house I could hear the soft, lilting strains of the Hawaiian music and I felt myself almost in another world.

I found a little two-some seat and sat there looking up at the glorious sky, content to be alone now because I had my thoughts—thoughts of a memorable night which would never come again.

I don't know how long I sat there dreaming, humming the words of the little song of romance to which the exquisite movie couples were dancing back there in the house. All I know is that from somewhere I heard a familiar voice, a voice which suddenly broke the spell when it whispered: "Why are you sitting out here all alone?"

Quickly I turned and my hand went to my throat to stifle the sudden joy and surprise which threatened to make me scream. For there, before me, in this glorious spot of all places, stood the man of my dreams.

"Why, it's you," I breathed, getting up from my seat.

He laughed mirthfully. "Of course, did you think it was my double? I use him, now and then—but only in pictures."

HE sat down and motioned me to take my seat again. I did so at once.

"You haven't told me yet what you're doing out here all by yourself," he insisted.

"I wanted to get away from it," I told him, nodding toward the house, "just to roam around the garden and breathe in this glorious atmosphere. I love to sit all alone and think. Sometimes I believe I never was meant to be very sociable. I've always been that way. I like to read and to take long walks alone and try to think out things about life."

He turned and regarded me quizzically for a moment. "You don't really mean that you prefer to be alone most

Here you have Greta Garbo done according to the principles of dynamic symmetry. This bust portrait was executed by Julian Bowes, New York sculptor. The bust is based on the proportions actually existing in the physical make-up of the famous actress. Because they are of such high order and coincide with the proportions used by Phidias, the famous sculptor of ancient Athens, in his statue, "Athena," Mr. Bowes believes that the proportions actually existing in the head of Miss Garbo are the most beautiful in the world.

THE ONE AND ONLY GRETA GARBO IN THE ARMS OF FASCINATING CLARK GABLE! WHAT A PAIR OF SCREEN LOVERS THEY MAKE!

GRETA GARBO

Sold by her father, she runs away.

The circus owner shows his true colors!

magnificently thrilling in
David Graham Phillips classic love story—

SUSAN LENOX
(HER FALL AND RISE)

with an all-star cast including

CLARK GABLE Jean HERSHOLT
John MILJAN

A ROBERT Z. LEONARD Production

Get ready for the supreme, exotic thrill of your picture-going days! Here truly is gorgeous Greta Garbo in the picture that will make you forget all her previous triumphs. Come and be thrilled!

METRO-GOLDWYN-MAYER

New Movie

DECEMBER 10¢ 15¢ in Canada A TOWER MAGAZINE

GRETA GARBO

Visual Study.Jacob Adrian.Copyright©2012-2014.All Rights Reserved.

HOLLYWOOD'S BATTLE OF THE AGES

Solving the Mystery

The Stars Tell the Secret, for the Famous Actress Was Born with Venus in Scorpio. The Celebrated Astrologer Tells What the Planets Hold in Store for Those Born in September

Greta Garbo, born in Sweden on September 18, 1906, has a remarkable horoscope. Venus was in Scorpio, sex sign of the heavens, and was friendly to Jupiter, ruling success; to Uranus, bringing that success by unusual means; to Saturn, endowing her with application and industry; and to Neptune, ruler of the films. With such an array of planetary influences, her success was assured.

WELL, after eleven months of most agreeable association, the editor has decided to put me to the test.

"Solve for me," he writes, "the mystery of Garbo."

Now I am not what you would call a movie fan. I do not pretend to know the idiosyncrasies of every pretty little thing whose likeness flashes across the screen, but I do know Greta. Not personally—for she is one of the few outstanding theatrical personages who have never entered my studio in Carnegie Hall—but as we all know her: the most engaging, the most intriguing, the most baffling personality in the world of make-believe.

If, therefore, I succeed with the help of the stars in solving "The Mystery of Greta Garbo," I must prove myself the Sherlock Holmes, or perhaps I should say the Edgar Wallace of astrological detectives.

And yet to the stars all things are starlight clear. For Greta Garbo was born, as any competent scientific astrologer, knowing her career, could have guessed, with Venus in Scorpio—the most devious and most mysterious of the twelve signs of the Zodiac. And such a Venus! It is not only in Scorpio, most powerful and most highly sexed of the signs, but it is friendly to Jupiter, ruling success in any line; friendly to Uranus, indicating that that success would be won by unusual means; friendly to Saturn, endowing her with the application and industry essential to that success; and lastly, friendly to Neptune, the Shadow Planet and ruler of the shadow stage, indicating that the success would be achieved on the silver screen.

ASTROLOGICALLY speaking, therefore, there is no mystery so far as Greta Garbo's professional career is concerned. No one with such an array of favoring planetary influences could fail to have achieved success in substantially the manner and substantially the field in which she has achieved it.

I could go much further into detail in backing up what I have just said. Miss Garbo has four planets in the mental, systematic, detail-loving sign Virgo—and as everybody knows, her life in Hollywood is one long succession of business days followed by quiet, secluded, energy-conserving nights. Her directors will tell you that there is no extra boy or girl engaged for her pictures more punctiliously prompt than Greta Garbo; that there is no detail of scenario construction or film production so small that it does not receive her critical, analytical, interested study.

As to the mystery surrounding Miss Garbo's personal life, over which commentators on Hollywood affairs have spilled countless bottlesful of ink, you may have noticed that I suggested, in the very beginning of this brief analysis of Miss Garbo's chart, that Scorpio, the sign which plays such a major role in her picture of the heavens, is itself a sign of mystery. You will recall, too, that Neptune and Uranus, the two mystery planets, were in that sign when Greta Garbo was born. I do not know the exact moment of her birth. In her case, as in the case of all the other stars whose charts I am analyzing, I must depend on the information given me, which, so far as Miss Garbo is concerned, relates only to the day and year of her birth; but if, as I suspect, the planet Venus in this same sign Scorpio was rising over the Stockholm horizon when she entered this life, we should have as complete an explanation as any astrologer could wish—or any movie fan, either!—

of GRETA GARBO

BY EVANGELINE ADAMS

of the well nigh impenetrable haze of mystery with which this Swedish Duse has chosen to surround her life.

So much for the mystery which, astrologically speaking, is no mystery at all!

NOW for more mundane things. Venus is the Goddess of Love. Scorpio is the Sign of Sex. Venus in Scorpio invariably gives its possessor tremendous magnetism, which is usually reserved, in the secretive Scorpio manner, for one individual. Miss Garbo is capable of the highest expression of romance and of the deepest loyalty to the person who causes it. We will not go into the question as to whether she has yet given her heart to any one man—although there are stories of a loyalty to her discoverer quite unusual among the all-too-forgetful Hollywood beauties—but there is unmistakable evidence in her horoscope that she has, or at some time will "love one man 'til she dies."

That Miss Garbo is able to translate this Venus-in-Scorpio emotion so that her magnetism is felt by thousands of people is due, of course, to the influence of Neptune in her horoscope, which, as we have seen in the case of Rudolph Valentino and many other successful screen lovers, enables them to create the image of love when love itself does not exist.

Miss Garbo has not been under very favorable conditions financially these last two years, so if she has succeeded, as we are told she has, in amassing a considerable fortune during this period it is doubtless due to the favoring influence of Jupiter, which enables her to get the money and to the favoring influence of Saturn which enables her to keep it. In fact, the most interesting feature of Miss Garbo's chart, to an astrologer, is the position of Jupiter, the God of Wealth and Success, which is in strong aspect to Mercury, a combination so frequently found in the horoscopes of multi-millionaires.

I wish I had space to tell more about Miss Garbo's chart. Little things are so interesting. For example: I would be willing to wager, in spite of her passion for hiking over the countryside, that when she is tired, she feels the fatigue first in her feet, and that nothing so refreshes her, after a hard day's work, as a change from shoes to slippers or mules. I would like to warn her also to eat only such food as she enjoys, and not to be led astray by over-enthusiastic dieticians. She should be on her guard, also, for any symptoms of appendicitis.

Beginning with the last half of 1932 and extending into 1933 the all-powerful Jupiter will be friendly to all four of the planets which were in the sign Virgo at the time of Miss Garbo's birth; so, regardless of what her success may have been in the past, she can look forward to extraordinary conditions during that period.

FREDRIC MARCH is another celebrity born strongly under the influence of Virgo, who is coming under wonderful conditions for success beginning with the last half of 1932. But, as it happens, he is not a typical Virgo person any more than Miss Garbo is. If the information furnished me is correct, the sign Libra was rising when Mr. March was born; and that sensitive, artistic beauty-loving sign has played quite as important a part in his career as the deeply mysterious Scorpio played in Greta Garbo's.

Fredric March, born in Racine, Wis., on August 31, 1897, is a child of Virgo. The sign Libra was rising when Mr. March was born and that sensitive sign has played an important part in his career. Venus, ruler of the world of entertainment as well as the world of love, was in midheavens. Mr. March's unusual horoscope gives him the intuition of a woman with the logic of a man.

Mr. March's Moon, ruling his relations with the public, is in Libra. So is his Mercury, the ruler of the mind; and so is his Mars, the planet from which he derives many of his most forceful qualities. This combination should give him the intuition of a woman and the logic of a man. It should make him understanding of human nature and capable of portraying it in many different guises.

Neptune, the planet which plays so large a part in the lives of nearly every outstanding performer on the stage or screen, is in that part of the heavens in Mr. March's chart which gives him a subjective turn of mind and causes him to have dreams that come true. This planet is in a most favorable aspect to his Moon, ruling the public, so that it was inevitable that he should follow with success a public career. The fact that the Sun and Jupiter are very nearly in conjunction in Mr. March's horoscope further indicates that his profession will bring him financial success.

Solving the Mystery of Garbo

The most powerful planet in the heavens when Mr. March was born, however, was not Neptune or Mercury or Mars, but Venus. I am sure that this statement will not come as a surprise to thousands of his admirers in the feminine portion of his audiences! Venus rules the world of entertainment as well as the world of love, and since it is in the midheaven of Mr. March's chart, there is no question but that he is in the profession for which he was destined. Moreover, this very favoring planet is in such relationship to the inspirational Uranus and the practical Saturn as to increase still further his remarkable versatility, and to enable him to play successfully either serious roles or those which are conceived solely in the spirit of masquerade.

Mr. March should keep away from his birthplace in order to fulfill his highest destiny. And he should look out for the machinations of Mrs. Grundy, especially when her evil tongue is trained on the subject of married women or widows!

A VERY high type of Virgo person is Doris Kenyon, beautiful young widow of the much-loved and much-mourned Milton Sills. It is interesting to note that she also has the Sun and Jupiter in conjunction, not only indicating that she will be successful financially, but indicating that she will benefit through marriage and through fortunate managerial connections.

Miss Kenyon's horoscope indicates that she has three talents: acting, writing and singing—which is especially interesting in view of the fact that she has tried her hand with considerable

Evangeline Adams, the famous astrologer, analyzes the interesting horoscope of Doris Kenyon this month. Miss Kenyon has just returned to pictures following the death of her husband, Milton Sills.

success in all three of these arts. Virgo very often gives a voice of wide range, which is a favoring circumstance in view of the concert career which I understand she is about to undertake. That this career will be quite as successful as her acting career has been, is indicated by the fact that Jupiter, the God of Success, will be friendly beginning with this Summer to both Saturn and Uranus, a combination which is bound to bring her good fortune in some new and different endeavor.

And, as is the case with most of these early September people, she is coming under the best conditions in late 1932 and 1933 that she has been under for a long time.

Miss Kenyon's Venus is in the noble sign Leo, which is a wonderful place for a woman's Venus to be, in as much as it means that she will never look her age!

If you have been following these astrological articles from month to month, you must realize from the brief descriptions which I have just given of Miss Kenyon's, Mr. March's and Miss Garbo's horoscopes that they are not typical Virgo people, but owe their success in large measure to planetary influences which happened to be active at the time they were born. Miss Garbo, for example, in spite of her systematic devotion to her work, is much more of a Scorpio type than she is a Virgo type. The inference to be drawn from this fact is that Virgo, the sign which rules over the period beginning August 24th and ending September 23rd, is not essentially a sign of the theater.

As a matter of fact, Virgo is ruled by the planet Mercury; and Virgo people as a general thing, seek success—and find it—in mental rather than emotional activities.

In short, Virgo the Virgin has small place in the annals of Hollywood!

WHAT THE PLANETS HAVE IN STORE FOR PEOPLE BORN UNDER VIRGO

VIRGO the Virgin, the sixth sign of the Zodiac, is ruled by Mercury, the God of the Mind.

The typical Virgo person is, therefore, above all a mental person—a person blessed with an intellectual vision of virginal clarity and purity. He has an inventive, systematizing brain. He is logical in all his mental processes. He has keen observation, and notices details that would escape the ordinary person.

If you are a Virgo person, this last trait is sometimes a very uncomfortable one for your friends!

Your justifiable pride in your own abilities makes you critical of others. You must watch this tendency, as it may be construed as conceit; it may even turn into that undesirable quality. You should cultivate the sympathetic, tolerant side of your nature, and speak more freely in praise of others. Don't be afraid to show your appreciation.

You are just as apt to turn your excellent critical faculties on yourself as on others. This is a good trait, if not carried too far. Keep the results of your self-analysis to yourself. Don't bore others with it!

You are commendably slow to anger. This is a contributing factor to your mental efficiency. You are also slow to forgive. Be careful of the latter trait. You have a great flair for system. This also is an aid to you in whatever work you undertake. Be careful, though, not to go too far in imposing your systems on others.

You are not exactly a "good mixer," but your mental equipment is so fine and your command of it so complete that you can force yourself intellectually to a social attitude that will increase your popularity threefold.

Many excellent teachers, accountants and private secretaries are found under this sign. Virgo men usually succeed in manufacturing, and as builders, miners, farmers and real estate dealers. It is also a favorable sign for many kinds of literary endeavor. Zona Gale, Rex Beach, Theodore Dreiser and H. L. Mencken are all Virgo people.

The sons and daughters of Virgo—that is, those who are born between August 24th and September 23rd—do well to seek their life mates among the natives of Taurus or Capricorn, but much depends, of course, on the position of the planets in the individual chart.

Their tendencies, if ill at all, are toward disorders of the liver, spleen and pancreas. They should not ignore symptoms of gall stones, peritonitis or typhoid fever. They should choose simple diets and avoid excessive use of alcohol.

The final injunction is very important for you Virgo people. You have fine minds. You should keep them clear!

The COLLEGES Select Their FAVORITE STARS

Greta Garbo, Winning All the Polls, Turns Out to Be the Collegiate Idol

BY ANTHONY JAMESON

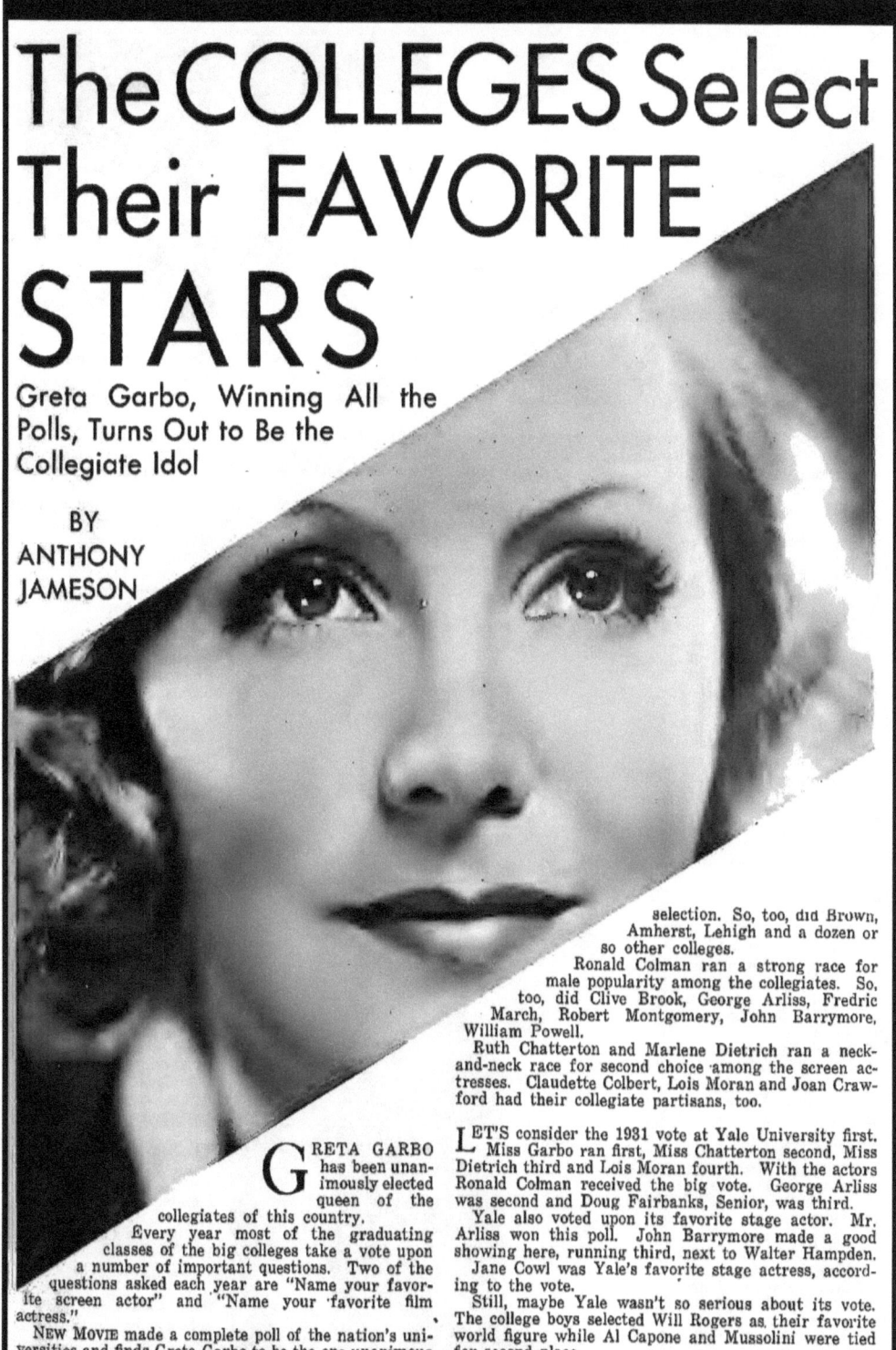

GRETA GARBO has been unanimously elected queen of the collegiates of this country.

Every year most of the graduating classes of the big colleges take a vote upon a number of important questions. Two of the questions asked each year are "Name your favorite screen actor" and "Name your favorite film actress."

NEW MOVIE made a complete poll of the nation's universities and finds Greta Garbo to be the one unanimous selection of the college boys and girls.

Yale voted for Miss Garbo. Columbia voted for her. Princeton named the favorite Scandinavian as its selection. So, too, did Brown, Amherst, Lehigh and a dozen or so other colleges.

Ronald Colman ran a strong race for male popularity among the collegiates. So, too, did Clive Brook, George Arliss, Fredric March, Robert Montgomery, John Barrymore, William Powell.

Ruth Chatterton and Marlene Dietrich ran a neck-and-neck race for second choice among the screen actresses. Claudette Colbert, Lois Moran and Joan Crawford had their collegiate partisans, too.

LET'S consider the 1931 vote at Yale University first. Miss Garbo ran first, Miss Chatterton second, Miss Dietrich third and Lois Moran fourth. With the actors Ronald Colman received the big vote. George Arliss was second and Doug Fairbanks, Senior, was third.

Yale also voted upon its favorite stage actor. Mr. Arliss won this poll. John Barrymore made a good showing here, running third, next to Walter Hampden.

Jane Cowl was Yale's favorite stage actress, according to the vote.

Still, maybe Yale wasn't so serious about its vote. The college boys selected Will Rogers as their favorite world figure while Al Capone and Mussolini were tied for second place.

Columbia University, in the heart of New York City, voted for Greta Garbo and Ronald Colman.

Princeton University also selected Mr. Colman, in

MARLENE DIETRICH
Yale and Amherst Like Her Next to Garbo—and Can you Blame Them?

GEORGE ARLISS
He's Yale's Favorite Stage Actor and Their Second Screen Choice

FREDRIC MARCH
Ran a Strong Race for Favor Among the College Boys and Girls

RONALD COLMAN
Captured First Place at Yale, Columbia, Princeton and Lehigh

second place. William Powell ran an easy third.

Princeton voted for Miss Garbo, of course. Miss Chatterton was its selection for second spot and Miss Colbert was Princeton's third choice.

At Lehigh University, which is located at Bethlehem, Pa., Miss Garbo was first choice again. Miss Chatterton ran second and Joan Crawford was third. Lehigh picked Mr. Colman as its favorite film actor. Clive Brook was second and William Powell third.

OUT at Stanford University, on the West Coast, the vote was a lot different. The frat men selected Charles Farrell as their favorite actor. He received 1782 votes. Robert Montgomery ran a close second, just one vote behind. Fredric March was third.

John Barrymore, Ben Turpin, Maurice Chevalier each polled one vote. McLaglen was named "cutest" and Buddy "most virile."

The non-orgs or "barbs" selected Doug Fairbanks, Junior, as their favorite. Ben Lyon was their second selection, with Slim Summerville third. Antonio Moreno fourth, and Mickey McGuire fifth.

The Stanford sorority belles selected Victor McLaglen as their favorite. Stan Laurel was second and Buddy Rogers third. The vote of both boys and girls gave Polly Moran first place with 3654 votes. Mitzi Green was second, with 1001 votes. Miss Garbo didn't get a single vote.

Marion Davies, however, polled 345 votes for third place, while Ruth Chatterton, Mae Murray, Billie Dove, Miss Dietrich, Winnie Lightner, Jean Harlow and Beryl Mercer ran in the order named.

Amherst named Miss Garbo as its favorite. Miss Dietrich was second. Fredric March was Amherst's choice as favorite actor, with Robert Montgomery in second place.

Brown University's year book vote resulted in the selection of Miss Garbo as Brown's favorite motion picture actress. Miss Chatterton was second choice. John Barrymore was Brown's first choice among the screen actors. Clive Brook ran an easy second.

At Brown, too, the faculty went on record unanimously for Miss Garbo.

YOU can draw your own conclusions from the collegiate votes.

It seems to me that the boys and girls made singularly sane and well-balanced decisions.

When you stop to think about it, their decisions really represent the opinions of all movie audiences. Miss Garbo would run first in any national voting contest, without a doubt. Miss Dietrich and Miss Chatterton would be strong contenders. And national audiences certainly would select their favorite from a list numbering Messrs. Colman, Montgomery, Brook, Arliss, March, Powell and Barrymore.

IF Miss Garbo will step up on the platform she will be awarded the Collegiate Loving Cup for the year 1931.

Right this way, Miss Garbo!

Ruth Chatterton turned out to be a favorite among the college boys and girls. She ran right behind Miss Garbo in collegiate favor.

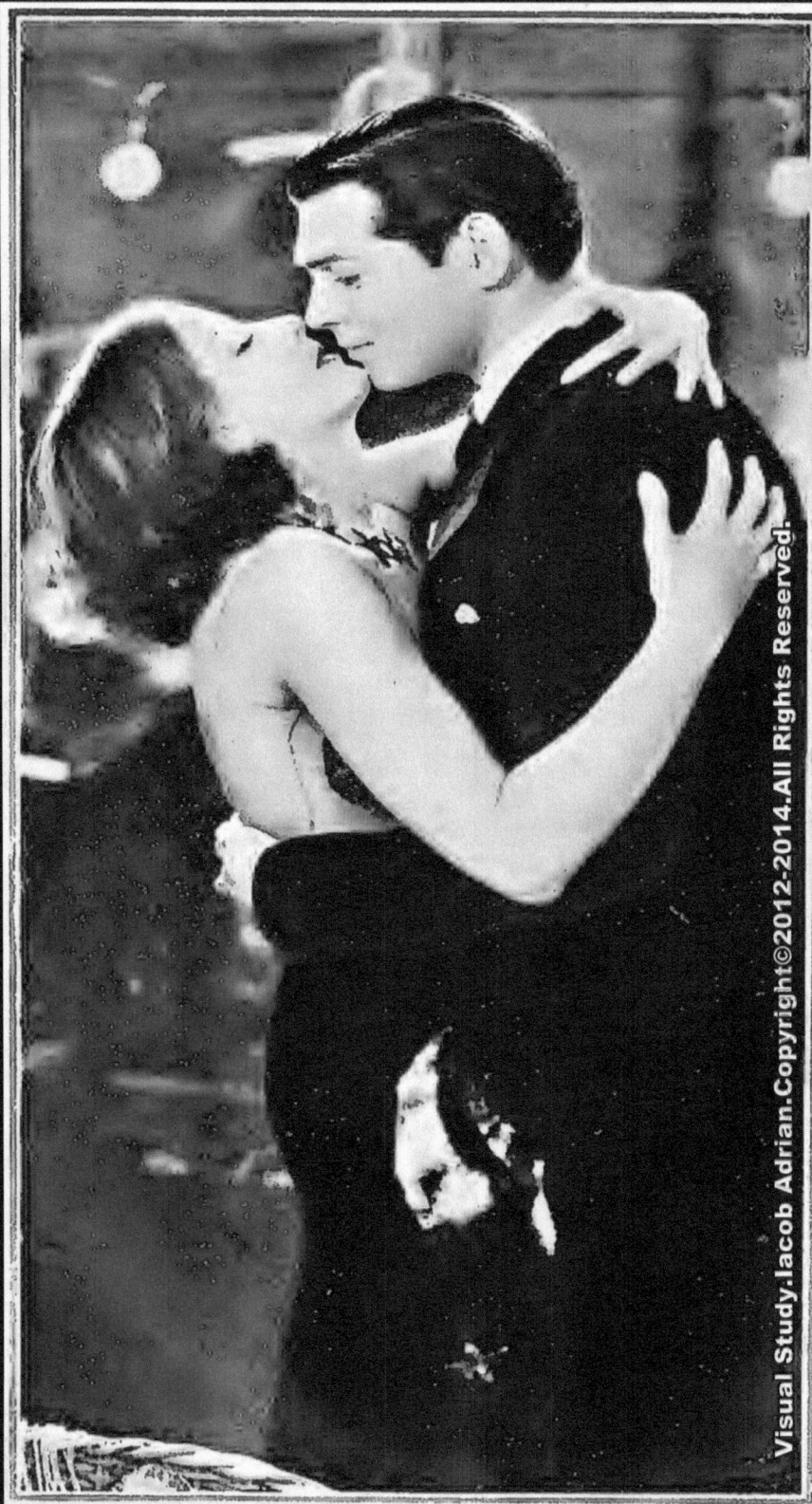

The POSE Pays

By HARRY CARR

 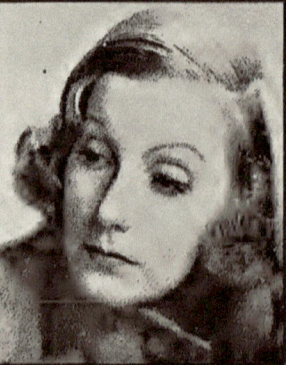

The pose of recluse started with Lillian Gish and has been perfected by Greta Garbo. In neither case was it a false pose. With both stars it grew out of their unusual shyness. But in both cases it added to their fame.

NOW that Legs Diamond is in the Big House and Al Capone has tearfully confessed, all of the rest of us might as well walk up to the Amen Bench.

I never did much with beer. The racket I knew was making movie stars like something they were not.

It's still going on—the Trappist-monk-like silence and taciturnity of Greta Garbo—the Latin volatility of Dolores del Rio—the intense marriedness of Joan Crawford . . . the good-old-palishness of Hedda Hopper—the J. Pierpont Morganness of Corinne Griffith. . . .

The newest "act" to come pecking out of the shell here just happened. It was invented by Herb Howe and Pola Negri. It is terrible. It just ain't fair to the other girls. If it proves catching, all the little stars will drag you behind a corner of the set and tell you the secret diplomatic intentions of Briand—how the German admiralty scooped the world with the new cruisers—the secret war plans of the French air service—what is behind the mechanization of the American cavalry. Gosh! Gosh! Gosh!!

THIS thing started—largely through my evil machinations in the days of the Mack Sennett beauties.

One day I got an unfortunate hunch to show the domestic and softer side of Hollywood and its queens by telling all about a lovely new bungalow belonging to one of our beauties. As I remember it, the young lady selected was the delectable Mary Thurman. Mary happened to be sharing a shabby apartment with another girl—Juanita Hansen. That wouldn't do at all. So we decided gracefully to give Mary a house. This was done by the simple process of planting her in the driveway of the first good-looking house we saw; rigging her up in a sun bonnet with her apron filled with near-roses and—well, there you were—Mary and her nice new house. . . .

What we hadn't figured on was the jealousy of the other beautiful young ladies. They all demanded new houses and the stars gave us plainly to understand that we couldn't get by with the bungalows that we gave the girls who were just in stock.

Big and better houses became the Valkyrie cry.

In desperation we went on and on.

In the end I gave Phyllis Haver the castled towers of the magnificent Southwest Museum in Los Angeles as her Hollywood cottage. Straightway I found myself in hot water with Gloria Swanson. I squared myself as well as I could my making her a present of the $50,000,000 Huntington Library in Pasadena as her little homey nook. Then I struck before some other lady could demand the Grand Central Terminal.

STRANGE to say, the next publicity racket had to do with Lillian Gish—who does not fit into rackets.

Lillian had been made a star and, in the opinion of many critics, she made the best job of the acting part of any girl who ever showed on a screen. But she wasn't getting the necessary fame. Fame makes cash customers. It was not a question of vanity. It was a question of selling the goods. Other girls of lesser ability were driving Lillian right off the front pages.

We tried to make her talk to reporters—to do stunts. She just couldn't. She was a very timid, shy girl. She almost passed out with the prospect of meeting reporters; the idea of making a public appearance left her in a fainting condition.

All that was left for us was to make the best of a bad matter. To our surprise, our desperate device made a sensational success. We planted Lillian as the recluse—the little "she" monk who remained alone with her thoughts. We would like to let the reporters talk to her, y' understand, but Lillian was cast for the part of a French peasant girl and—during this period of spiritual preparation—she ate only French food;

thought French thoughts—read French books—associated only with French people. Gosh, man! What cha wanta do—just jar her out of her art by posing for a picture laying the cornerstone of the Old Ladies' Rest Home?

It worked, but more has been done with the idea since. Garbo has given it the Tiffany finish.

EVERYTHING has to start out in a crude way. Even Robert Fulton didn't launch the *Ile de France* when he invented the

The monastic seclusion of Ramon Novarro was built by his press agent advisers. So picturesque a background had been created for him that the press men feared he couldn't live up to the act. Hence the seclusion. The pose paid, as you know.

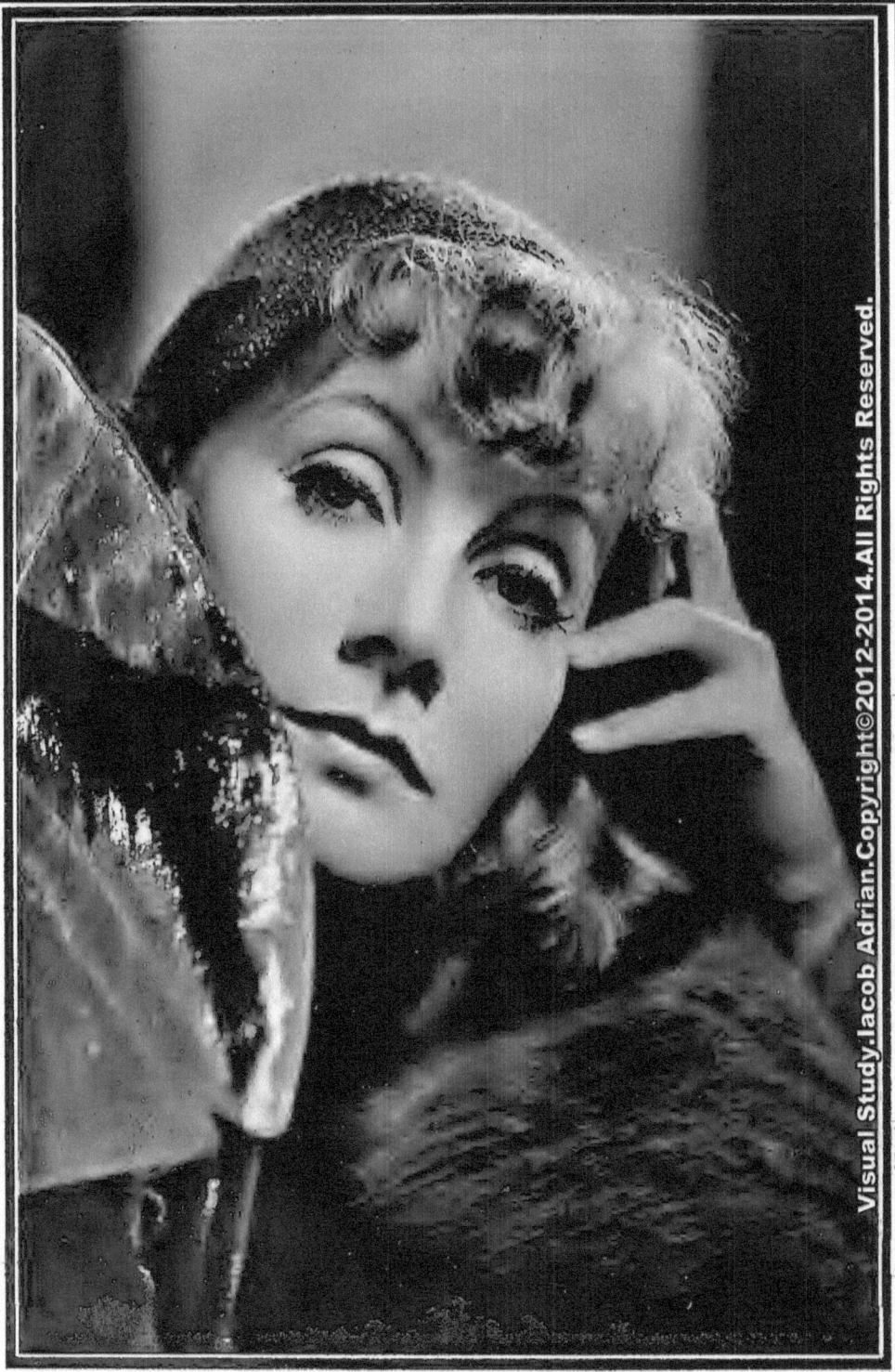

GRETA GARBO

GRETA GARBO — The Glory that is Garbo transcends even the cruel medium of caricature in this unusual study of the screen's most glamorous personality, as depicted by Avtori, noted Italian artist and basso. This is the first exclusive publication in America of this unusual pen-picture.

Brutal? Cruel?—But Fearless!

Jim Tully Dissects GARBO

Jim Tully, vagabond writer, whose ruthless pen finds a new and different Garbo

A MAN who is a Watchmaker sat through a Garbo film and said when it was over: "I'd like to get that woman into the shop and take her apart to see what makes her run."

A good many millions of other people have the same idea of a something they would like to do. The majority are convinced they would find inside of her only a myth. Others cling to the notion they would find some strange new essence of woman.

Most all of them would be surprised by what they really would find. Garbo is much more than a myth, and much less than a woman—considering that a myth is supposed to be elusive and a woman desirable.

Garbo is not elusive. When you first meet her you see her, find her, know her immediately. That is, if you have any kind of a brain at all.

No matter what the circumstances of that first meeting, your first impression is—if you look beneath exteriors—that you are running into Louvisa Gustafsson, a Swedish peasant girl who lathered more faces in a barber shop and sold cheap hats in a second-rate department store. Her hands and feet and round shoulders, her thick neck, masculine jaw, and a voice that all the languors of the world haven't robbed of its guttural quality, are the things that belong to the peasant girl. So, there is no myth about her. There she is.

But, now that she is the great Greta Garbo—and make no mistake as to my analysis, she is "great," in a way—you think of her as a woman and wonder about that side of her. You won't find a woman. As Louvisa Gustafsson she wasn't a success in the barber shop for the all-comprehensive reason that the men patrons preferred any one of the other women to lather their faces. In the department store she could sell only the cheapest hats, to patrons who were interested only in the price tags. Only one man who has been in love with her missed her after she turned to someone who could do her more good. That man, Swedish like herself, died before he grew accustomed to the relief in not having her around. Consequently he may be said to have been the only one who missed her. John Gilbert didn't miss her. Ina Claire once said that if ever she divorced Gilbert she would look around and try pick up another of Garbo's "ex's." "They are so appreciative," Ina explained.

"Garbo is much more than a myth and much less than a woman ... considering that a myth is supposed to be elusive and a woman desirable. Garbo is not elusive. When you first meet her you see her, find her, know her immediately. That is, if you have any kind of a brain at all."

NOW that Ina has finally divorced Gilbert, she may have some difficulty finding an ex—of Garbo's. The wise men of Hollywood cross their fingers when Garbo is about. Brain and cunning are desirable qualities, but a man doesn't want too much of either in a boudoir.

But the fact remains indisputable that the Louvisa Gustafsson who became Greta Garbo because it sounded better is the world's outstanding screen actress. In more particulars than one she stands alone in the midst of her film sisterhood. Not a myth in any sense of the word, we still want to take her apart. Less than a woman, every laborer's son and every college boy wishes his girl were a Garbo.

Her early film history is, of course, pretty well known. The department store in Sweden made an advertising film and chose the hat saleslady as one of the background because she was thin and tall and would photograph well. Next year they put her in another advertising film. That experience stirred her ambitions. She persuaded her family to take more of the wages her brothers earned, so they could get along without hers, and then began to haunt the Swedish studios.

She was eventually given a small rôle in a film made for Japan. It was called "Eric, the Tramp." Frans Enwall, head of a government dramatic school, took her in as a pupil. She played some small film rôles and attracted no attention.

One day Mauritz Stiller, Sweden's greatest director, saw her on a film and sent for her. That was when the clock struck twelve for Louvisa, and the echo of the chimes still rings around the world.

Today it is a characteristic of Garbo to like things that are different. Some

Jim Tully Dissects Garbo

say it is a pose. I don't think so. I think she is naturally cynical and contemptuous, a thing the Swedish workers who came to her barbershop sensed about her.

ONE class says that the girl deliberately set out to make Stiller fall in love with her in order to win his influence on her behalf. I don't think so. And I haven't come to my opinion without knowing and studying Greta Garbo.

I think she was attracted to him because he represented, in the first place, the world into which she was trying to break, and in the second place, because of his grotesque difference from all other men. She was a timid, slim, gawky creature then. He was the big master. However, there is no doubt about Stiller. He fell in love with the awkward, serious-minded and stubbornly hopeful girl. Fell in love with her as a woman and as a potentially great actress.

Louis B. Mayer of Metro-Goldwyn saw some of Stiller's work and imported him to this country. Mayer saw the girl, Garbo, and didn't think anything about her except that she had to come with Stiller the same as one of his trunks. Film magnates are accustomed to that sort of thing.

In the Hollywood circumstance the Swedish director who was a czar at home was only a new experiment. He talked in favor of the girl he'd brought along and the studio officials listened politely. They are accustomed to hearing directors talk in favor of young women. They listen and promise and forget.

Now you may begin to see the inside of Garbo.

She saw the direction the wind was blowing. She might have picked out another director, though Hollywood directors who amount to anything are cagey. She turned to an actor instead. And she chose the actor, the same as Stiller had chosen her. One who had in him potential greatness. She chose Gilbert. And calmly walked away from Stiller, who still was refusing to do great work unless they promoted Garbo too.

Stiller went back home, broken. Garbo was busy at something or other and didn't have time to go to the station and see him off.

GILBERT was instrumental in getting the girl cast in "The Torrent." Louis B. Mayer, viewing "The Torrent" in the studio projection room, looked twice at this girl, Garbo, and then had the film run over many times. From there on new cinema history began.

Other pictures followed with Gilbert. He got an eight thousand-dollar-a-week contract and Garbo got one for ten thousand dollars. People began to notice Garbo. Watch her. Study her. She made up her mind she had to be different and *was* different. But her greatest decision, while her success was being born, was really to fall in love with Stiller—whom she had let go off with a broken heart. She threw Gilbert over and settled down to dramatize the memory of a love. At a dinner one night, in full view of a crowded dining room, she caught the hand of the man sitting across the table from her and kissed it. She didn't know the man, and he was astonished. She left the table in tears, not explaining.

The man's hand was a big, beefy hand. People began to compare notes and reminiscences and it was recalled that Stiller's hand was big and beefy.

Stiller died in Sweden of a broken Garbo-torn heart. She'd kissed a hand in Hollywood that looked like his, but she hadn't written him a love letter.

Because she still is the peasant, Garbo is petulant and stubborn. She is utterly indifferent to anyone who gives her a lift upward. She has no sense of humor. She is sincerely surprised by people who ask more about herself than about her work. Opinions are, of course, divided. Some of these, which can't be published, are not complimentary. I don't believe them. She is, of course, utterly selfish. It is a pose to ignore publicity which is the very essence of her success. Ignoring it she gets it. No one is allowed on her set when she is working. She is discourteous to reporters, but reads what they say every morning.

Now, then, we must be fair to the woman. She has a quality of courage that is true. More than cynical indifference. When "Anna Christie" was being cast wise ones told her that Marie Dressler would steal the picture from her. She faced the camera with an intrepid heart. No other woman on earth or in Ireland could have held her own in that picture against the wisest old trouper ever born, Marie Dressler. The Swedish peasant did it with the unconcern and power of a primitive animal.

It is said she is too lazy to open either her mouth or her eyes. That is wrong. The girl is a tempest under control. Some say she is only "lucky." That is scandal. She is a great, a very great artist.

SHE is neither jealous nor envious, any more than afraid. They brought a new importation from Europe, a girl who was touted as a "new and better Garbo."

Garbo went on. She was utterly indifferent to this new and widely publicized find. When the newcomer failed and was going back home Garbo sent her one of her rarely autographed photographs. "From your true friend."

In "Susan Lenox," her last production, the film is opened by the appearance of a shadow on a wall. You recognize Garbo, about to appear. The shadow brings out all of her physical imperfections. Rounded shoulders, flat chest. She is no more seductive in this shadow than the policeman at the crossing.

Then she comes full into the picture.

Gone is the pitiful life-whipped woman of the shadow. In her place is Garbo of all the allure, bringing desire into the world.

The throwing of such a shadow of a lesser woman would have been the year's great film blunder. With Garbo it was different.

Someone has said that no man or woman is greater than his or her shadow.

Garbo is far greater than hers.

The Garbo we know, and the Garbo that counts, is less than a woman but —she is an actress.

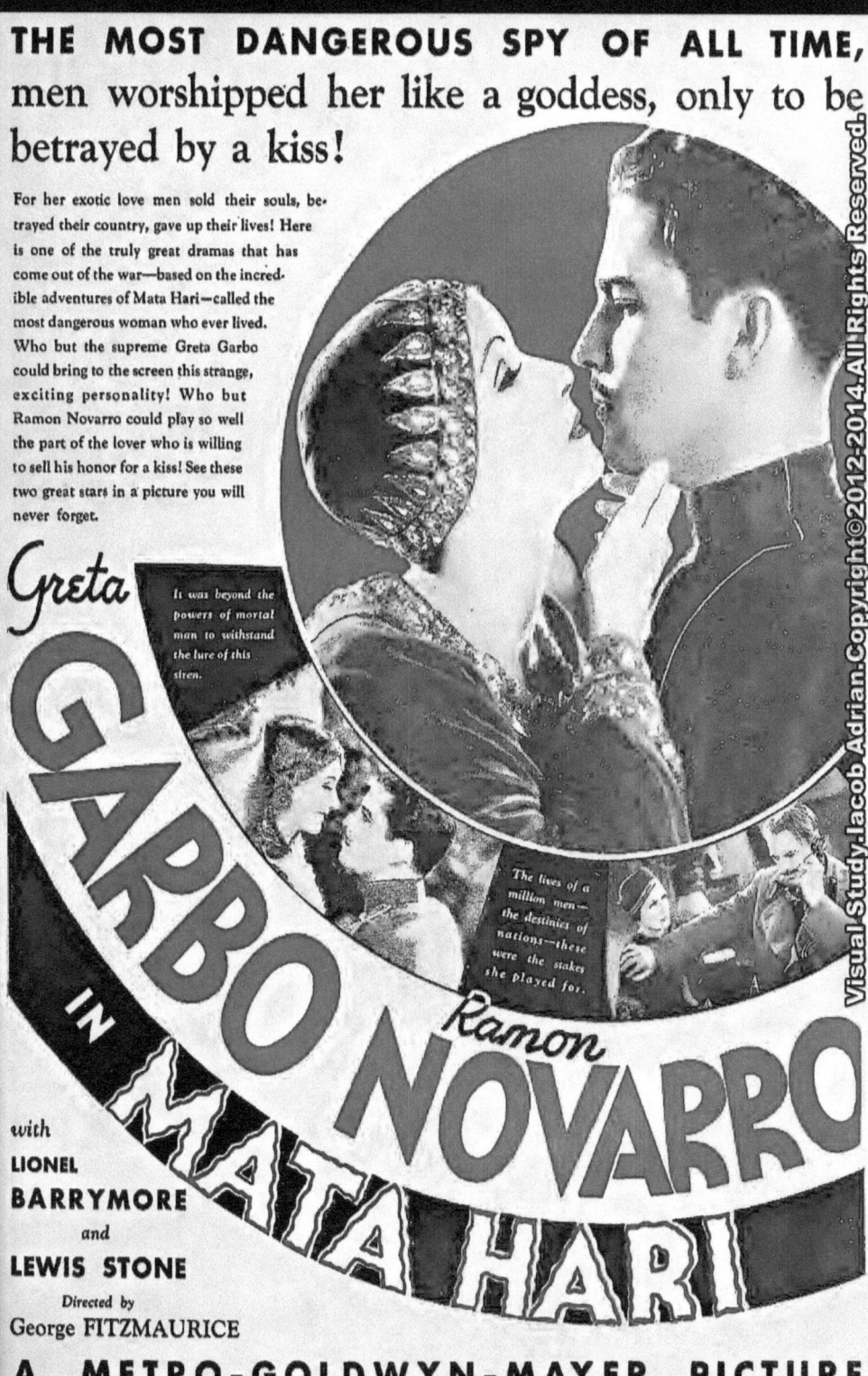

Garbo's "MATA HARI" Is One of Her Greatest

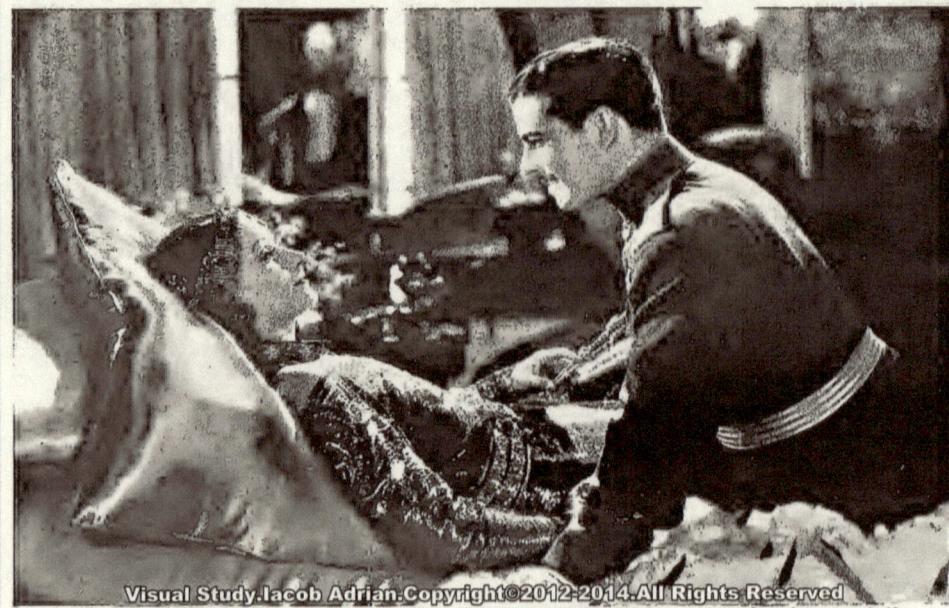

Greta Garbo and Ramon Novarro in a scene from "Mata Hari" (M-G-M), a story of a Javanese half-caste spy in the service of the German government whose career ends before a firing squad. Garbo immortalizes her character part and makes one of the most powerful war dramas yet produced. Her ritualistic dance before the God Kali in an early sequence is one of the beautiful episodes in the picture. Portrayals by Ramon Novarro, Lionel Barrymore, Lewis Stone and C. Henry Gordon are excellent. This picture, directed by George Fitzmaurice, is easily one of Garbo's best, and leaves an indelible impression that she is the screen's most sincere artist.

This is an unusual view of Greta Garbo, but then Greta is an unusual woman. Much of the wistfulness that flickers by so rapidly on the screen is caught in this photograph.

GARBO IS LIKE LINDBERGH

By R. Fernstrom

AS a newsreel cameraman I have knocked around ... perhaps quite as much as our friend Tully. During this time, some ten years or more, I have learned to know people—especially Swedes —and many of Greta Garbo's type.

I have hunted moose with the present Kings of Sweden and Denmark; traveled through the Swedish provinces with their Crown Prince and Princess. Even here, in our own country, my assignments have included many Swedes or Americans of Swedish extraction, including Colonel Lindbergh.

In addition to all this, I am an American of Swedish descent and, though born and schooled in our country here, have spent several years in schools over there.

I have made several trips to Sweden in recent years and spent about two years there in these visits.

I think I understand Swedes.

GARBO is like Lindbergh. They act alike toward publicity. They shy from reporters. Garbo is like the King of Sweden in many ways—kind, but aloof to everyone.

America is the promised land— or was—to all Swedes. Sweden sent us the best and hoped they would make good Americans. One of the persons most interested in American-naturalized Swedes is their king.

They make some of our best citizens and have contributed greatly to our arts and sciences. Why, if it had not been for one John Ericsson our boats might yet be side-wheelers. So, a Swede invented the propeller of the plane; a Swedish-American Lindbergh flew to France; and now a Swede is the world's reigning movie queen.

Swedes are proud and sensitive. Slow to anger, but slow to cool, also. They are all ambitious, but also fair players and square shooters.

DID JIM TULLY DISSECT GARBO?

By Ned C. Williams

I HAVE just read Jim Tully's "dissection" of Garbo in the January NEW MOVIE and an immediate urge for retaliation has taken possession of me. I have known her slightly for a number of years. This so-called "vagabond writer" with the ruthless pen has gone at his subject so vigorously that I am prompted to come back at him in just as ruthless a manner. Begging patience of my readers and apologizing for my methods, which may be a little crude, I proceed in defense of this lovely lady.

The writer's name, which he forced before the public through such a beautiful literature as the "Circus Parade," and by his reputation as an ex-pugilist, is undoubtedly the only thing that has sold this article.

It assuredly wasn't what he had to say or the way he said it.

Knowing Garbo as I do, I can't believe that she had very much of a conversation with him. Possibly his friend, Mr. John Gilbert, said, "Miss Garbo, this is Jim Tully," and that was all there was to it. This "brutal, cruel, but fearless" person offends me with his remark, "When you first meet her, you see her, find her, know her immediately. That is, if you have any kind of a brain at all." This statement is characteristic of a person who has failed to get any kind of an interview from Garbo.

The type of article Mr. Tully has written is an outcome of Miss Garbo's indifference. Because she has the good sense to want to keep her private life private and her soul her own, a certain class of rude and unrefined newsmongers have thought it a clever idea to get revenge by panning her. Here is exactly what Greta has said to me about writers she has talked to: "I talk to them and answer their questions, and soon I read things I have never said in my life. And what I have said is so enlarged that I scarcely recognize it. They all poke fun at me."

Jim Tully's article on Greta brought many letters of praise and protest. Here are two of the most interesting.

Garbo is Like Lindbergh
By R. Fernstrom

Perhaps that is why he is often called a "square head."

Jim Tully—in your magazine—calls Garbo a peasant.

She is not a peasant and never was. I defy anyone to go to Sweden and find anyone who looks like the accepted peasant type that everyone laughs at.

Swedes are a contented, peace-loving and industrious people. They have been at peace with the world for over a hundred years. They are diplomats, instead. We can learn much from their sane laws.

They were one of the first countries to give women the right to vote. Divorce by mutual consent. Trial marriages. Equal share of expense of raising children after divorce, if the women are financially able. Then, also, a sane solution of the temperance or liquor situation.

SWEDES who come here resent the general conception of them. Therefore, they are always on their guard. They are a quiet, easy-going people who cannot understand our hustle-and-bustle ways. Our wisecracks hurt them, and they vow to themselves that some day they'll show us what these "dumb Swedes," "crazy Swedes," "Square Heads" *can do*.

A Swede as I said, may be slow, but once he gets going—look out. He plods stubbornly along toward his goal and usually reaches it—as both Lindbergh and Garbo have done.

To understand a Swede, you must know and speak his language. And it is *not* gutteral at all, but rather sing-songy. It is the happy language of a happy people.

Our hustle and bustle, their task of learning our American tongue and slang, plus the battle to understand our ways and to struggle to forge ahead, has a tendency to make the Swede unhappy. And a Swede who is unhappy is silent. Yet he never deviates from the course he has set out to follow, until the goal is reached—even if it means sailing across the Atlantic in a row-boat as the Vikings did.

I don't know what goal Garbo has set for herself, but I can understand her desire to go home to Sweden.

Back to Sweden, where one has privacy. Where there is seldom, if ever, a boom-time or a depression. Where one lives an even, happy, contented existence within ones own social class—and all classes are happy.

Garbo is probably of the middle class. Those who own a home, a boat and go to the theatre. In the summer, they hire or own a home on one of the thousand islands of the Stockholm archepeligo and commute daily on the small steamers that run like commuting trains here. She'll probably go home when she's ready, buy a house on an island and settle down to a quiet, happy Swedish home life.

She'll probably marry a Swedish man, one who speaks her tongue, knows her heart—and raise a few Lindberghs, Ericssons or Garbos.

Did Tully Interview Garbo?
By Ned C. Williams

Garbo's individuality is something I fear even Mr. Tully does not comprehend. Individuality is somewhat at a loss in Hollywood, anyway. But I am willing to wager that ninety per-cent of the picture fans all over this country admire Garbo tremendously for this quality. Depth of character and this very individuality are what make Garbo the truly great actress she is.

I AM very much surprised at the wisecrack he attributes to Miss Ina Claire. To say that if she ever divorced Gilbert she would look around for another of Garbo's "ex's" as, "They are so appreciative," is a very catty remark.

Deep water threatens Mr. Tully when he is so bold as to analyze Garbo's friendship with Mauritz Stiller. That relationship was something that even the closest friends of Garbo wouldn't attempt to "dissect." Any such bond of sympathy and beautiful understanding as existed between Garbo and Stiller would naturally be beyond the comprehension of some.

Mr. Tully says that Garbo made up her mind to be different. Unless he means that she came to this decision when still a young girl working in a barber shop, he is being horribly inconsistent. Because, wasn't it this difference in Garbo which the patrons of the shop sensed as they turned to other women for the lathering of their faces? Wasn't it because right from birth she has had those characteristics which have made her different from other women? If Mr. Tully thinks Garbo affects this difference to the extent that she would take bedroom slippers to a party with her, to slip on because of a sore foot, just to be laughed at, he is badly mistaken. It was because she couldn't be her natural self, be different from the common herd, that she gave up going about in Hollywood society.

I can't honestly let Mr. Tully's statement about Garbo having no sense of humor go unchallenged. Can this man who claims to have read her so easily really think that she has no sense of humor?

I have been with Garbo when she displayed a marvelous sense of humor, one which would possibly go over Mr. Tully's head. At least I have seen her laugh at herself, and that according to scientists proves an intelligent sense of humor.

At the end of Mr. Tully's article he hands Miss Garbo a few bouquets. Perhaps Mr. Tully isn't even aware of how much he really admires her, deep in his heart.

In dissecting Miss Garbo, Tully compares himself to a watchmaker. I say heaven help the watches that fall under his hands!

NOW —it CAN

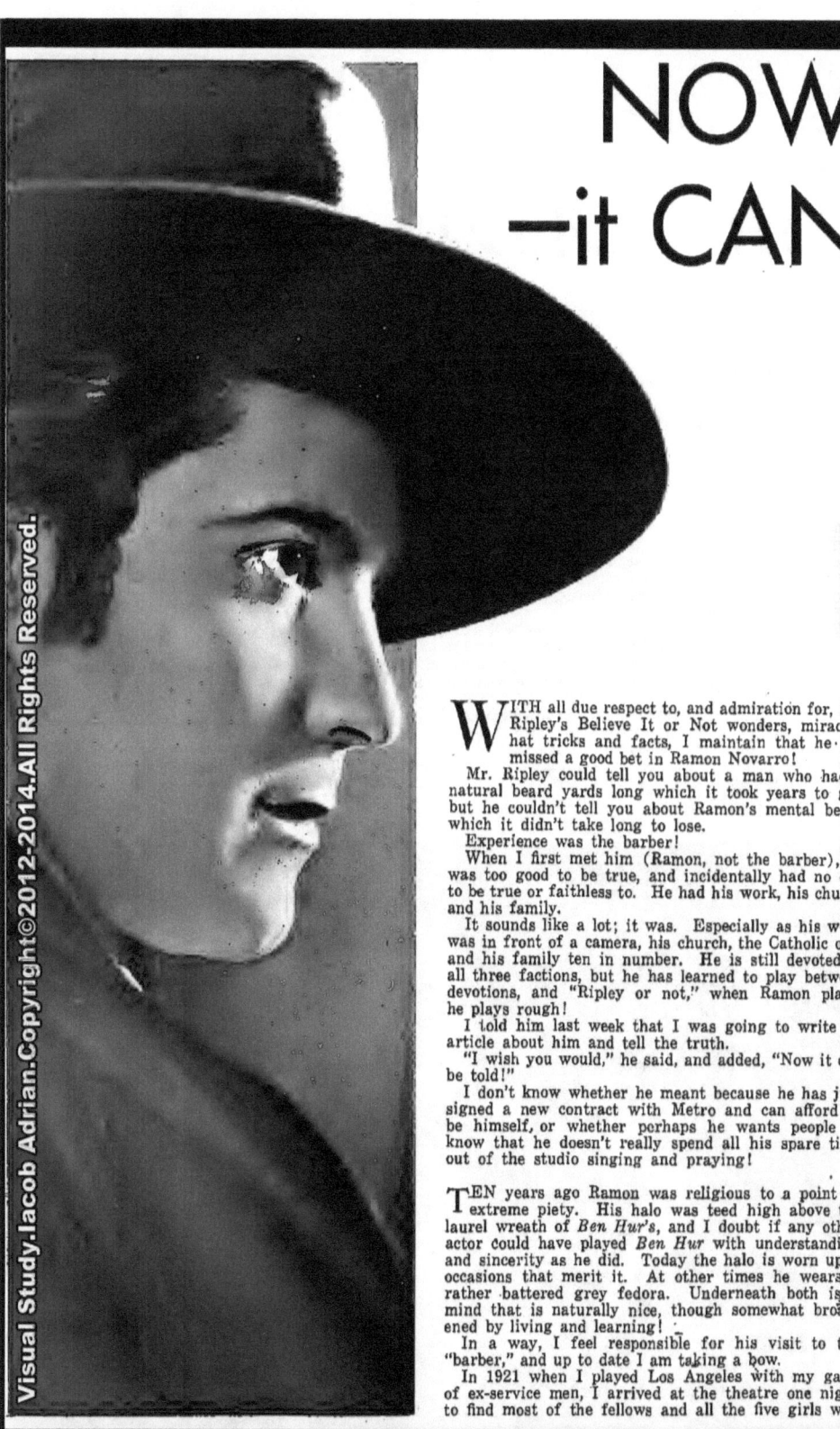

WITH all due respect to, and admiration for, Mr. Ripley's Believe It or Not wonders, miracles, hat tricks and facts, I maintain that he has missed a good bet in Ramon Novarro!

Mr. Ripley could tell you about a man who had a natural beard yards long which it took years to get, but he couldn't tell you about Ramon's mental beard which it didn't take long to lose.

Experience was the barber!

When I first met him (Ramon, not the barber), he was too good to be true, and incidentally had no one to be true or faithless to. He had his work, his church and his family.

It sounds like a lot; it was. Especially as his work was in front of a camera, his church, the Catholic one, and his family ten in number. He is still devoted to all three factions, but he has learned to play between devotions, and "Ripley or not," when Ramon plays, he plays rough!

I told him last week that I was going to write an article about him and tell the truth.

"I wish you would," he said, and added, "Now it can be told!"

I don't know whether he meant because he has just signed a new contract with Metro and can afford to be himself, or whether perhaps he wants people to know that he doesn't really spend all his spare time out of the studio singing and praying!

TEN years ago Ramon was religious to a point of extreme piety. His halo was teed high above the laurel wreath of *Ben Hur's*, and I doubt if any other actor could have played *Ben Hur* with understanding and sincerity as he did. Today the halo is worn upon occasions that merit it. At other times he wears a rather battered grey fedora. Underneath both is a mind that is naturally nice, though somewhat broadened by living and learning!

In a way, I feel responsible for his visit to the "barber," and up to date I am taking a bow.

In 1921 when I played Los Angeles with my gang of ex-service men, I arrived at the theatre one night to find most of the fellows and all the five girls who

—Says Ramon Novarro
be TOLD!

And here it is—told by the famous star—ELSIE JANIS

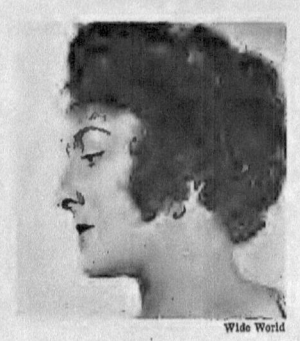

Vibrant, dynamic Elsie Janis, the favorite of a world of theater-goers, whose colorful dramatic careér has fitted her splendidly to take up her new work as a writer—and on the staff of New Movie Magazine.

added the feminine touch to the little show clustered about a peep-hole in the curtain, arguing over the comparative charms, talents, and ability of Rudolph Valentino and Ramon Novarro, who were both in the audience, Ramon in the first row and Rudy in the fourth.

That anyone should compare another actor with the latter seemed childish to me. I said so, and we rang up the curtain! I don't believe I looked at Ramon more than once. I heard him laughing and applauding, for he was, then, as now, an excellent audience.

But my eyes, ears and smiles were all for Valentino. That saint-like quality of which one heard so much in connection with Ramon (Ben Hur) Novarro left me cold, and I still prefer love scenes to chariot races. Rudy, however, came back after the show, and Ramon probably went to a midnight mass.

Ramon Novarro and Greta Garbo in a scene from their latest picture, "Mata Hari," wherein Ramon plays the part of a Russian air captain.

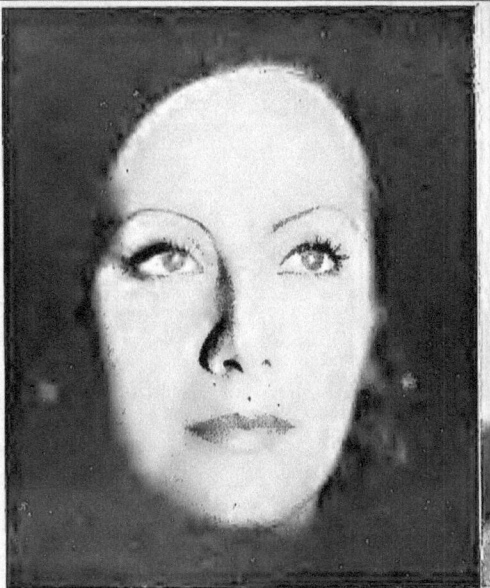

Greta Garbo Ramon Novarro

The MOST ELIGIBLE COUPLE Will NEVER Marry

by REGINA CANNON

"GRETA GARBO is my ideal woman, but I shall never marry."

This was Ramon Novarro's somewhat startling statement regarding the two subjects concerning him in which his fans are most vitally interested—women and matrimony. For, with Richard Dix safely launched on the matrimonial high seas, Ramon finds himself unanimously elected Hollywood's most eligible bachelor.

Since the casting of "Mata Hari," rumors have seeped through the tightly guarded Garbo set to the effect that Novarro has fallen deeply in love with the Swedish star.

To back up their assertions, those claiming to know cited the fact that, though Ramon is a star in his own right, he was perfectly content to take second billing in this production, a concession seldom made by one who has fought every inch of the way to his place on the cinematic heights. Further, that he actually requested to be considered for the role he ultimately played, and finally that he spent every available moment during production in Greta's decidedly exclusive company.

"Perhaps Ramon admires her work and his interest is not personal, after all," we suggested.

To which our informant retorted such a withering and disgusted "Oh, Yeah?" that we decided to, as Jimmy Durante would say, "ups to Novarro" and ask him.

This procedure, as you may suspect, required a certain temerity if not a little good old-fashioned brass, but we gritted our teeth dutifully and breathlessly hurled, "What's all this talk about your being in love with the Garbo, Ramon?"

And poor defenseless Novarro, taken completely unawares, couldn't hedge if he wanted to.

"GRETA GARBO is marvelous," he declared. "No other woman has ever impressed me so much; not even poor beautiful Barbara La Marr. Greta is everything that man desires. She has beauty, lure, mystery and an aloofness that only men understand, for it is a quality which is usually to be found only in men.

"It is not a coldness either, for she has emotion and fire, else she could not be the greatest artist the screen has ever known. But Greta keeps her emotions repressed and the audience somehow knows that she is, with difficulty, holding back something greater than she is giving."

Ramon's eyes were aglow with love and admiration for his ideal as he sang her praises in the enthusiastic vocabulary of the Latin and we, who had come prepared to cagily though painlessly extract a word from him now and then about Garbo, sat a little dazed by his rhapsodizing.

RAMON NOVARRO, in a startlingly frank interview, tells why Greta Garbo and he have no right to marry.

"Yes," he reminisced, "Greta has everything. A sense of fairness and perfect companionship. And those are the things a man looks for in the woman he marries. Those are the qualities that endure. This red-hot romance business doesn't last. It is often over before the

The Boulevadier on Parade

If Garbo is as sick of all the Garbosh being printed as I am, she'll go back to Sweden. The stuff about her being in love with each leading man, of having no friends, attending no parties, muttering "It is I, Garbo."

Greta has friends, does attend parties, does not fall in love with leading men, never says "I, Garbo."

I could also give the lie to the story about her which claimed she made use of Stiller and Gilbert to advance her career.

I'm just warning you. Keep it up and our address is Sweden.

A CONTRIBUTOR to a pretty swell weekly in New York writes for information about Clark Gable. Says she can't get any copy back there because everyone seems to like him. "Is it true," she asks, "that he has false teeth, I mean all of them?"

No, baby. Jacket crowns, perhaps, even as you and I. But no false teeth. Nothing to bite New Yorkers with.

But perhaps your dental weekly would be interested in Polly Moran. I'm told she has.

I do not contend that stars have a right to their private lives. Goldfish never chose the bowl, but movie stars did. If they didn't want to be exhibitionists, why didn't they stick to the ribbons, the trays and the dishes?

But as a reporter I resent the current tabloid gossip about movie stars. The stuff about who kisses who and when/ll they have a baby. On reading it I'm confronted with the question: Is a reporter's place under the bed? For myself, no. Would rather be on it. Understand?

Born tired.

The Most Eligible Couple

honeymoon. People who are really in love—not merely infatuated—marry for one reason and that is to insure each other's companionship for the future."

We suggested that Ramon sounded a bit pessimistic regarding "the holy bonds."

"Oh, no!" He hastened to reassure us. "I think everyone should marry. That is, everyone except the artist. And he cannot serve two masters—Matrimony and Art. If he is the true artist he doesn't hesitate in his choice and he doesn't think that he is making a sacrifice either, for there is no sacrifice in art.

"Greta Garbo is first and always the artist and I hope I am that, too. She has promised never to marry and I know that I never shall."

NOVARRO spoke with an intensity and conviction that defied argument.

"An actor has no *right* to marry," he continued, "even if he were weak enough to consider such a step. He is public property, for hasn't he literally sold himself body and soul to the public? Yes, I mean bodily, for first of all, audiences are attracted or repelled by his physical being. Nearly as many men capitalize on their ability to horrify as to intrigue. Lon Chaney and Louis Wolheim for instance, were two players whose sheer physical unattractiveness aided and abetted their fine artistry.

"A writer or a lawyer or a salesman can afford the luxury of a private life, but not the actor. To be a successful actor, a man must think only of himself. His appearance, his diet, his characterizations, his rest. What woman should be asked to put up with so self-centered a creature?

"On the other hand, consider the man who has spent a hectic day at the office and comes home, rightfully expecting companionship, to discover that his actress-wife is off somewhere making a personal appearance or asleep for the night from the sheer exhaustion of a gruelling day at the studio.

"No, even players, with their intimate knowledge of the exacting demands of their profession, should never marry. For they *know* that a tremendous amount of self-interest is necessary to get there in the first place and stay there in the second, and that their communion of interest will serve to add fuel to the flame instead of making for understanding."

We almost found ourself beginning to be glad that we were unendowed with a great talent, for Ramon's views on the subject of artists seem so entirely sane and plausible.

NOVARRO has just rounded out ten years with Metro-Goldwyn-Mayer, an unheard of record in cinema annals.

At the completion of his ten years service, Mr. Louis Mayer invited him to sign a new contract for three years more, but he agreed to make two pictures and called it a very good day indeed. He would like to do a "pal story" on the order of "The Champ" with Lupe Velez playing his younger sister, a saucy young Mexican Miss who encourages him to become a great bullfighter. Ramon has the yarn all worked out and it contains the tried and approved movie ingredients—lots of comedy, a tug at the heart, plenty of action and a colorful locale. All this, coupled with Ramon's and Lupe's talent should cause the box office bell to resound.

But whether he is permitted to do this story or not, when 1933 rolls around it will see Mr. Novarro headed for an around-the-world concert tour. He will sing and dance, design his sets and synchronize the music for his specialty numbers. That has been the ambition of this particular bright and shining star since he was a little boy.

"But what would you like to have best—if you were not an artist, of course?" we asked, preparing to depart.

"Greta Garbo," Ramon replied, simply and reverently and, we thought, a bit wistfully.

HOLLYWOOD BANDWAGON

Drawings by Vince Callahan

Chatter About the Stars Off the Set and On

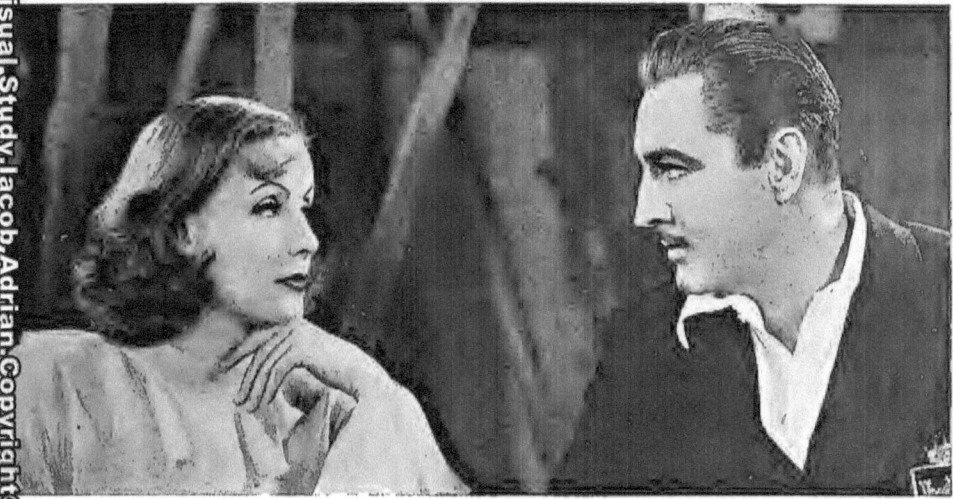

Greta Garbo and John Barrymore enjoy a chat on the sidelines during the filming of "Grand Hotel," in which both play leading rôles. They are still friends.

Clark Gable is one of the autograph seekers' best bets. He just grins and signs—and signs and grins.

BRIGHT AND NEW: Joan Crawford likes to start a rôle with a clean slate, so to speak. With every new picture she has her portable dressing-room, which she uses on M-G-M stages, repainted and refinished inside. New surroundings help get a new perspective on a rôle, she believes.

Daily wisecrack from Estelle Taylor's bedside:
When surgeons were sewing up that gash in Estelle Taylor's head following her automobile accident, Estelle said:
"Hurry up, Doc; I feel a draft."

MOTHERS-IN-LAW: Here's one man who doesn't see anything amusing about mother-in-law jokes. He is Laurence Olivier, the young English actor now under contract to RKO. Olivier is married to Jill Esmond, whose mother recently paid the young couple an extended visit. Whenever Laurence brought home flowers, candy or a gift for his wife, he duplicated the present

Papa Ben and Mother Bebe with their newly-named Barbara Bebe Lyon, just after the christening.

Jimmie Starr tells one: "Dracula" and "Frankenstein" were walking down the street with "Dr. Jekyll and Mr. Hyde," when they saw Groucho Marx approaching. And they all ran away, scared to death.

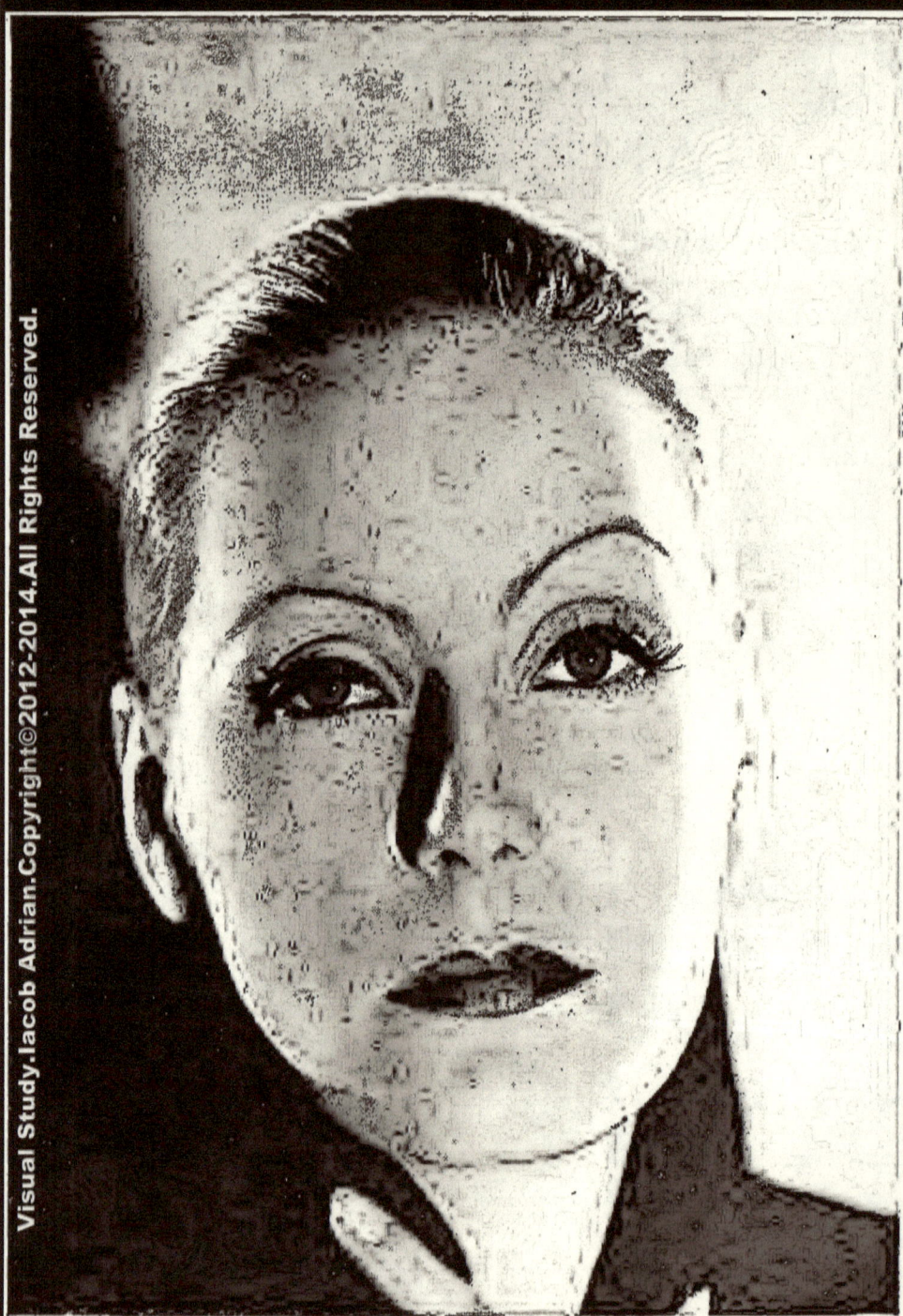

LA DANSEUSE — Gone is the famed Garbo bob. In this photo Greta shows her latest coiffure, smoothed close to the head and combed back tight. The glamorous one recently had the Eastern fans agog with a surprise visit to New York. She is now at work on "Grand Hotel"—she plays the dancer.

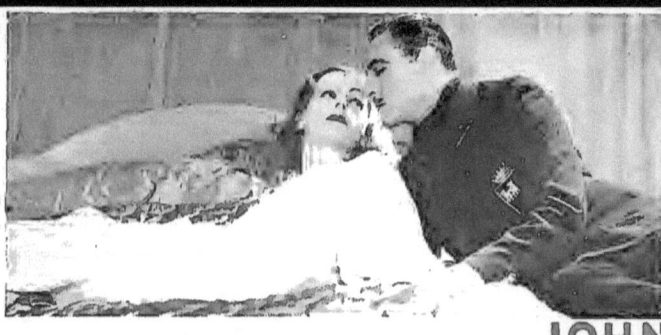

THE GREATEST CAST IN STAGE OR SCREEN HISTORY!

GARBO - BARRYMORE
JOHN

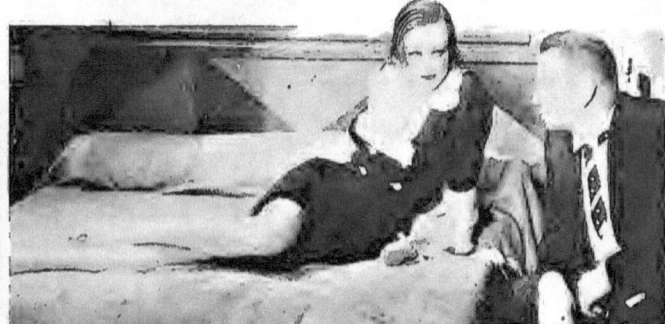

CRAWFORD - BEERY
JOAN WALLACE
LIONEL BARRYMORE

GRAND HOTEL

The play that gripped New York for a solid year—and toured America with many road companies. Now it is on the screen—long heralded—eagerly awaited—and when you see it you will experience the biggest thrill of all your picture-going days.

with LEWIS STONE
JEAN HERSHOLT

An EDMUND GOULDING production

METRO-GOLDWYN-MAYER'S PROUDEST TRIUMPH!

Above at the left: Jackie Cooper seems about ready to cry. Directly above: Garbo in a dancing scene from "Mata Hari."

COOPER Lip and GARBO Limb

Dr. FRANK SULLIVAN, famous humorist, makes a clinical examination disguised as his own grandfather

MY granddaughter, Kitty, came leaping into my study one evening recently and sputtered:

"Grampcmogosegrgabbonmahri!"

"Take that cigarette out of your mouth and speak distinctly," I told her.

"Grandpa, come on go see Greta Garbo in 'Mata Hari'," repeated Kitty.

"Why?" I asked.

"Because they say her legs appear in the picture. I'm dying to see them."

"Granddaughter!"

A crimson blush suffused my gnarled old cheeks and, I doubt not, showed through my sideburns. What, I asked myself, is the younger generation coming to?

"Granddaughter," I told her, gravely, "in my day a young man never wanted to see a young lady's *legs*. He wanted to see her *limbs*. In polite society, "leg" was a word—but no matter. I am not interested in Miss Garbo's limbs. The years that have snowed these locks and bent this once rugged frame have taught me that there is something in life beside limbs. What time does the Garbo picture go on?"

"The nine o'clock show starts in half an hour," said Kitty.

"Let's hurry then, or we'll miss the start," I urged.

"There may be a Mickey Mouse, too," added Kitty, hopefully.

ON the way over Kitty explained to me about Miss Garbo's celebrated limbs. She said they had never appeared in pictures before, and that there had been disturbing reports that they were not of a perfection to match the rest of the Garbo ensemble. It was said that in previous pictures they had been necessarily present, but had been relegated as much as possible to the background, like poor relations come to Christmas dinner. Hence the excitement of Kitty and the rest of fandom at the news that the Garbo limbs were to come into their own at last.

"And one other thing, Gramp," Kitty added: "There's no use your calling them limbs. Nobody'll know what you're talking about. You might as well call 'em legs, because that's what they are these days, even on Garbo. We're all human."

"I suppose you're right, Kitty," I said. Yet, I sighed as I thought of what dear old Jenny Lind would have said had someone accused her of having legs.

Of course, I yield to nobody in respect for the leg as an institution. Personally, I should have got nowhere, and did, had it not been for my legs, of which I now have a complete set of two. In moods of depression, when a fellow feels that he wants to have something to give way under him, there's nothing like having a leg handy. In such emergencies I always fall back on mine. As legs go they aren't much, but they do. They would never cause Marlene Dietrich to worry. I mean they would never cause Marlene to worry as long as they remain on me. They would worry her if they were on *her*. A place for everything and everything in its place. Marlene's legs on her, Garbo's legs on her, Wallace Beery's legs on him and my legs on me.

The picture had been running two or three minutes by the time we got seated and Garbo was already tempting Ramon Novarro,

Cooper Lip and Garbo Limb

but without any display of legs. Ramon was playing a Russian sub-altern whose name escaped me, and by this time has probably escaped Novarro too, for it was that kind of name; one of those untamable Russian monikers that are liable to turn any minute on their own masters and choke them.

Then Garbo tempted Lionel Barrymore. She was wearing a spangled evening, tempting gown. This is probably not a quite accurate description. Whoever designed the Garbo costumes for "Mata Hari" (with a hoe, as some critics maintained) might describe it more accurately as a spangled evening Barrymore-tempting gown. (You must be dressed absolutely right when you tempt a Barrymore. Ticklish business, that. The Barrymores are old hands at tempting and if you don't watch your step very carefully, they may turn the tables and tempt *you*.)

Suddenly, without a particle of warning, a Garbo leg swung out and up, in front of Lionel. *He* seemed disturbed, but as for *me*, I was prostrated. It took me so by surprise. I gasped and choked until Kitty and a lieutenant-general of ushers had to slap me repeatedly on the back.

The début of the Garbo leg should not have been so sudden. George Fitzmaurice, who directed the picture, should have prepared the audience gradually, something in this manner:

First, some casual, general conversation between Garbo and Lionel about legs as such. Then this dialogue:

BARRYMORE: Speaking of legs, as we just were, Madame Mata Hari, may I have a look at yours?

GARBO: You cad! How dare you!

BARRYMORE: I'm sorry. No offense intended. It was merely that I collect legs and am always in the market for a likely one. I thought that if one or both of yours proved up to snuff, I might take an option on it. But don't bother. I guess I don't want to see your legs anyhow. Probably they're no great shakes.

Now then, if I have the slightest right to my reputation as the one man in the whole world who completely understands women, the instant reaction of Garbo to this taunt would be to say, "Oh, is that so?" and forthwith flash both her pins, or props, at the wily Lionel. By that time the audience would have been properly prepared.

In any event I failed to see why there had been so much fuss about the Garbo legs. They seemed all right to me as legs go. I examined them from the viewpoint of a scientist and, although I had to work fast because Garbo did not leave them out very long, I was able to jot down a few clinical notes. Both the quadriceps and the gastrocnemius muscles seemed to me to be quite normally developed. She has an excellent soleus and both the long and short extensor muscles seemed adequate. I was particularly gratified with the Garbo peroneus, which is as fine a specimen of its kind as I have yet seen. In brief, to abandon the more technical phraseology, I am gratified to report that I found the Garbo heel, ankle, sole, instep, calf and hock quite all right, and as far as I am concerned Garbo can go right ahead and do whatever she likes with her legs.

THE other major event of my recent moviegoing was Mr. Cooper's lower lip. I refer to Jackie Cooper's lower lip, not Gary Cooper's, although I have no desire to demean or asperse any lip of Gary's. His lower lip is, I have no doubt, a splendid specimen of its kind, and serves the function of lower lips, whatever that function is. I never gave much thought to the function of a lower lip, as a matter of fact, until Jackie Cooper made me lower-lip conscious. I always struggled along on the old principle of never letting your upper lip know what your lower lip is doing. This practice had its disadvantages in that it created confusion between the two lips, thus often causing a lisp.

For inthtanth, Gary Cooper's lower lip never made me cry, but Jackie Cooper'th thertainly hath. . . .

You see? See what I mean by confusion between the upper and lower lip? Just a moment, please, until I get straightened out. There!

I went to see "The Champ" partly because I always try to see any picture containing Wallace Beery and partly because I wanted to see the Cooper lower lip, having heard of its powers.

I came to scoff and remained to pray. By the time "The Champ" was half over the Cooper lip had reduced me to such a maudlin state that every time Jackie gave it one of those pathetic fillips, I would burst into a new freshet of tears. The picture over, I slunk from the theatre so that other members of the audience would not see the traces of my unmanly emotion. It did not occur to me that they were all slinking, too.

There's gold in that thar lower lip of Jackie's. I hope the Cooper family is taking good care of it. I hope they don't let it stay out nights. It should be insured, like Paderewski's fingers or Marilyn Miller's toes. I predict freely that as long as Jackie's lower lip stands the wear and tear to which scenario writers and directors will submit it, the Cooper family will never feel the pinch of want. I wish I had a son like Jackie. Would I be sitting under an umbrella on the beach at Coronado this very moment?

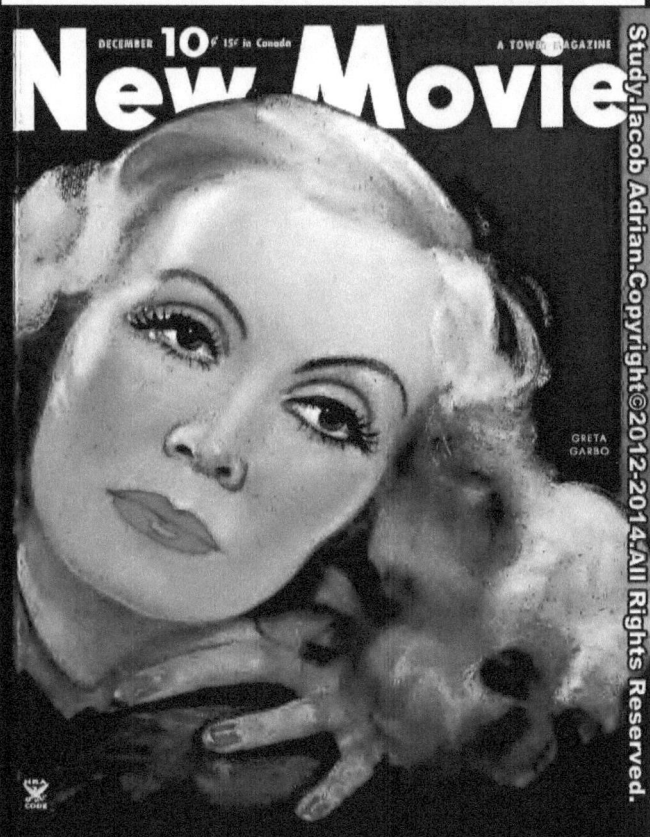

HOLLYWOOD'S BATTLE OF THE AGES

Character studies of the Movie Great, rendered by the actor that Mary Pickford distinguishes as the greatest of all character portrayers, who works and plays with the stars—and employs his intimate knowledge of them to sketch them with brilliant candor.

Lewis Stone as Dr. Otternschlag.

Lionel Barrymore as Kringelein.

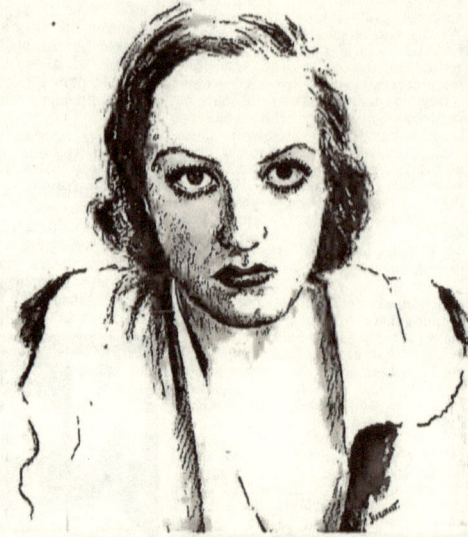

Joan Crawford as Flæmmchen.

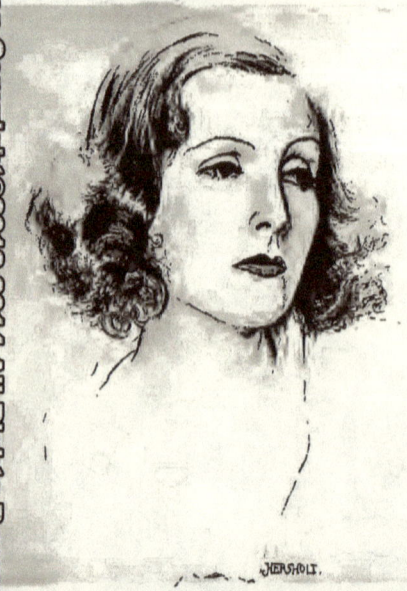

Greta Garbo as Grusinskaya.

John Barrymore as Baron von Gaigern

How GARBO puts

Paris dictates fashions but they don't get across with young America unless some of Hollywood's favorites take them up

By VIRGINIA SCHMITZ

*J*ust *Like the* Blouse Greta Garbo Wore in a Recent Picture!

Clothes and personality are all mixed up in the glamour that is Garbo. Here she is (lower left) before she achieved the personal glamour and the clothes glamour that made her famous. Above, left: In a fashion-making square-on hat. Above, right: This is a typical advertisement from Gimbel Brothers, New York.

Glamour into Clothes

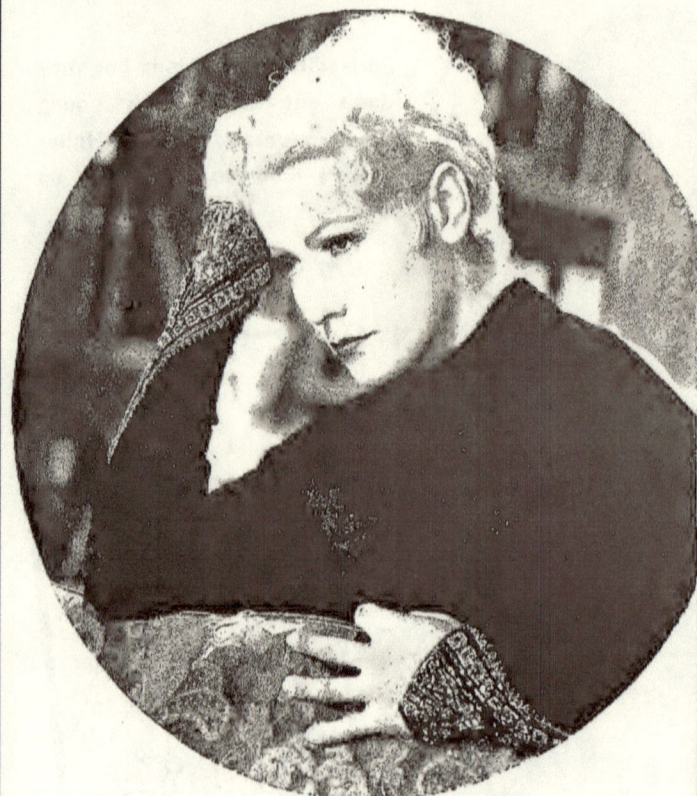

Here's what a platinum wig, skillful make-up and the famous Garbo romantic high neck, plus black velvet, will do for a girl. Garbo in a scene from "As You Desire Me." Right: The Garbo look becomes copy in a Saks Fifth Avenue advertisement.

off-for-sweden

For that inscrutable look the Great Garbo made famous, muffle yourself from chin to toe in black velvet and go Out Into the Night. This devastating wrap uses yards and yards of black matt velvet, lined with white satin. All pretty staggering.

AND if you had your choice, whose clothes would you step into? Not those of a Paris mannequin. Not those of a New York society leader. Not those of a mythical crown princess.

Garbo's!

Maybe you wouldn't want to step into Garbo's shoes. They aren't quite glass-slipper size. But you'd take the shoes along with the rest if that were part of the bargain.

You'd take the Garbo long line, the Garbo clinging velvet, the Garbo romantic high neck, the Garbo low back—but you've taken them. You're wearing Garbo's clothes already.

It's been a gradual invasion of your wardrobe, so gradual that perhaps you haven't realized. Maybe, too, you haven't had time to stop and take notice that at least half of the girls in the advertisements wearing clothes for your approval are modeled after Garbo.

For more than three years now the men and women behind the scenes who draw fascinating pictures of what the stores and shops have to sell you have been using Garbo, consciously or unconsciously, as their model. Look through your newspaper and you'll find as many as ten Garbo heads.

And that isn't all. You are reminded that this long, black velvet evening wrap has the Garbo inscrutable look; that that perky down-in-front hat is the kind that Garbo wears; that these sports pajamas have that Garbo languor; that this ultra evening gown has that Garbo glamour.

PARIS is still the fashion dictator of the world on paper. But Paris must get Hollywood to accept and use its fashions if it wants to make a dent on young America. Garbo, of course, isn't the only actress who sets styles by what she wears.

But the Garbo influence goes deeper and is more comprehensive than that of the rest. Not a copy of one of her dresses nor all of them is the point. It's an attempt to get the same mood that Garbo expresses. You are not offered a "Susan Lennox" dress but a gown will catch for you the glamour that is Garbo. It's more subtle; it's more

"I AM THE Unhappiest GIRL

Real facts, collected from the most reliable sources, tell the new and amazing story of the girl who has everything—and yet lives in continual fear of poverty and death

By JACK CAMPBELL

EDITOR'S NOTE: *Mr. Campbell, the author of this article, is a Paris newspaper correspondent.* NEW MOVIE MAGAZINE *assigned to him the work of writing an article on Greta Garbo abroad. We told him we wanted nothing but facts. To get these facts Mr. Campbell found he would have to go to Stockholm when Garbo was there. He remained three months, talked to her family, friends and former associates.*

AFTER spending nearly four months in Sweden, returning to Paris and visiting other haunts of Greta Garbo, I am in a position to report:

That Garbo was never married to Mauritz Stiller, the Swedish director who first took her to America, and for whom she has confessed the most ardent passion of her life.

That Garbo's latest trip to her homeland and to the Continent cannot be catalogued as a happy one; that, as a matter of fact, Garbo is not likely to use again the phrase she often repeated, "I tank I go home." Because she is now really a girl without a country.

That Garbo, if one can believe her old-time friends and stage and screen associates, is greatly changed; that she continually complained that she "is the unhappiest girl in the world" and that she is in constant fear of poverty and death.

That countless reports that she had lost the mass of her fortune in the Kreuger-

GARBO TRUTHS

EDITOR'S NOTE: Because so much has been written about Garbo that isn't true, NEW MOVIE MAGAZINE, in line with its usual policy, went after the real facts. We went to innumerable friends of Garbo's, both professional and personal, in New York, in Hollywood, in Paris, in Berlin and in Stockholm. Herewith and elsewhere on these pages you will find their statements.

"Why doesn't Garbo give interviews? Because she knows that whether she says anything or not, she'll be quoted anyway. And when she did give interviews, when she first came here, they were so garbled she's been frightened of interviewers ever since.

"Since late in 1927 Garbo has never given an interview or written a story. Yet hundreds have been printed. Garbo doesn't understand that sort of thing—doesn't want to have anything to do with it.

"She suffers terribly from anæmia and, consequently, insomnia. She hasn't the strength, after work, for social Hollywood.

"Now is she a bore? She's brilliant. But she has never learned to make small-talk."

Mauritz Stiller and Greta—a photograph taken just before they left Sweden to enter American films.

GARBO TRUTHS

"I don't understand all this talk about Greta's big feet," one friend of Garbo's told us. "She wears size six and a half, which any shoe salesman will tell you is average. And Greta is a big girl; there's no reason to expect her to have a tiny foot.

"Greta goes out wherever she pleases. She's not the hide-out girl people would have you believe. When she's in New York, or Paris, she goes to the theater almost every evening. And she does her shopping at the big stores.

"The drama is her weakness. She prefers it heavy, in keeping with her nature. She does not like musical comedy. Problem plays are her favorites. Her favorite actress is Katharine Cornell.

"Greta is the calmest person I've ever known. She has a soothing effect on everyone around her. She's the most relaxed human being I've ever known. Her emotions are always under absolute control. She was born that way—and that's what gives her that slow smile and that gradual change of expression on the screen."

Greta and her mother, photographed during Greta's recent visit.

"IN THE WORLD"
– Says GRETA GARBO

Swedish Match Company collapse are not true; that—and, again, according to her friends—most of her money is invested in Swedish and American government bonds.

NOW when I state all of these facts, and the facts to come, please regard me as simply a reporter repeating, almost parrot-like, for the sake of bald truth, the things I heard. I cannot, in this capacity, take sides, and if some of these reports hurt the feelings of Garbo fans, remember that I am only the medium through which they come, and that I, personally, have not inspired any of them.

For instance, Garbo's old-time friends, many of whom complain that of late she has paid little attention to them, give many and varied reasons for her self-pity and for her odd actions. No one seems to understand why she is so unhappy. For instance, Gosta Ekman told me he believed Garbo had a "suffering complex" brought on by the long fight in Hollywood to preserve a personality carefully built up for her, but one not really hers. Neither could anyone understand why she went to bed at four or five o'clock in the afternoon, had dinner in bed, complained she couldn't sleep and got up at five or six in the dark Swedish mornings to take long walks.

Yet, perhaps, all this could be explained away with one word—anæmia.

When Garbo first went to Sweden on this last trip she retired to the castle of the Count and Countess

(At right) This picture was supposedly taken, while Garbo was abroad recently, on a secluded Mediterranean island. Some experts declare that it was really taken in Sweden.

(At left) Another publicity picture of Greta, made shortly after her arrival in Hollywood for the first time. Here she is shown shaving off Lew Cody's beard. . . . This picture is especially interesting in view of the changes that have come over the star.

Wachmeister, some sixty miles from Stockholm. Some said she passed much time at the country place of Victor Seastrom. Anyway, she is credited with having played a lot of tennis and done a lot of swimming, and all that sort of thing, even to reports of revelers

GARBO TRUTHS

"No matter what Greta does, she does it so calmly that she is a relief after being with the average nervous person. . . . I spent three hours with her in her hotel room recently. We talked about plays and books and her plans, but the conversation was interspersed with long, restful silences. And all of the time she was busy doing things.

"She sorted her clothes and packed and repacked them. She arranged flowers and tried on new hats. Constantly moving about, but so calmly that I wasn't aware of it.

"Has she changed? Only in appearance. She's still the same calm, collected, quiet, clear-thinking person.

"Don't believe what you hear—she's not temperamental. She won't work long hours because her health won't permit it. But did you ever hear of her refusing to work with anyone, or leave a production flat, or make a scene on the set?"

Greta Garbo and the Countess Wachmeister photographed at the Komedi Teater in Stockholm during Garbo's recent visit. Garbo's friendship for the Count and Countess started the gossip that she was seeking to break into Swedish society.

returning from the Saltsjobaden summer resort that they had spied her at the wheel of a speedboat.

But Sweden is unlike America. There it was a case of everyone doing everything possible to make her happy, to grant her the seclusion she desired. But, alas, it was not long before rumors began to percolate into Stockholm that the Garbo was dissatisfied with the country. And the next thing we knew she was back in town.

Yet she wasn't happy. Her friends, charging that the last three years had robbed her of her once-charming personality, called her sadness a pose. Others claimed she was one of the world's really tortured souls.

AT a cocktail party I gave for a number of Swedish actors and directors I had known in Hollywood the talk naturally turned to Garbo.

Lars Hansen, who played opposite her in "The Flesh and the Devil," and who has since returned to the Swedish stage, remarked that he hadn't seen her. Yet they were once close friends.

"She doesn't seem to care for her old friends any more," he said. "I haven't seen her in three and a half years. . . . She's changed. She has big ideas now."

Can you imagine the Garbo of today being photographed thus? This was a publicity picture of her made at the studio shortly after Mauritz Stiller brought her to America.

He said this without rancor. I want you to understand that these people were not complaining. It was simply that they couldn't understand the new Garbo.

"She was always a timid girl," broke in his wife, Karin Molander, one of Sweden's great dramatic actresses. "Terribly shy. Even in the old days in Hollywood, she used to go right home from the studio and go to bed. She'd never see anybody. . . . You must admire her for the way she has fought herself upward, all alone, since Stiller died."

Young Knut Martin, the actor, who went to the Royal Dramatic Academy with Garbo, made his comments:

"We were pals then. Greta was a grand person. We could go anywhere with her and have a good time. When she came over three years ago she came up to my house to see my wife and me at least twice a week.

"She went to the theater with us the other night. But what a changed person! She's grown distant and haughty. She places herself above everyone else. It was amusing to see the newspapers the next day, which told of such and such a Prince and Princess being present, and such and such a Count and Countess, and that Greta Garbo was also in the house. She wasn't accustomed to second mention. She has given up all of her old friends."

Remember that these views come from scattered sources. Remember that Garbo is ill—that she can't afford to give away the least particle of her strength. Perhaps she would love to keep up these old friendships. Perhaps, too, many of these old friends are over-sensitive; if this girl were other than the world-famous Garbo they would think nothing—simply consider her busy, tired, or any number of things, and forgive. Remember, too, that Garbo is a very wealthy girl, and that she

I'm the Unhappiest Girl in the World

must continually be subject to all of the disillusionments that go with wealth.

I personally feel that Garbo has not changed so much, but simply that she has been hurt so many times that she has retired more and more into her shell, become more cautious of outside contacts, and that one of the main reasons she is so unhappy and so seemingly friendless is because she has become afraid to trust anyone—that she can't draw the line between her real friends and her false ones, and so, perhaps, avoids all.

ALTHOUGH I had interviewed the glamorous lady in 1926 for a Los Angeles newspaper, I do not claim to have talked to her in Stockholm. By chance at the Komedi Teater on August 29, my place was only a few seats away from Garbo and whenever the Swedish became too complicated on the stage I passed the time looking at her. That was nearer than *any other American newspaperman came to her in Stockholm.*

Hotel keepers, newspapermen and the American consul in Stockholm were among those who were relieved that Garbo went away. She was forever being rumored in one hostelry or another and journalists had a standing order for one Garbo story a day. She twice figured at the American consulate and both times threw the organization into an uproar.

The legal department heard a case in August to settle the nationality of Mauritz Stiller. The star was expected to testify along with Victor Seastrom, who since coming back from Hollywood has returned to acting on the stage. But neither showed up and this strengthened stories around Stockholm that Garbo and Stiller may have been married in Constantinople in 1924. But like other stories about the pair, nothing could be adduced from the evidence and the case closed most unsatisfactorily.

During her stay the only overt act Garbo did to perpetuate the association of her name with that of her benefactor was when she placed a wreath of flowers on his grave just after arriving.

THE next time Garbo perplexed our consular service was when she decided to get a visa in September to facilitate her return to this country.

It might have been all right if she had not insisted that she would send in a friend to have the document stamped and avoid the publicity of an appearance. She was furious when politely told that she must appear in person and also take the physical examination required of all foreigners entering the United States.

Over her indignant protests that she was not an immigrant she was told that only President Hoover could make an exception of her case. She hung up the telephone before the vice-consul could add that the examining American doctors were leaving in two days and would not return to Stockholm for another month. So she waited until December to get her visa.

I'm the Unhappiest Girl in the World

OTHERS who were somewhat upset by the visit of *la* Garbo were the members of the Royal Family of Sweden. They try to ignore any and all attempts to associate the unmarried princelings or nephews with her, but the press is continually finding some new royal admirer of the star.

Any association with the screen personality is frowned upon by the palace, which created a most amusing situation during the visit of the Prince of Wales and Prince Bergeorge to Stockholm.

They decided one bleak morning to take a Turkish bath at the Sturebad, where the Swedish massage is given its finest demonstration. The same idea appealed to Garbo and she appeared simultaneously with the royal visitors. Naturally the public linked the three names, business in massages jumped and every Stockholm social matron wanted to know just why Garbo had found it necessary to come in for a treatment. The Royal Family, however, was left again to share the headlines with the actress.

Among those who benefited by the visit of Garbo were the tourist companies of the city who now include in their *charabanc* tours a visit to the house in which the star was born, the shop where she worked as a lather girl in one of the poorer sections of the city and where her mother now lives. Visitors prefer these sights to museums and churches and some of the tours also include visits to Bergstrom's department store where Garbo once worked, and the Royal Dramatiska Teater, where she played as a student on the stage for an entire season.

I asked Mr. Olson, the manager of the theater, to go back and find the records of Garbo's activities. She is listed as a "student" under the season of 1924 and played bits in "Dr. Knock," a Benaventi comedy and two other pieces of the repertory.

"She was an ambitious youngster," he told me. "We didn't think she had so much talent but she was a hard worker and anxious to get ahead. She played small bits, usually as aged characters."

Also in that interesting record, I found Nils Asther's name under the 1923 season as having appeared in "The Admirable Crichton."

THE Swedes are a proud people and Sweden is a small country. That a girl of Garbo's humble beginning should rise to such an important part of the news of the day fills her countrymen with pride and admiration. But first of all she is admired for being Swedish. After that she may be a genius, a good actress or just an interesting looking girl.

The Swede tries to forget that in her own country Greta went unrecognized. And he tries to guard her primarily as a Swedish girl.

Swedish talkies are notoriously poor and when Garbo was quoted as interested in producing films in her native country, the Swedes were naturally enthusiastic. But despite a long-avowed hate of Hollywood, the actress thought kindly of the Culver City studios when she had one look at the native equipment. And so no more was heard of her production activities. A change of heart which her countrymen resented, as they did her announcement to appear on the Stockholm stage, which was quickly retracted, but which disappointed thousands who hoped to see their idol in person.

Gosta Egman, who played with her in the first film she ever made and who is now the greatest legitimate actor in Scandinavia offered her the rôle of *Grusinskaya* in "Grand Hotel," which had not as yet been done on the Swedish stage. After thinking the matter over, she declined.

"Naturally I would love to have Greta with me on the stage," he told me one evening. "And I would do everything in my power to make her reappearance before the footlights as easy as possible. But Greta will have to come down to earth if she wants to work on the stage again. She'll have to forget some of her poses and decide what she wants to do. Temperament is all right—all right in its place—but we can't afford to have much of it on the legitimate stage."

Few persons in Stockholm believe the story that Greta was interested in the late Ivar Kreuger or that she even lost a fortune in his stocks. It was believed, however, that she took home a trunkful of dollars at a time when the Swedish crown was at its lowest.

Greta may champion her seclusion but if she dined out it was at the Kastenof, one of the most prominent restaurants. And if she went to the theater she sat in the middle of the front row in her familiar brown sports outfit.

In Paris she stopped at a small hotel in the very center of things, off the Rue Royale. And she was quoted as seeking a quiet spot in Majorca, which is now the center of American Bohemian life in Europe. Dr. Axel Munthe, the Swedish author of "The Story of San Michele," told me that Garbo could have gone down to Anacapri and be forgotten in a few months. Several papers showed photos of her there but a closer inspection of the photos revealed the background to be Sweden.

Coming down from Stockholm to Hamburg I traveled with Karl Gerhart at whose revue I had seen Greta. He said that from the stage, he believed he had once "caught" the Garbo of three years ago in the comedy sketches, when she laughed like a little girl and applauded his parody of her. But that the arrival of photographers spoiled this mood and changed her into the moody personality of today.

One attitude about Garbo was briefly expressed by Harold Lloyd when he arrived in Stockholm in November.

"Are you going to see Garbo?" he was asked.

"Why should I?" he inquired. "I've been living in Hollywood ever since she came out there and I haven't seen her yet."

Picking the Winners in the Type-sketch Game

Portraits of Greta Garbo, made on the typewriter, selected as the best

Above: The photograph of Greta Garbo that appeared in the May issue of The New Movie Magazine, from which many readers made strikingly good likenesses on their typewriters.

★

At right: The type-sketch made by Harry D. Reese, 5514 West Washington Boulevard, Chicago, Ill., selected as the best of all submitted.

★

For full details of the Type-sketch awards

At left: The type-sketch made by Roy Erlenborn, picked as the second best, and (at right) the type-sketch made by Alicia J. Spaulding, 632 Norfolk Avenue, Buffalo, N. Y., named as one of the ten next best.

TRY THIS FASCINATING NEW

You can make your own pictures of

Using the picture of Greta Garbo on this page as the subject, see if you can make a typewritten copy of it, just as Miss Parsons did on the opposite page.

The PEOPLE'S Academy

A page of answers to one who dared criticize Greta Garbo

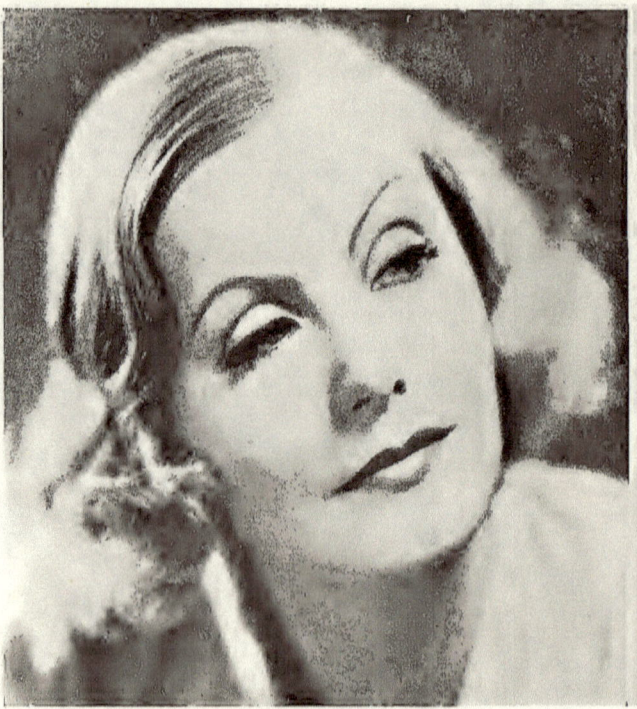

"Garbo has sheer genius. She is and ever will be considered one of the greatest actresses on the silver screen."

Fay G. Du Bow, of Hartford, Conn., writing in this department of the September New Movie Magazine, said: "I have never seen any Garbo pictures and wouldn't want to.... I don't see anything wonderful in Greta, and I believe there are American girls just as good. Away with Greta Garbo."... The letters that appear on this page are only a few of those received in reply to Miss Du Bow's startling comment.

They're off: A fight for Garbo!
This note is in response to an unjust, catty opinion expressed of Greta Garbo. "In a frank way, I say that the writer of that opinion shows complete ignorance. She is condemning Greta before she has even seen her. How could Fay see "anything wonderful in Garbo" if she had never seen any of her pictures? Answer that!
Garbo has sheer genius. She is and ever will be considered one of the greatest actresses on the silver screen.
Hail to Greta!—Harold H. Brewer, R. F. D. No. 1, Great Barrington, Mass.

Torch-bearers: Wow! What a challenge for Garbo torch-bearers. After all, where is the need for her to show gratitude to any public responsible for her salary? The public, most assuredly, pays to see only what it cares to. If this is true, what price gratitude?
The public goes to no picture with its eyes closed, nor is the public an imbecile. Its eyes are wide open and we'll hope its mind is, too. It goes to pictures to see and be entertained; surely Garbo is worth seeing and is, without doubt, entertaining. So we do get value paid for.—Miss Hildegarde M. Johnson, 1331 Belmont St., N.W., Washington, D. C.

Incoherent: I've started this letter three times and each time I've grown incoherent with rage and pity.
"Never seen GARBO!" Oh! Away with *her*? Never!
You don't know what you've missed, never having seen Garbo! I believe you are prejudiced by jokes—cartoons—misquotations, etc. You don't know how warmly alive and beautifully human she is. And, besides, it is the screen work of an actress that concerns us, and what she does or does not do outside is not going to blur our entertainment in a darkened movie theater. I think producers could do much to prevent such one-sided views by having a "heart-to-heart" talk with publicity men.—Irene Murray, 675 No. Terrace Ave., Mt. Vernon, N. Y.

From Canada: This letter is directed to Fay G. Du Bow. Miss Du Bow says she has never seen a picture of Garbo and doesn't wish to because Garbo doesn't go out among the crowds and let them paw her. Garbo is naturally shy of crowds, and she is paid for her acting, not for personal appearance. She also says there are Americans just as good. I'll admit there are, but who is to play foreign parts if there are not to be any foreign actresses? What American actress could play "Mata Hari," or the opera singer in "Romance." Miss Du Bow also says, "Away with Greta Garbo!" Suppose you talk for yourself, not for the millions of fans who are satisfied. Garbo makes two pictures a year and if you are not satisfied with her, then don't see her pictures, and it certainly won't hurt her box-office draw.—George Smith, 853 Home Street, Winnipeg, Canada.

What's She to Do? Time for me to express my opinion of a self-conscious idiot who criticizes Greta Garbo. It isn't seeing her that is only wonderful; it's her human character and her acting ability that make her what she is. As to show gratitude, what is she supposed to do—fall on her hands and knees? There may be many American girls just as good, but would they show a bit of gratitude to the public responsible for their salary? Hoping to see more of Garbo, the Great.—Joan Sonnen, 2830 N. 7th St., Milwaukee, Wis.

Calls Expression Stupid: On page 66 an article, "Never Seen Garbo," and signed Fay G. Du Bow, attracted my attention. This person claims to have never seen a single "Garbo" picture, but she has no use for her, anyway, etc., etc. This is about the most stupid expression of anyone I ever heard of. To think that a great artist like Greta Garbo would ever have to play to such an ignoramus. (I do wish I could see these few lines in your much admired magazine, it would do me a world of good.)—H. R. P., Evanston, Ill.

THE NEW MOVIE MAGAZINE pays one dollar for every interesting and constructive letter published. Address communications to A-Dollar-for-Your-Thoughts, THE NEW MOVIE MAGAZINE, 55 Fifth Avenue, New York, N. Y.

Garbo and Asther: Just a word in defense of Greta Garbo, my favorite actress and my idea of a marvelous personage. Although many of my associates have denounced her with decidedly unflattering remarks, I remain unchanged as to my opinion of this remarkable actress. She is individual, and seems to me to be very sensitive and refined, with enough poise and personality to remain unspoiled by Hollywood society. I suggest that she again be co-starred with Nils Asther as she was in the silents of previous years, because I consider Nils Asther one of the best actors of the screen. He also seems to be more refined, more

"Stuart Erwin seems to be the only one who can speak the southern dialect properly."

"Leslie Howard approaches my ideal of a man."

sensitive, and more outstanding than other actors. I certainly would be very happy if my two favorites could again play in the same picture as in "Wild Orchids," and "The Single Standard." A 100 per cent American movie goer.—B. Drake, 56 Pembroke St., Newton, Mass.

Suggestions: Greta Garbo in "She Done Him Wrong"
Mae West in "Rebecca of Sunnybrook Farm"
Janet Gaynor in "Back Street"
Joan Crawford in "Little Lord Fauntleroy"
Clark Gable as "Frankenstein"
The writer does not like to see our stars "typed," so why not a little variety?—C. H. N., Minneapolis, Minnesota.

"Mitzi Green is the ideal actress to play Alice in 'Alice in Wonderland.'"

Which? Foreign talent and home talent, more home talent and less foreign talent. How often we hear things like that and every time I hear it I feel sorry for the person who said it, because it expresses his ignorance. Talent, like art, is too great to be bound in a nationality—neither knows a nationality for both are universal. Does the fascinating Greta captivate the hearts of her audiences because she's Swedish? Never! It is her inimitable performances and her elusive charm. We fall in love with Chevalier's art because of his engaging smile and infectious charm, not because he's French. Do we love Joan Crawford because she's an American? No, we love her because of her individuality, her vital personality, her real, genuine acting, and the fact that she is a real trooper—she won't let anything lick her. It is Leslie Howard's intangible appeal that has won the hearts of his audience, not the fact that he is English. The duty of the producer is to give the public what they call for, and that is talent and art—nationality does not enter. Then artists are sure to make a hit for their appeal is universal.—Mildred Stucky, Moundridge, Kansas.

Although back-biting is not in my line, this is in direct response to a dollar-thought of September. The writer, never having seen that polished artist, Garbo feels that she is capable of placing a taboo on her. Her main objections seem to concern the great Greta's private life. What bearing has this on her supreme ability as an actress? Her love of solitude may be a result of timidity rather than aloofness. Who are we to inquire into the petty details of her existence? We give up our precious pennies at the box office to see her perform which she certainly does with the most melodic poise of the screen. She abandons herself and becomes the character she is portraying. A true lover of the stage will never forget the youthful, quivering passion of Greta Garbo as she answered John Barrymore in "Grand Hotel" when he called her on the phone. To judge anything fairly, one must know something about it. I should advise Miss Garbo-hater to see the finest Swedish idol and then give her opinion.—Margaret Brenman, 7 Bergen Court, Jamaica, L. I.

Words and Music: Ooooo! I'm in a coma of joy! I'm uproariously happy! I'm going to run amuck, shouting and bellowing (not to exclude the usual crazy gestures) that I have just discovered the one and only personification of youth,—an outstanding, delicious female who expresses and possesses youth in all its glory! And when I do this Paul Revere, (minus horse), my strange audience will be greeted with a—"Hark ye! Hark ye! The New Light of My Life has come to me to worship and adore her, and, believe me, doing this I shall now and—forever!

Hark ye!—again SHE is decidedly human! She is faultlessly true to herself and to her associates! She has an immeasurable amount of womanhood in her; and every fibre and shred of it I will find—for I love it all! "How to find?" You inquire? This way: by witnessing her forthcoming pictures; and by studying and analyzing her every gesture would be adequate, I should think. But, ah! please forgive my stupidity, for I see impatience and wonderment in your eyes to be told the name of my ideal. Very well, then; open your ears:—the her and she happens to be one Katharine Hepburn.—Eugene McKenzie, 1710 Fourteenth Ave., Altoona, Penn.

Peace: I will treasure the memory of "I Cover The Water Front," because it was the histrionic l'envoi of a great actor—may thy lovable and gentle soul rest in eternal peace, Ernest Torrence.—Mary Erwin, 513 E. Call St., Tallahassee, Fla.

Where Have They Gone? La Hepburn has certainly skyrocketed to the heights of stardom, so likewise have Bette Davis and the importations—Dorothea Wieck and Lilian Harvey. More power to them!—but I would like to see some of the little girls who have spent the better part of their lives working up to stardom get a few breaks. Little Mary Brian, Sue Carol, and Maureen O'Sullivan have passed out of the picture as far as the screen is concerned. Just what happens to them when they are discarded after the producers decide they want a "change of scenery?" The movies have taken a trend toward

"Katharine Hepburn is my idea of thrilling youth, brilliant acting and a girl who is always herself."

The People's Academy of Motion Pictures (sponsored by THE NEW MOVIE MAGAZINE) will present twelve gold medals for what the readers of this magazine consider to be the twelve outstanding achievements of the year 1933 in the films.

Letters from our readers, carefully tabulated, will be the sole guides to these awards.

These letters may be addressed to either The People's Academy or to the Dollar-Thoughts department of this magazine, 55 Fifth Avenue, New York, N. Y.

You are the judge and the jury. Write us what you think.

The medals will be given for the following:

1—Best all-around feature picture
2—Best performance (actress)
3—Best performance (actor)
4—Best musical picture
5—Best human interest picture
6—Best mystery picture
7—Best romance
8—Best comedy
9—Best short reel picture
10—Best news reel picture
11—Best direction
12—Best story

The Garbo-Gilbert Reunion

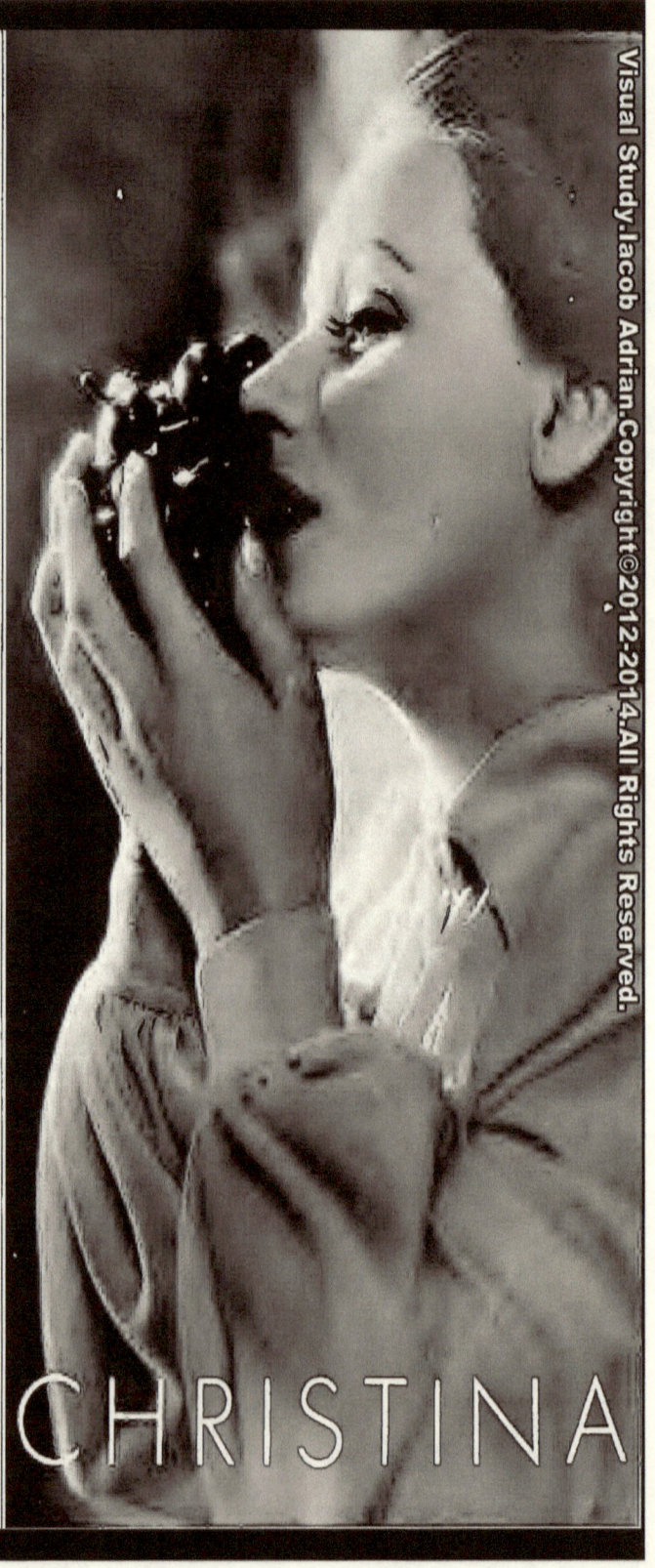

dressing-room bungalow that was once his in the days of his million dollar contract, toward the two-room suite on Dressing-room Row.

While back on the set he has just deserted....

The director stands behind Garbo's bed, his inevitable script in hand. Well! Garbo and Gilbert are reunited! Has he changed ... ?

GRETA (smiling slightly): "He looks well; better than I have ever seen him. He will be marvelous in this role. Changed? There is nothing for him to change from. John Gilbert is never the same person."

BUT to these eyes of mine there is a change ... in both of them. A man as sensitive and high strung as John Gilbert cannot listen for three years to the din: "He is through ... he is through ... he is all cleaned up as a star and an actor" without confidence-shattering humiliation. A woman cannot know the overpowering success of Garbo without gaining confidence and sureness.

For the moment, temporarily, their personalities are reversed. It is Gilbert who is shy, ill at ease. Garbo is in command of herself. When they were making their great "Flesh and the Devil" it was not that way. It was Gilbert the strong one. Garbo, the sensitive. It is not right, it is not natural this feeling on the part of Gilbert. He is behaving like a grateful pup that has had an unexpected pat of approval on the head. He cannot be his abandoned, colorful self on the screen until he is free of it.

TWO days later ... and things are not going too well on the set of "Queen Christina." They have moved into a tavern scene and it seems cold and unfriendly as though they might have sensed the presence of ghosts.

It needs only a casual drift through to realize that Jack has not yet recovered his poise. He is nervous in his scenes; not quite sure of himself. So much has happened so suddenly. The birth of his daughter ... the unexpected "comeback" opportunity of this role with Garbo ... interviews that take much out of him because he is forced to tell and re-tell of *what happened* to that great idol, Gilbert.... There have been photographic sittings, costume fittings ... millions of little things to upset him. He is nervous ... they have rehearsed the scene at the tavern table many times. The rehearsals are not going so well.

Garbo is wearing a costume from the picture, a colorful affair of breeches and a wide sweeping hat with a plume on it. It is obvious she is disguised as a man. Her long-bobbed hair is swooped up under the hat in mannish severity. Suddenly, in the middle of the tedious rehearsal, she speaks:

GRETA: "Let us stop and rest a moment. Shall we smoke?"

The tension is relieved. Garbo moves casually over to a camera stool ... perches herself on it. The crew is "at ease." The director yawns, stretches. Now Jack is standing beside Greta's

The TRUTH about the

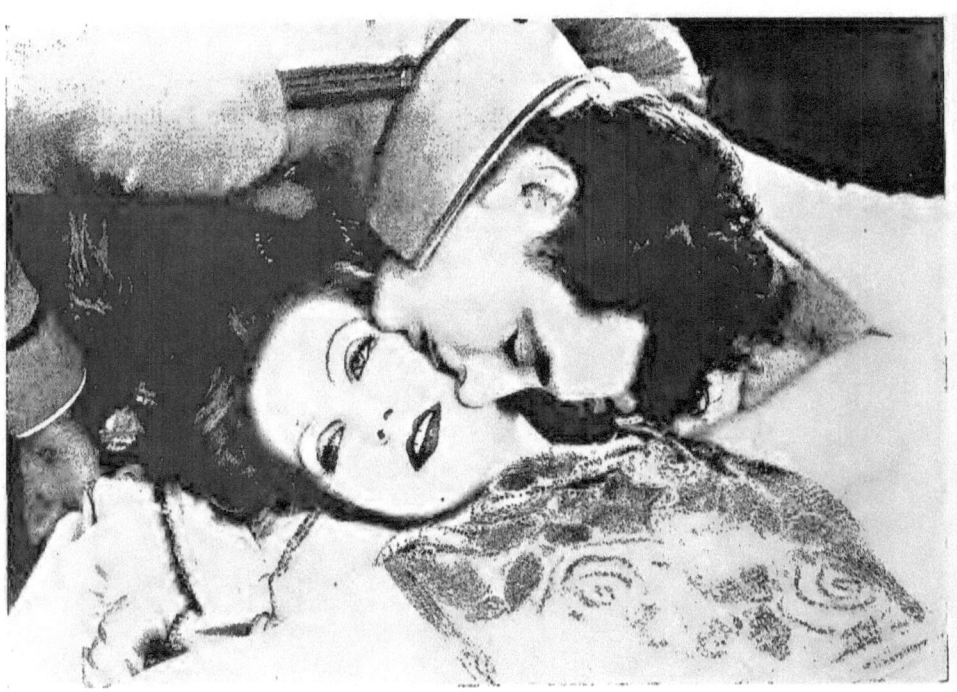

One of the thrilling scenes from "The Flesh and the Devil," the notable silent picture made when Jack Gilbert was the outstanding romantic actor in the films, and Garbo little more than unknown. "If you feel I have done you a favor now," she said to Jack recently, "I feel that you did me a favor when you, the great John Gilbert, had me play in your pictures."

NOTE: The most dramatic story in Hollywood today is not the actual story of "Queen Christina," starring Greta Garbo with John Gilbert. It is the story *behind* the make-believe plot of the Swedish Queen and her lover—the story of the screen's queen and the man who was, once, the great romance of her life. But fate, as well as temperamental differences, separated the two great idols and Greta went on to greater fame in the talkies while Gilbert knew the bitter defeat of temporary oblivion. It is sheer unadulterated drama that these two colorful and exciting figures are reunited after all these years! Hollywood thrills to it more than it has to the drama of "the best picture of the year." What thoughts passed through their minds as they once more met under the strong lights of a studio set—one a great star of today and the other a great star of yesterday, staging a comeback? What did they say to each other as they shook hands over the bridge of the years which is marked by such milestones as their lover's quarrel, Greta's success in the talkies, Gilbert's failure, his marriage to Virginia Bruce and the recent birth of their daughter?

Here is the intimate story behind a story that makes "Queen Christina" the most exciting picture of the hour to Hollywood. For obvious reasons, the article is unsigned. But it was written by a man intimately connected with both Garbo and Gilbert.

Written anonymously by one closely associated with both principals in Hollywood's latest real-life drama

T HE door to stage seven on the M-G-M lot swings open to admit a shaft of light ... and two young men. The first is a press agent, familiar about the studio, and by his side, nervously and briskly strides a man with black hair beginning to gray slightly at the temples. He is wearing a blue sports coat and white flannel trousers, a cigarette caught nervously between his fingers.

In the center of the darkened stage is a circle of light that is the set of Greta Garbo's "Queen Christina," and only the sound of the prop boys moving quietly about and the occasional creak of the director's chair disturbs the almost cathedral-like silence. For Garbo, the one-and-only, the queen of all Hollywood, lies in the royal bed of the movie script!

The two men pause lest they disturb the almost whispered rehearsal of a scene under way. The one in the blue jacket is desperately nervous. Every gesture betrays it. A light dew of perspiration beads his forehead.

Garbo looks up, frowns at the unexpected interruption. And then her moody, complex face breaks into a smile. Two hands are extended quickly in welcome. Greta (in that guttural voice that is famous the world over): "Hallo! This is so nice ... I am happy to see you ... I ..." Her voice trails off as though she, too, is suddenly self-conscious, ill at ease.

The man in the blue jacket swings forward, catches both her hands in his. They laugh nervously. *Not*

GARBO-GILBERT Reunion

Two days later... and things are not going too well on the set of "Queen Christina." They have moved into a tavern set scene and it seems cold and unfriendly as though they might have sensed the presence of ghosts. Jack has not recovered his poise. Then the tension is relieved. "Let us stop and rest a moment," Garbo says. "Shall we smoke?"

What actually happened when they met after all these years, the two who had once loved — she now the queen of the movies, he unwanted as an actor?

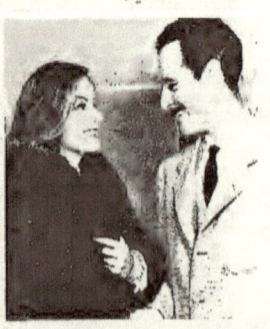

The first meeting of Greta Garbo and Jack Gilbert since their romance ended years ago. It was at this meeting that Greta told Jack he had been selected as her leading man.

for three years have they seen or spoken to each other! Even the technical workers are not immune to the great drama of this moment. They wander away to a respectful distance, to smoke, to talk quietly and casually together.

For John Gilbert and Greta Garbo are reunited again!

And as almost a prowling, disembodied ghost I have been present at that fateful meeting!

Then John Gilbert and his companion stride back toward Gilbert's dressing-room and Greta remains on the set in rehearsal.

THE press agent (to the almost racing blue jacketed figure beside him): "Nervous?" with a little laugh.

Gilbert: "Nervous? Scared as hell! I quaked in my boots. If I'd never put eyes on her before I couldn't have felt more like a self-conscious frightened school boy."

The P. A.: "Do you think she's changed since . . . well, do you think she looks any different?"

Gilbert: "She never changes. She will look the same fifty years from now. She is the most unknowable, complex person in the world. I've never felt that I really knew her. Two years ago I would have sworn that she would never have permitted me to appear with her in a picture again. And yet, now, when I need help and encouragement the most . . . it is Garbo who gives it when every producer in Hollywood had turned me down as an actor.

Funny, isn't it? Crazy . . . only in Hollywood could such a thing happen."

HE strides on, his hands thrust deeply in his pockets, past that elaborate

The Garbo-Gilbert Reunion

dressing-room bungalow that was once his in the days of his million dollar contract, toward the two-room suite on Dressing-room Row.

While back on the set he has just deserted....

The director stands behind Garbo's bed, his inevitable script in hand. Well! Garbo and Gilbert are reunited! Has he changed...?

GRETA (smiling slightly): "He looks well; better than I have ever seen him. Changed? There is nothing for him to change from. John Gilbert is never the same person."

BUT to these eyes of mine there is a change... in both of them. A man as sensitive and high strung as John Gilbert cannot listen for three years to the din: "He is through... he is through... he is all cleaned up as a star and an actor" without confidence-shattering humiliation. A woman cannot know the overpowering success of Garbo without gaining confidence and sureness.

For the moment, temporarily, their personalities are reversed. It is Gilbert who is shy, ill at ease. Garbo is in command of herself. When they were making their great "Flesh and the Devil" it was not that way. It was Gilbert the strong one. Garbo, the sensitive. It is not right, it is not natural this feeling on the part of Gilbert. He is behaving like a grateful pup that has had an unexpected pat of approval on the head. He cannot be his abandoned, colorful self on the screen until he is free of it.

TWO days later... and things are not going too well on the set of "Queen Christina." They have moved into a tavern scene and it seems cold and unfriendly as though they might have sensed the presence of ghosts.

It needs only a casual drift through to realize that Jack has not yet recovered his poise. He is nervous in his scenes; not quite sure of himself. So much has happened so suddenly. The birth of his daughter... the unexpected "comeback" opportunity of this role with Garbo... interviews that take much out of him because he is forced to tell and re-tell of *what happened* to that great idol, Gilbert.... There have been photographic sittings, costume fittings... millions of little things to upset him. He is nervous ... they have rehearsed the scene at the tavern table many times. The rehearsals are not going so well.

Garbo is wearing a costume from the picture, a colorful affair of breeches and a wide sweeping hat with a plume on it. It is obvious she is disguised as a man. Her long-bobbed hair is swooped up under the hat in mannish severity. Suddenly, in the middle of the tedious rehearsal, she speaks:

GRETA: "Let us stop and rest a moment. Shall we smoke?"

The tension is relieved. Garbo moves casually over to a camera stool... perches herself on it. The crew is "at ease." The director yawns, stretches. Now Jack is standing beside Greta's stool. They are talking together quietly. He is trying to say something to her ... apparently something he is having difficulty in phrasing. Then Greta speaks in that soft, low voice:

"I do not want to hear you say how grateful you are to me... again. Why should you be grateful to me? If you feel I have done you a favor," (she shrugs) "I feel that you did me a favor when you, the great John Gilbert, had me to play in your pictures. If I have in any way done you a good turn... this just evens the score."

JACK looks at her. Something that even ghosts can't understand is happening. With that simple little speech Greta Garbo has done far more for Jack Gilbert than give him his comeback opportunity. She has restored that spark... that fire... that self confidence that is as much a part of the real Jack Gilbert as the color of his hair and eyes. In a moment, a bare split second, it is all back again.

THE DIRECTOR: "Let's shoot it now."

But even he doesn't realize what has happened until the noiseless, glass-encased camera starts turning. A colorful, exciting and dashing hero strides across that tavern set, his words ringing confidently. It is the Jack Gilbert of old, the most exciting and outrageous figure that ever cast a shadow on the screen, going through his paces and "doing his stuff" again! The scene is in the box! It is a wow!

HOW different it is! The ice of restraint so noticeable between Garbo and Gilbert is broken now. As the days of production pass, they laugh and joke just as they used to do between scenes of their silent pictures in the past.

That is Gilbert standing there before Greta's chair, giving an imitation of the way his baby daughter looked the day she was born. He puckers his face and twists his mouth. Greta laughs: "You are such a fool." She says it the way she used to say it when something the amazing Gilbert said, or did, made her laugh!

There is to be a long wait between these scenes. The carpenters are repairing something in the back of the set. The set chairs of Gilbert and Garbo are side-by-side as they sit and talk.

JACK: "Where are you living, now, Greta?"

GARBO: "Santa Monica... if you can call it *living*?"

He seems amused.

JACK: "If you are not happy the way you live... why don't you live some other way?"

GARBO (shrugs): "I do not know any other way of living."

Ah, this is what we have been waiting for. That first intimate tete-a-tete between Gilbert and Garbo that has really been the sole purpose of all this confounded spying of mine.

Jack is curious. If Garbo is not happy in Hollywood, why did she return.

JACK (teasingly): "You know you love it here!"

GRETA: "I do not love it anywhere."

JACK: "I don't believe it! Whether you will admit it or not you are a creature of habit. You would be perfectly miserable making a picture, or doing a play, in a strange country with strange faces about you. And what's more... I think you've even begun to like the 'eternal sunshine' of California!"

Gilbert, then, like all the rest of us, is musing why Greta came back, and just like the rest of us... he didn't get a definite answer to his "Why?" It was Greta's turn to tease.

She said: "You are always asking questions... just like a reporter."

JACK: "And never getting any answers... just like the reporters!"

AND I wondered if there was ever any answer to anything Garbo did? There are those rumors that won't die that Garbo suffered severe financial reverses and that she came back for that tremendous salary of $12,000 weekly offered her on her new contract with M-G-M. But then, tremendous money for Greta Garbo could have been obtained in any capital in the world. The city of Stockholm would no doubt have floated a bond issue to keep her had she wanted to return.

JACK (laughing): "It must have been the sunshine that brought you back. It couldn't have been your Hollywood social life!"

GRETA (pretending to be offended): "Oh, I have social life!"

JACK: "You have?"

GRETA: "Sure! I know some musicians and two artists!"

Could it be true? Was Greta Garbo actually kidding herself? Has the queen of the screen a secret sense of humor that no one has ever suspected? It was too much for even my gift of bearing up!

It was surprise enough to find Garbo and Gilbert self-conscious and ill at ease with each other. But actually joking together—and joking about the *legend of Garbo!*

NEW Movie

DECEMBER 10¢ 15¢ in Canada

A TOWER MAGAZINE

GRETA GARBO

HOLLYWOOD'S BATTLE OF THE AGES

Ramon Novarro (in "Mata Hari") says: "She has the rare quality of agelessness."

John Miljan (in "Susan Lennox") feels she is "shy," and Gilbert (in "Christina") "Her imagination is limitless."

GARBO'S DESTINY

By POTTER BRAYTON

What is to be the future of the glamorous Greta? Will she become immortalized as another Bernhardt, or another Duse? Here are some answers from stars who have worked in pictures with her. Do you agree?

WHETHER you call her "Greeta," or "Grayta," or "Gretta," the glamorous Swedish star will always remain just plain "Garbo" to all the world.

You've noticed writers are coming more and more to refer to Greta Garbo by her last name alone. It's a fact that when Sarah Bernhardt and Eleanora Duse first began to taste immortal fame, one of the earliest indications of their outstanding importance in the theatrical world was the insistence of writers and the theater-going public on dropping the "Sarah" and "Eleonora."

I rattled off "Sarah" and "Eleanora" just like that. But I may as well confess I had to look up Duse's first name in the dictionary just now. Some day, if Greta Garbo becomes immortal too, we'll be looking up her first name in the dictionary.

—If Greta Garbo becomes immortal—but that is a matter of destiny! And who are in a better position to predict that destiny than those men who have starred with Garbo in pictures, who have known her on and off the set, studied her, laughed with her, and worked with her!

Ramon Novarro, for instance, whose emotional Latin outlook usually disguises his opinions, is very clear and altogether original in his impression of Garbo's power. "Working with Greta Garbo in *Mata Hari* was one of the most memorable and outstanding experiences in my life. I shall never forget it," Ramon began with his customary exuberance.

We were sitting at lunch in the M-G-M refectory. He suddenly smiled and pushed back his plate. "But I didn't mean to say that—that tells you nothing!" he laughed. "What I meant to say was that I had expected to find an artist—not just another actress—who would demand of me all the ability and experience which I possessed.

"I found that, and also I found one of the most sympathetic, human women whom I have ever met, a woman who, in spite of all her success and fame, is astonishingly self-conscious and modest. So much for her definable characterstics.

"As for her hold on the public, I say: Yes, Garbo is inspired. In the first place, she has the rare quality of agelessness. Off the screen she is a surprisingly young woman. On the screen she might be any age. Bernhardt had that quality. So did Duse. So have all great artists.

"And Garbo defies imitation. You can see that! Other women can copy her appearance, her clothes, her mannerisms, even the husky timbre of her voice. But they cannot copy the inner self which is the real Garbo and which the camera sees and photographs. There has never been a second Bernhardt or Duse. There will never be a second Garbo. They are immortals."

JOHN MILJAN, well-known screen heavy who appeared with Garbo in *Inspiration*, *Susan Lennox*, and additional pictures, on the other hand is of the opinion that the Swedish actress is not great.

"Garbo is a product," says Miljan, "of Mauritz Stiller's advice, and of sure-fire publicity. When Stiller brought his protégée to America, he drilled into her one fact:

"'In America,' he told her, 'you are an actress, a master of your art. Let nothing that would please or hurt you as an individual affect you; think only in terms of your career as an actress.'

"When Garbo found herself alone and baffled by American ways, she remembered Stiller's advice. If people misunderstood her and frightened her, she would stay away from people; she would concentrate on acting in pictures. M-G-M

Below: Robert Montgomery (in "Inspiration") says: "She is an enigma." On the right: Mauritz Stiller, who brought Greta to America from Sweden and who also believed in her immortality.

Clark Gable (in "Susan Lennox") believes: "She possesses something more than acting ability." Left: Charles Bickford (in "Anna Christie") says: "Her power comes from within."

Garbo's Destiny

found that the less people could find out about Garbo, the more they wanted to know, and the studio proceeded to spin a web of mystery around her.

"Duse and Bernhardt were constantly in personal contact with the public; and they were as dazzling off-stage as they were behind the footlights. They were truly great. On the other hand, Garbo would probably faint if she had to attend a reception for the newspaper and magazine writers.

"By saying she is not great, I do not mean that she isn't a fine actress and a charming woman. She is just a wholesome, natural person. For instance, it's difficult to think of the 'mysterious' Garbo as the giggly sort, isn't it? But it's a fact. On the "Inspiration" set, Bob Montgomery's customary banter and ribbing among his fellow actors had Garbo in continual spasms of giggling —as much at home and having as good a time as any of the others on the set.

"Garbo herself doesn't think she's great; that's why her fellow actors do not feel that she's being high-hat when the prop boy places a black screen back of her during the shooting of a scene. They understand that she is shy, and they realize that she can do her best work if a gang of extras, technicians, and actors aren't watching her. And so they respect her and leave her alone as much as possible.

"She is almost as diffident today as she was five years ago. A suave, well-poised actor like Lewis Stone scares her to death. As far as I can see, Greta Garbo differs from any shy girl with an ability to act, only in that she has the gift of shaking off this shyness while being photographed."

JOHN GILBERT says, "I played opposite Garbo at practically the beginning of her career ... 'A Woman of Affairs,' you remember. And now I have just finished playing opposite her in 'Queen Christina' her most recent picture. In the latter picture, I was aware, of course, that her screen technique had improved immensely. That is natural; she has become confident of her English and of her growing knowledge of American customs.

"What is generally called *genius* is not as mysterious as it is claimed to be. Every great person is *great* because he or she appeals to a large number of people through a remarkable ability to understand humanity. Greta is great, because shy as she is, she understands and deeply sympathizes with a wide range of human problems. Her ability to give understanding interpretation to her roles is not due to a self-imposed divine inspiration, but to the ease with which she can project herself in the part she is portraying. Her imagination is so limitless that she can—on the screen—be a disillusioned circus performer or a queen trapped by her own regal power and laugh or weep in either role with equal sincerity.

"When Garbo says to a camera 'all this great joy I feel now, Antonio' she means it from the bottom of her heart. As she develops as a woman, so Garbo's technique in interpreting the vast scope of her imagination will grow. To that extent, a thing which only the future can divulge, Greta Garbo will become a screen immortal."

CLARK GABLE pulled in his belt a notch and leaned back reflectively against the sound stage. "East is East, and West is West, and ne'er the twain shall meet," he said. "—And neither shall the stage and screen. Miss Garbo is a screen actress; I can only talk about her in that light.

"When you think of the screen's most enduring personalities, the people who have survived the years and all the changes, you think only of a small handful of men and women. And I sincerely believe that Greta Garbo will always be numbered among them. Each one of these so-called immortals has offered to the world something new and different, something which cannot be duplicated. That I believe, is the fundamental truth upon which her amazing success has been built."

At this point Clark lighted a cigarette and puffed at it dreamily in silence. I began to think that in humpty-dumpty fashion he had finished with the interview, but suddenly he continued, frowning, as though arguing something out with himself, "She possesses something more than beauty and acting ability ... I can't name or define it ... The word *personality* does not cover it—" Suddenly returning to earth and smiling his good-natured smile "—But everyone feels it, the people with whom she works as well as the audiences who see her on the screen. I don't think that Miss Garbo, herself, is aware of it. As a co-worker she is always cooperative and cordial. She has a thoroughly human sense of humor and understanding. She has the strength of will to live her own life her own way. But, in spite of this humanness and this cordiality, she has Something—which must be spelled with a capital 'S'."

"It's that capital 'S' that makes you repeatedly refer to her as 'Miss' Garbo," I interrupted.

Clark grinned and nodded his head. "She's an individual," he concluded. No one else is, or can be, like her. And all immortals are individuals."

CHARLES BICKFORD, Hollywood's red-headed, two-fisted, he-man, who in "Anna Christie" played opposite Garbo at the most crucial moment of her career—her talkie debut—believes that the famed Swedish star has genius.

"Her power comes from within," Bickford says. "She doesn't know what her power is any more than she knows what makes her eyelashes so long—they're the real thing, by the way. She only knows what I do, that when she goes before the cameras she is able to project herself into her role—forget shyness—live the role. That's genius.

"Genius isn't discovered. Genius just is. Stiller didn't think he was bringing a genius to America. He had a good job in America; he was in love with Garbo; so he did what any man in love would have done. He said, 'I have an actress friend; she's good. If you want me, you'll have to take her too.' And so M-G-M took Garbo, and no one was more surprised, when the box office recorded her a smash hit, than Stiller, Garbo, and M-G-M!

"As for her immortality, I don't believe that Garbo will ever rest in a niche beside Bernhardt and Duse unless she follows her screen career with a stage career. An in-the-flesh role, uninterrupted by repeated mechanical changes of scene, or breaks in continuity, such as is only possible behind the footlights, is the only medium by which an immortal characterization can be performed. If in the future, Garbo overcomes her dread of public contact—which I doubt greatly she will do—and gets a few good stage roles, I would be the first to predict her immortal triumph.

"Garbo's present hold on her public isn't all due to the 'mystery woman' publicity which has been built up around her. Other screen actresses have tried to be retiring and silent, but in no case have they succeeded in mystifying the public, for the obvious reason that they weren't altogether sincere. Garbo is shy from the very bottom of her heart. She dreads and dislikes to be noticed or touched by strangers. She is simple and honest and direct with her friends and associates on the set. And through the medium of the silver screen she brings a lot of pleasure and fine interpretation to the movie-going public. With these things in her favor, I can't understand an attitude that begrudges her the right to be shy and retiring off-screen, if it so happens that it isn't in her nature to be otherwise.

"Garbo is an artist. She isn't waiting to amass a great fortune and then scuttle back to Sweden with her American dollars. She loves every minute on the set. She was born with that love of acting, seldom so pronounced in women of this age—I mean acting, not just showing off—which enables her to give the inspired performance you see on the screen. What she is off-screen is of no importance—a mystery woman—a myth created by writers for the sake of sensationalism —in reality, a natural girl who wants to be let alone."

ROBERT MONTGOMERY'S ten-league legs had carried him half-way across the M-G-M lot before I caught up with him. "Aw, for the love of Mike!" he puffed. "Why don't you ask me something easy—I don't understand the woman—I was so nervous and excited when I was assigned that role with Greta Garbo in "Inspiration" that I was practically inarticulate. And I still don't know what there is about her ... I don't know what to say!"

"She affects me that way too," I encouraged. "What *is* it Garbo has that other actresses lack?"

"Well," Bob resumed, "I don't know what I expected Garbo to be, certainly not just an ordinary woman, or, comparatively new in pictures though I was, I wouldn't have been quite so jittery. And what did I find?—" lifting his eyebrows in one of his arch smiles "—A gal who did everything in her power to make it pleasant and easy for me, and a swell actress to get along with! Needless to say, I soon got over the jitters, and in fact had a lot of fun kidding with her. Nothing gets by Garbo—she has a great sense of humor!

"About this immortality business, I believe that my first feeling, that strange mixture of awe and excitement, that belief that she is more than an

Garbo's Destiny

ordinary woman, is the secret of Garbo's hold on the publics of the world. She has built about herself a wall of mystery and inaccessibility. People, watching her on the screen, feel that. While other actresses are warm, flesh and blood women with human feelings and frailties, Greta Garbo seems made of different clay.

"Of course she's shy and justifiably silent about her private affairs—but that isn't what I mean by calling her 'mysterious.' I mean that certain something that makes Garbo an enigma even to herself. Bernhardt and Duse were open books, compared with Garbo! Yes indeed! ... Garbo will rank with the immortals, with Bernhardt and Duse of the stage, not because she is a greater actress than many other women of motion pictures, but because she has this personality that is so outstandingly unique and undefinable."

And thus the men in her American picture career predict the stellar destiny of the one and only Garbo. "To live in hearts we leave behind, is not to die," said some scribe. And with that the case, whether or not we ascribe greatness to Garbo's repeated screen triumphs, it is safe to say that her destiny lies the way of the Immortals.

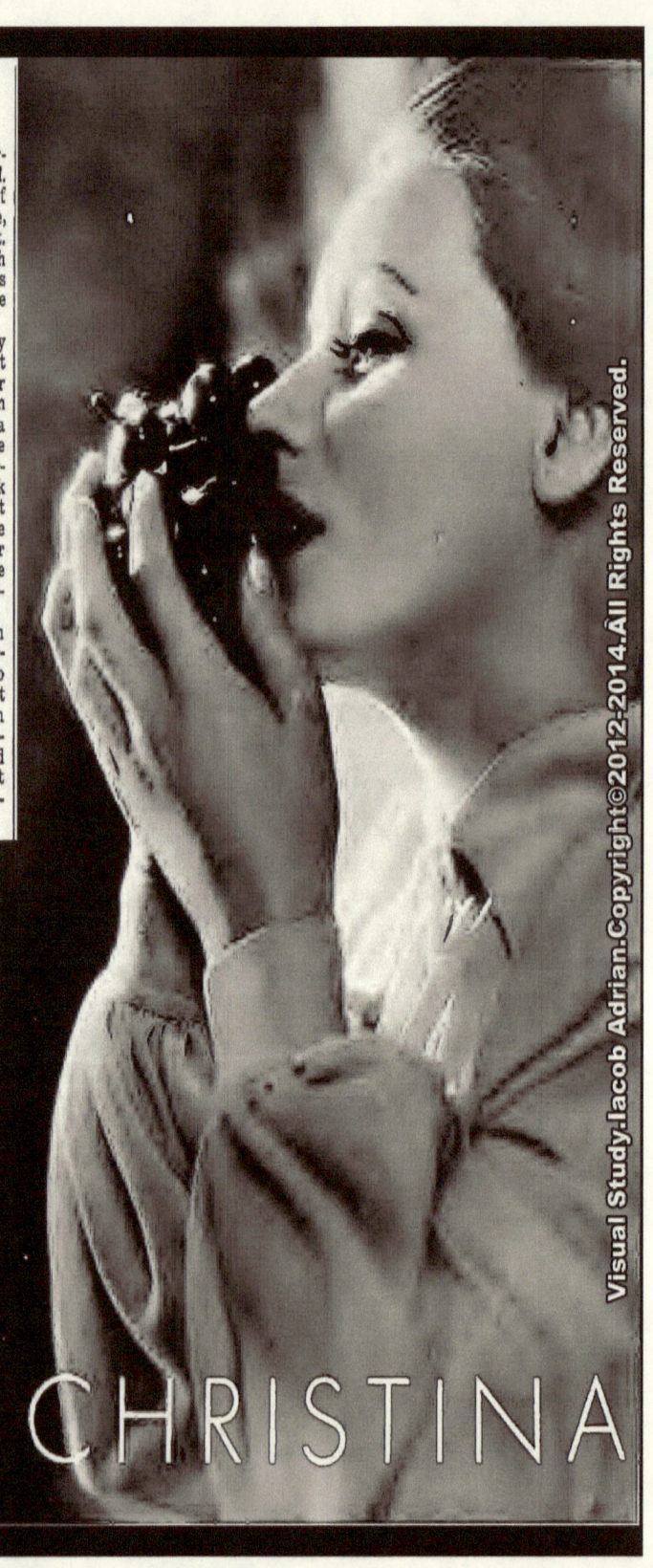

CHRISTINA

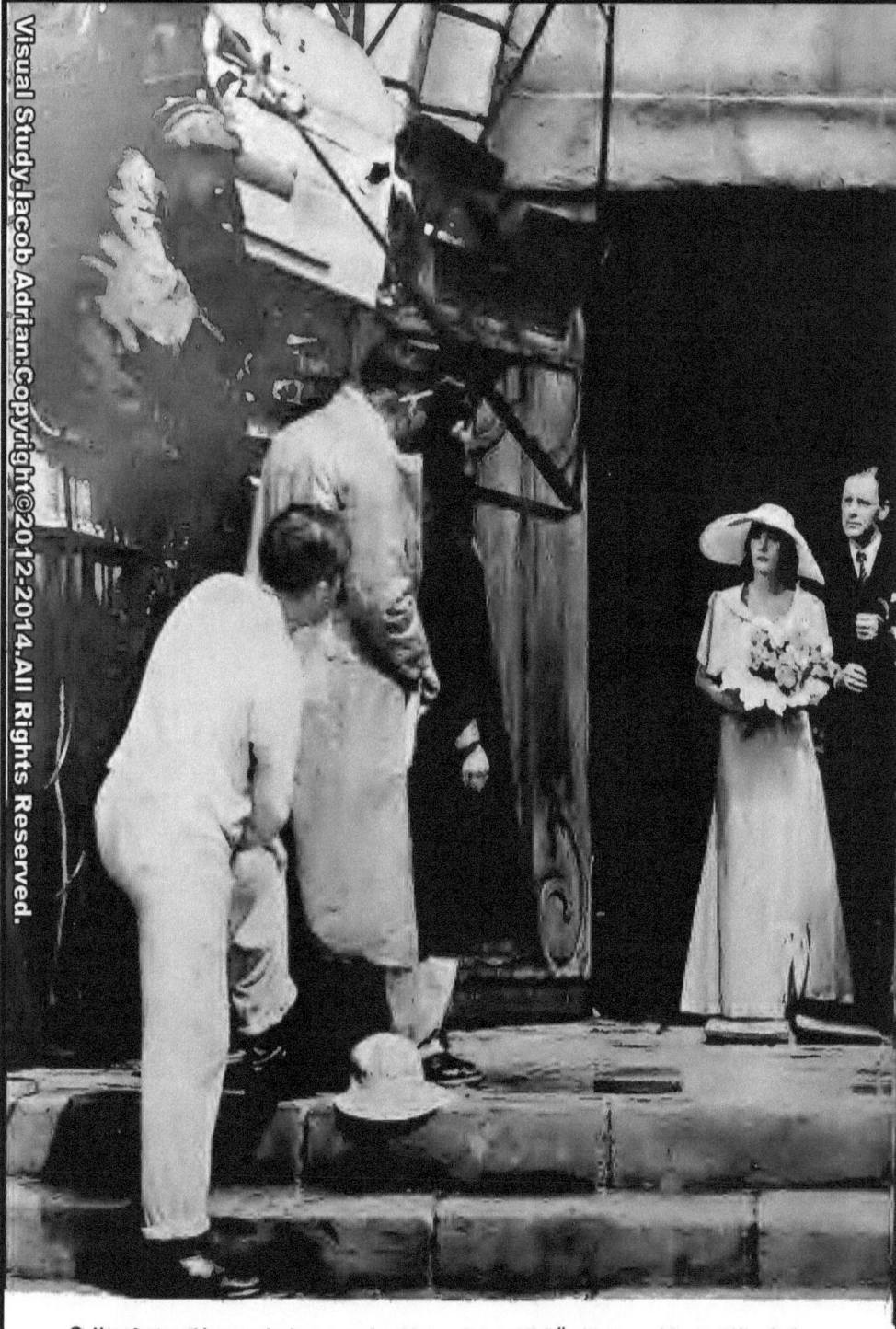

● Here is something you don't see once in a blue moon—a photograph of Greta Garbo at work. This is the wedding procession scene from "The Painted Veil." Garbo and Herbert Marshall you can pick out without any trouble. Beside the camera, wearing a raincoat and with a pencil

tucked behind his ear, is director Richard Boleslavsky. And over at the right, on the steps, find Beulah Bondi, Jean Hersholt, Cecilia Parker, and Billy Bevan, who used to play in comedies years ago. Notice the raised boards Garbo walks on to increase her height? Marshall is a six-footer.

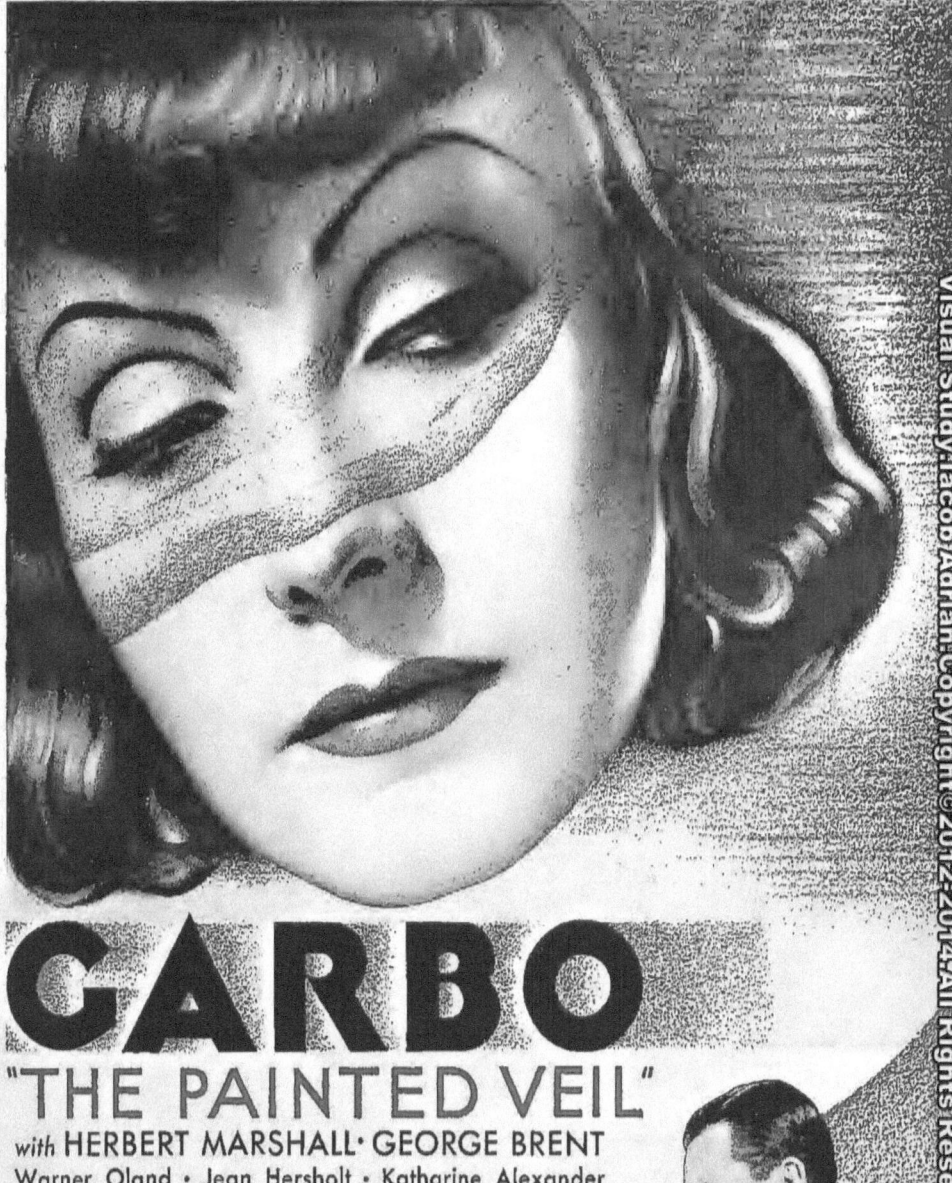

Bibliographic sources :

Hollywood (1934-1943)
Publisher: Hollywood Magazine, inc. ; Fawcett Publications, inc.

The New Movie Magazine (1929-1935)
Publisher: Tower Magazines, inc.

This documentary study use,
combined in various proportions,
elements from the following categories,
forms and subsets :
- fair use
- documentary
- documentary photography
- feature
- journalism
- arts journalism
- visual journalism
- photojournalism
- celebrity photography
in order to :
- employ material as the object of cultural critique ,
- quote to illustrate an argument or point ,
- use material in historical sequence,
providing independent opinion,
using photos, press articles, advertisements,
opinions of fans etc. ...

Copyright©2012-2014 Iacob Adrian
All Rights Reserved.

www.ingramcontent.com/pod-product-compliance
Lightning Source LLC
Chambersburg PA
CBHW030759180526
45163CB00003B/1087